THE FIRST SIGNS

"Von Petzinger has created a fascinating look at signs found in caves that have not been thought of before. I have been in many of the caves myself and recognized many of the symbols. I thought her analysis of the symbols reflected the intelligence of our ancient ancestors. She has done a remarkable job of analyzing a part of cave art that has never been done in that way before."

—Jean Auel, author of the bestselling Earth's Children series

"Fascinating . . . A journey through later prehistory, interspersed with personal anecdotes of her exploration. [Von Petzinger] delves expertly into many of the questions around the earliest expressions of art, symbols, and language."

—Louise Leakey, paleontologist and
director of the Turkana Basin Institute

"Brings fresh eyes and fascinating theses to the study of ancient rock art . . . Lively . . . Linking these systems to other graphic conventions may eventually yield some sort of Rosetta stone. . . . Anyone who's longed to visit Lascaux or the caves of Cantabria will be eager to read von Petzinger's admirable efforts at cracking the code."

—*Kirkus Reviews*

"An exceptional read that should capture the imagination of anyone fascinated by time, humanity, and prehistory."

—*Library Journal* (starred review)

THE
FIRST
SIGNS

UNLOCKING THE MYSTERIES
OF THE WORLD'S OLDEST SYMBOLS

GENEVIEVE VON PETZINGER

ATRIA PAPERBACK

New York London Toronto Sydney New Delhi

ATRIA
PAPERBACK

An Imprint of Simon & Schuster, Inc.
1230 Avenue of the Americas
New York, NY 10020

First Atria Paperback edition March 2017

ATRIA PAPERBACK and colophon are trademarks of Simon & Schuster, Inc.

For information about special discounts for bulk purchases, please contact Simon & Schuster Special Sales at 1-866-506-1949 or business@simonandschuster.com.

The Simon & Schuster Speakers Bureau can bring authors to your live event. For more information or to book an event, contact the Simon & Schuster Speakers Bureau at 1-866-248-3049 or visit our website at www.simonspeakers.com.

Interior design by Renato Stanisic

Manufactured in the United States of America

10 9 8 7 6 5 4 3 2 1

The Library of Congress has cataloged the hardcover edition as follows:

Names: Von Petzinger, Genevieve.
Title: The first signs : my quest to unlock the mysteries of the world's oldest symbols / by Genevieve von Petzinger.
Description: First Atria Books hardcover edition. | New York, NY : Atria Books, an imprint of Simon & Schuster, Inc., 2016. | Includes bibliographical references and index.
Identifiers: LCCN 2015051281 (print) | LCCN 2016001997 (ebook) | ISBN 9781476785493 (hardcover : alkaline paper) | ISBN 9781476785509 (paperback : alkaline paper) | ISBN 9781476785516 (E-book)
Subjects: LCSH: Paleolithic period—Europe. | Glacial epoch—Europe. | Signs and symbols—Europe—History. | Symbolism in art—History. | Geometry in art—History. | Art, Prehistoric—Europe. | Rock paintings—Europe. | Von Petzinger, Genevieve—Travel—Europe. | Europe—Antiquities. | Social archaeology—Europe. | BISAC: SOCIAL SCIENCE / Anthropology / Cultural. | HISTORY / Civilization. | ART / History / Prehistoric & Primitive.
Classification: LCC GN772.2.A1 V66 2016 (print) | LCC GN772.2.A1 (ebook) | DDC 302.2/223094—dc23
LC record available at http://lccn.loc.gov/2015051281

ISBN 978-1-4767-8549-3
ISBN 978-1-4767-8550-9 (pbk)
ISBN 978-1-4767-8551-6 (ebook)

For my husband, Dillon, my partner in love, life, and work.
Without you, none of this would have been possible—thank you.

And for my son, Marius, who was with me throughout this journey.
You, more than anyone, have taught me what it means to be human.

The Geometric Signs of Ice Age Europe

 Asterisk

 Aviform

 Circle

 Claviform

 Cordiform

 Crosshatch

 Cruciform

Cupule

 Dot

 Finger Fluting

Flabelliform

 Half Circle

 Line

Negative Hand

Open Angle

 Oval

 Pectiform

 Penniform

 Positive Hand

Quadrangle

 Reniform

 Scalariform

 Segmented Cruciform

 Serpentiform

 Spanish Tectiform

 Spiral

 Tectiform

 Triangle

Unciform

W-Sign

Y-Sign

Zigzag

Contents

Introduction 1

Contents

CHAPTER 16

Seeing the Unseen World: Visions, Shamans,
and the Seven Signs 243

THE
FIRST
SIGNS

Introduction

love patterns. I guess you could say it's in my blood—my British grandmother worked on the Enigma Project at Bletchley Park during the Second World War, and she was recruited by MI6 specifically because of how good she was at recognizing patterns.

Identifying patterns can often help scientists make sense of large-scale phenomena that may be difficult to see at the smaller-scale, or local, level. We see this type of patterning being used in fields like medical science (e.g., to track down the origins of a new global epidemic) or macroeconomics (e.g., how a manufacturing slowdown in a province in China can affect unemployment rates in certain US states). Patterns can often help us find meaning where there seemed to be none.

Patterns were what first attracted me to the ancient geometric signs of Ice Age Europe. I was in the last year of my undergraduate degree in anthropology when I took a course about Paleolithic (Stone Age) art. As I sat in class each week, looking at the slides of European cave art, I noticed that there were often geometric markings visible in the photos, but that they never appeared to be the central subject—the photos always seemed to focus on the animals. My interest was piqued when the instructor mentioned

that the signs had yet to be studied systematically, and I became very intrigued when I started to get the feeling that I was seeing the same shapes at different sites.

I was curious about how many different abstract rock art signs there were and whether these same shapes appeared at multiple sites across Europe. I wondered whether these signs spanned the course of the Ice Age, which was from 10,000 to 40,000 years ago. People have been studying European rock art for over a century, so I was certain that, even if there was work left to be done, someone must have researched this, but all my attempts to find information about the mysterious signs came up short. I asked my professor why I was having so much trouble finding material on this subject. The answer she gave me was not what I expected. She told me the reason I couldn't find any information was because the signs had never been studied on that scale or in that particular way before. And so I embarked on that grand investigation.

My first project focused on the geometric signs found at rock art sites in France during a time called the Upper Paleolithic. Dating from roughly 10,000 to 40,000 years ago, the Upper Paleolithic marks the arrival and settlement of Ice Age Europe by some of the first modern humans to leave Africa. This is also where we find some of the oldest art in the world. Using the available data from more than 150 French rock art sites, I was able to show for the first time that a very restricted number of abstract markings—such as triangles, circles, lines, rectangles, and dots—were in existence during this era and that these symbols did in fact repeat across space and time. Now I knew I was on to something. These images were not just the doodles or decorative embellishments that some researchers had dismissed them as. I wasn't any closer to understanding what the individual signs meant, but the patterns told me that they were meaningful. Not only were these early artists carefully replicating the same symbols at multiple sites, but I could

also see changes in popularity as some signs fell out of favor and new ones entered circulation. It was tantalizing, but to really get at what was happening I needed to expand beyond France to see if the same patterns were identifiable around the continent.

The more time I spent studying this ancient chapter of our history, the more fascinated I became with the art and the minds that had created it. Without a doubt the art is magnificent, but that's not why I study it. Two hundred thousand years ago modern humans appeared on the African landscape for the first time. They had our bodies; they had our brains. But the real question is: When did they become us?

When did they start to behave in a truly modern way, tapping into all the creative potential of the human mind? This is much harder to ascertain since we can't physically gain access to their minds—their skeletal remains tell us lots of things, like their average height, health (malnutrition, injury, and diseases like arthritis leave evidence behind on the bones and teeth), and brain size, but they don't provide us with any clues as to what they were thinking about. This is where the different art forms come in—they are undeniably nonutilitarian. There is nothing about their art that put a roof over their heads or kept them warm at night. And they couldn't physically hunt an animal with art. So what led them to start creating it?

Starting around 120,000 years ago in Africa, we begin finding little glimmers of modern thinking—an engraved bone here, a burial with red ochre and a necklace there. From 100,000 years onward, portable pieces decorated with geometric markings (lines, crosshatching, chevrons, etc.) begin to appear. With the passage of time, these abstract images—which could well be seen as the precursors to rock art—became more complex, and by 50,000 years ago, around the time that people began moving out of Africa to populate the rest of the globe, there was a sudden flourishing of rock art, figurines, necklaces, complex burials, and music.

All of these artistic traditions reinforce the widely held view that spoken language was completely formed by at least 100,000 years ago. But what about written language, one of the most distinctively human behaviors of all? We use symbols in the modern world constantly, so why couldn't our 25,000-year-old, or even 40,000-year-old, selves have been doing that, too? Is there evidence, buried here within these symbolic practices, of the first attempts at graphic communication—of attempts to send messages about identity or ownership, or possibly even to share more complex concepts?

More than any other type of imagery, the geometric signs may hold the key to unlocking some of the mysteries of our ancient past. My first study raised more questions than it answered, and it led me to pursue several new lines of inquiry, including: Were the signs invented in Europe or are they the product of an even older tradition? Does the same small group of signs appear at sites throughout Europe? And what does this say about the movement of people and ideas during the Ice Age? And, finally, were the signs in fact a form of graphic communication, and if so, how can we prove this when we don't know what language (or languages) they spoke?

This book answers those questions. (So as not to leave you completely in suspense, the short answer to that question is that, barring a few outliers, there were only thirty-two signs in use across the entire 30,000-year time span of the Ice Age and across the whole continent of Europe. And that is a very small number.) But I don't just want to tell you about my research, I want to show you. My work allows me to visit places that most people will never have the chance to see, to spend time communing in the dark with the silent images that bear witness to our ancestors' dawning awareness of their own humanity. It's an incredible journey, and I invite you to come along.

Two Red Dots

I am standing on the Camino de Santiago, the ancient pilgrimage route in northern Spain. This part of the Camino winds its way along the coast, passing through medieval villages on its way west. In the distance I can see the town of Comillas with its ancient yellow-gray stone buildings, their façades punctuated with vibrant splashes of red from the geraniums in their window boxes.

It's a blustery day in May of 2013, and white clouds dance across the sky, playing hide-and-seek with the sun. The Cantabrian Sea stretches out in front of me, slate blue topped with little whitecaps; it crashes against the shore below my feet and sprays my face with a delicate, salty mist. The sun breaks through for a moment, and the water becomes a translucent turquoise window, giving me a glimpse of the rocks and white sand beneath the waves.

Two people stride toward me, walking sticks swinging purposefully, their backs slightly bent under the weight of their backpacks. A white scallop shell—the symbol of their sacred quest—hangs from each of their packs, marking them as pilgrims. For over a millennium people have made this spiritual journey to visit what many believe is the final resting place in Santiago de Compostela, Spain, of Saint James from the New Testament.

But I am here on a different kind of pilgrimage. I'm with my husband and project photographer, Dillon, and we have just met up with Gustavo Sanz Palomera, an archaeologist with the Cantabrian government. We are here to explore a cave in the hillside behind us that is supposed to contain Ice Age paintings.

Long before this country was called Spain, people lived in this land. They survived the challenges of an Ice Age world in the relative stability of this region. With its protected river valleys and abundant marine resources, this landscape provided ancient humans with a suitable environment in which to live and thrive. They first settled here over 40,000 years ago and occupied this territory almost continuously until the end of the Ice Age, 30,000 years later.

We know they were here from the evidence they left behind: habitation sites scattered with stone tools and animal bones; human burials including "grave goods" and personal ornaments; and then, of course, there are the caves throughout this region that they decorated with the engravings and paintings that are, in many ways, their greatest legacy.

Art presents us with a window into the minds of these people that other types of artifacts just can't provide. It offers us glimpses into their world, their culture, and their belief systems; intriguing hints about their level of sophistication in thinking in the abstract and manipulating symbols; and insight into how far along they may have been in the development of graphic communication. While all of the art has this potential, the geometric imagery in particular seems to indicate a high degree of mastery of many of these uniquely human traits. This category of geometric signs is my passion. Sometimes they accompany the other imagery, and at other times they stand on their own. The signs are what I'm here to study.

Dillon and I have spent the last month and a half in France documenting the art at eleven different cave sites, so in some ways today's excursion feels almost like "another day at the office,"

albeit a pretty interesting and ever-changing office. We've worked in massive caves with high, curved ceilings that give us the feeling of being in an underground cathedral; we've worked in others so narrow in width that photographing the art required contorting ourselves into some very awkward positions; we've worked in caves with collapsing floors and caves with steep muddy sections that required very careful maneuvering.

But as I stand there in my hoodie, jeans, and hiking boots, watching Gustavo pull on a full-body waterproof suit and boots, I start to get the impression that my French caving clothes may not be entirely appropriate for this situation.

"I really hate this cave," Gustavo tells us as he's getting ready. Dillon and I glance at each other; these are definitely not the words you want to hear before you've even entered a site . . . especially when your guide is getting seriously geared up!

"Oh," I say. "What's so bad about it?"

"Deep mud and very small," Gustavo replies with a grimace. He speaks excellent English but I'm hoping in this case that something is being lost in the translation.

We turn our backs on the Camino and the sea to face a lush, overgrown green hillside. As we start to hike up a gravel path, I quickly spot the entrance to La Cueva de El Portillo on our left. The entrance doesn't seem too bad: a dark split in the hillside that's about eight feet high, with enough width for us to walk through comfortably. We step over the threshold into a roundish chamber with an even higher ceiling. The chamber is about twenty feet across at its widest point. The floor is pretty muddy, but my hiking boots have seen as much in French caves and survived.

Maybe this isn't going to be as bad as I thought.

I look around the chamber, my vision adjusting to the gloomy interior. The floor plan I was studying for this cave earlier in the day showed a passageway continuing quite a bit farther into the

hillside, but I don't see any exit from the chamber other than the way we came in. Then, as I scan the solid gray walls, my eyes are drawn to a small opening low down on the back wall. It doesn't even quite come up to my knees. Oh . . .

"Gustavo, is this where we're going?"

"Yes," he replies. "Much of the cave is like that. This is why I hate it."

Huh. I examine the narrow entrance more closely and notice that the passageway angles down sharply, and a small stream of water trickles across the thick muddy surface, its flow splitting to encircle jagged pieces of rock that rise like islands out of the mud as it continues downward into the darkness below. I see no sign of the passage broadening out, either.

Dillon cradles his camera bag protectively and gives me a look. Even big, relatively dry caves can do a number on camera equipment, so having to drag his expensive gear through the conditions that El Portillo has to offer is not something he's exactly thrilled about. We also have two battery-powered 500-watt LED banks of light with us, so I guess we're about to find out how rugged everything really is.

Gustavo leads the way as he slips the lower half of his body into the tight opening and begins to wriggle downward. As he vanishes into the dark, he tells us, "It only goes on like this for about fifteen feet, and then it levels out enough that you can crouch."

He calls up to let us know that he's made it down, then flashes his light on the tight walls of the descending passage, giving me a glimpse of what is to come. I'm pretty sure I can see a spot about halfway down where it gets even tighter.

It's my turn.

I grab hold of a protruding lip of rock above the hole and swing my legs into the opening. My feet search around until I find a rock to brace myself on—I'm not quite vertical, but my angle is

much closer to standing than to lying flat. Slithering down into the dark, the mud squelching underneath me, I now understand why Gustavo is wearing a waterproof outfit.

Shimmying down, feeling my way with my feet, I'm now completely inside the narrow passage—my back's against one wall and my face is about six inches from the other. The only sounds I can hear are my own breathing and the quiet trickling of water. A faint glimmer of light reaches me from the entrance chamber above, but other than that, with my body blocking any light Gustavo might be trying to shine up from below, I find myself in complete darkness.

Thank God I'm not claustrophobic.

I work my way down in small increments by pushing my hands off the rock in front of me. I try not to think too much about the weight of stone in the hillside above me. On the upside, at least this region of Spain is not very seismically active.

This type of adventure is a regular part of my job. Moments like this one remind me how lucky I really am. As a paleoanthropologist studying some of the oldest art in the world to better understand why our distant ancestors started to create paintings and engravings in Europe, I have explored many caves just like El Portillo . . . though not often so muddy or so narrow. Still, I love what I do.

After a couple of minutes, I feel a pair of hands grab my feet and guide them onto the cave floor. I turn myself around inside the narrow passageway so I'm looking up. We still need to get our gear down safely. Dillon leans in headfirst, and I boost myself back up until we are within reach of each other to receive the two light banks and a camera bag.

Finally, it's Dillon's turn to descend. With his greater height and previous experience climbing mountains, he manages the descent much more smoothly than me and emerges onto the cave floor almost doing the limbo as he slides his lower half out and to

the side to get around the bulge of rock at the mouth of the passage. We have arrived on the main level of El Portillo.

We get to work looking for the geometric signs that are shown on the one and only map that exists for this cave. As with the other rock art sites, there is very little information about El Portillo beyond a one-page description from an independent archaeologist forty years ago and the map I hold in my hand. No one has been back to study this site since 1979, when the archaeologist reported that there was Ice Age art here and made a quick sketch of the cave's floor plan with the locations of images marked simply as "*grabados*" (engravings) and "*restos de figuras*" (the rest of the images). His written description of what he found was not much more detailed: one, possibly two, red dots; a crumbling engraving of a quadruped, species unknown; other unidentifiable engravings; several red marks; and the remains of some red signs (no description of their shape). It is the red signs that most interest me. I hope to identify what they are.

Gustavo tells us we are the first people to have requested access since that archaeologist's original discovery. As I stand up to my ankles in a mixture of brownish-red mud veiled by a thin film of water, somehow I'm not surprised. Only a very small group of scholars studies rock art from the Ice Age, and with so many sites to choose from, a site like El Portillo, where only a handful of badly degraded images have been reported, is not likely to be at the top of most of their lists.

But I am interested in *all* the signs at *all* the Ice Age sites in Europe. At many of them these mysterious geometric signs outnumber the images of the animals and humans by a ratio of at least two to one. I built a database specifically to study these markings and record the contents of each site. That database now comprises more than 350 Ice Age sites. I use its information to analyze the movement of signs, ideas, and culture, as well as

the potential origins of graphic communication. Knowing that the information I am working with is accurate is crucial if I am to identify patterns, so even a seemingly insignificant site like El Portillo is important.

Having redistributed our gear and consulted the map, we start off along the passage that stretches forward into the dark. We can almost stand up straight here, so this part of the cave feels positively palatial, compared to the narrow entrance chute. We're headed for the red paintings that are supposed to be near the back of the cave, with a stop along the way to look for the engravings. I shine my light around as we walk—it's surprising how often I find new signs this way. Not this time, though. The interior rock of El Portillo is a yellow-brown color, with a heavy buildup of dirt and a smearing of mud across large sections of the passage. This is definitely not the prettiest cave I've ever been in, and as far as we can tell from the geology, it looked pretty much the same during the Ice Age when those early artists ventured in.

We walk along in single file, our boots making sucking sounds in the mud. The sounds echo off the walls, and I notice that the ceiling is starting to get low again. Of course. Gustavo was here only one other time prior to today, as part of his orientation, and apparently El Portillo was just as unpleasant that time around. On that occasion they were unable to find any imagery other than the dots, and the map wasn't even terribly accurate about the cave's layout. With those words of encouragement, and the ceiling sloping sharply toward the floor in front of us, it was time to lie back down in the mud.

We scoured the walls for the engravings and other mysterious red signs, using all the tricks at our disposal, but we were only able to find the two red dots. In all likelihood, the other images were never there in the first place. Sometimes natural cracks in the rock or different-colored mineral pockets can masquerade as images,

especially in low light, and that could be what the first archaeologist saw. Most of the time I am adding to the inventories, not subtracting, so this was actually a fairly unusual situation for us. Dillon and I have found new signs, or rediscovered missing ones (i.e., they'd initially been identified but no one had found them since), at over 75 percent of the sites we have visited. Some of these discoveries have been thrilling and surprising, but El Portillo did not challenge our existing knowledge.

I contemplate all of this as I am lying flat on my back in the mud once again, my nose almost scraping the low ceiling, on our way back from photographing the dots, which were located in a very small side chamber. I dig my heels in to get traction and inch my way forward using my fingers to grasp at little outcroppings above my head. After this, we have only to navigate the vertical passageway back to the upper level and we will be out.

When we emerge into the sunlight, Dillon and I are both so encrusted with mud that we can't help but laugh. Gustavo is apologetic that we have just spent almost three hours sliding through mud for the sake of a couple of red dots, but I assure him it was time well spent, since confirming the contents of these Ice Age sites is precisely why I am here. When doing research, even negative results are important. Now I can update my database.

The two dots were quite interesting in their own way. Rather than being painted in the typical red or black colors we usually see at sites across Spain and elsewhere in Europe, these were made using a distinct shade of mineral iron oxide (ochre) pigment that was much closer to pink than to red. This particular color seems to have become quite popular during the later millennia of the Ice Age in the region—maybe pink was the new red?—and it ties El Portillo in to the larger body of art in Cantabria. I often wonder what compelled these people to make this hazardous and rather soggy journey underground, with only the aid of a torch or oil

lamp. What was it about this cave that made it worth it, especially if they did little more than paint two red dots?[1]

These are the kinds of questions that kept me crawling through the mud in passageways deep under the earth over the two-year span of this project. And, luckily, not every site was as devoid of symbols as El Portillo. In fact, we had the opposite experience the following year, not far down the coast, at the site of Cudon. The entrance to this cave happens to be right in the town of Cudon—it felt funny to be trekking along a civilized road with all our gear before entering a gated grass square in the middle of a residential neighborhood. The entrance to Cudon is much more inviting than El Portillo's—a short climb down from street level brings you to a wide cave mouth framed by bushes and trees that have taken up residence outside the opening.

The first art you find is in daylight—a long row of large red dots, each about three inches across, running the length of a wall not far from the entrance. This cave complex was carved out by an ancient underground river, so the passageways tend to be tall and wide with curving ceilings, a bit like an old subway tunnel. Since this cave is very accessible, modern graffiti can be seen here and there along the walls as we move deeper into the cave. It is a four-hundred-yard walk to the next Ice Age image—a single negative handprint in that same pink shade that we saw at El Portillo. This hand is located on the left-hand wall just where the floor begins to descend and the passageway opens up into a large chamber with a forty-foot ceiling. We have to thread our way between deep cracks in the floor and around massive blocks of rock—evidence of an ancient ceiling collapse. We have trouble at first trying to find the curving row of red dots that is supposed to be in this chamber, but after a bit of searching and climbing around we manage to locate them. According to the official inventory, we have now found all the documented art.

Gustavo is with us again today, and he offers to take us to an area about 150 yards farther in, to a passageway where there are said to be a few more traces of red paint. Of course I'm happy to go check them out. As we move beyond the large chamber, the passageway starts to narrow and the ceiling begins to angle downward. Before long we're crawling across a floor of hardened calcite topped with a thin layer of old river silt—not a big deal for a few minutes, but it does start to get uncomfortable when you're crawling almost the length of a football field this way. We soon get to the section of the cave where the traces are supposed to be, and, sure enough, on the low ceiling is a set of three elongated dots that look like they were made by pressing paint-covered fingertips to the rock's surface. And just up and to the left is another pair of these marks.

As Dillon photographed them, I ran one of our lights around the passageway ahead. And that's when I saw even more red dots, similar in style to what we'd just found. These were grouped around hollows in the ceiling, and they trailed off into the distance as far as my light could reach (see fig. 1.1). Over the next few hours we worked our way along this passageway, stopping to document the red dots and a few accompanying red lines as we found them. The ceiling continued to slope downward until we finally hit a point where it was too low for Dillon to achieve focus with the lens on his DSLR camera (even with him lying flat on his back on the cave floor, the end of the lens was almost scraping the rock above). But the trail of red dots continued along the ceiling, and so I carried on, crawling military-style, with a simple point-and-shoot camera we'd brought for just this kind of situation. Those dots continued all the way to the very back of the cave, at which point I was over a third of a mile from the entrance.

As at El Portillo, I wondered what prompted people to venture so far underground just to make a few marks. The size of the passage hasn't changed much since Paleolithic times, and yet Ice

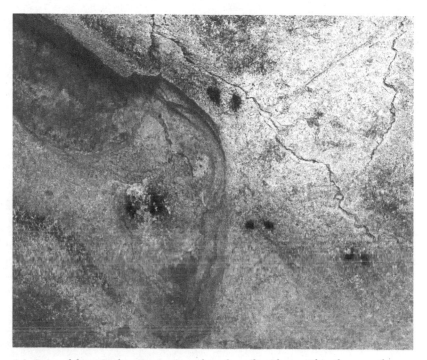

1.1. Pairs of dots, Cudon, Spain. Found on the ceiling deep within the cave, these pairs of red dots were likely created by the artist pressing a paint-covered fingertip to the rock. Many of these markings appear around the edges of cracks or hollows such as the one seen in this photo. PHOTO BY D. VON PETZINGER.

Age people braved the dark depths of Cudon to leave behind these little red dots. They must have been important to those who made them. This is what fascinates me.

To date, Dillon and I have documented the geometric paintings and engravings at fifty-two rock art sites across Europe, spanning seven regions in four countries, and ranging in age from the oldest art in the world, at 40,800 years old, to caves bearing witness to the end of this way of life 10,000 years ago. In each case my objective was to confirm what was there—and what wasn't.

With this information, I can now probe at the heart of the matter, the questions that underlie all my studies: When did we

become us? At what point did those clever tool-making ancestors of ours make the final leap to having fully modern minds? How did we get from there to here? Today we shape the world around us to a degree that has never been seen before. We use tools and medicine to protect ourselves from natural hazards, and technology, mathematics, and science to solve problems and overcome all manner of obstacles. We've used these skills to investigate our own history and to travel to space. And at the base of all these achievements we find language and creativity—both of them driven by the capacity to think and communicate with symbols. Without language and creativity, none of what we have accomplished would have been possible. This book is about the beginning of that journey.

Once Upon a Time in Africa . . .

The first time I saw Turkana Boy, I was shocked by how "human" he looked. I didn't see the actual person, of course, since he's been dead for 1.5 million years, but a life-size reconstruction of him at the National Museum of Prehistory in Les Eyzies-de-Tayac, France. I had seen fossil casts of his skull and skeleton before, but they don't convey how he might have looked when he was alive.

Turkana Boy greets you as you walk down the entrance corridor toward the exhibits at the museum. Found near Lake Turkana, Kenya, he was only about eight or nine years old when he died but was already five feet three inches tall and weighed, it is estimated, almost 110 pounds. While the cause of his death is not certain, it's thought, based on damage to his lower jawbone, that he may have died from a tooth infection that led to septicemia (blood poisoning).

From the neck down, Turkana Boy looks like a human adolescent. His head, though, gives him away as belonging to one of our ancestral species, *Homo erectus*.[1] Thick brow ridges dominate the upper part of a face that juts outward, and he doesn't have our style of chin. His skull is flatter, his forehead lower, but even so, he looks eerily human.

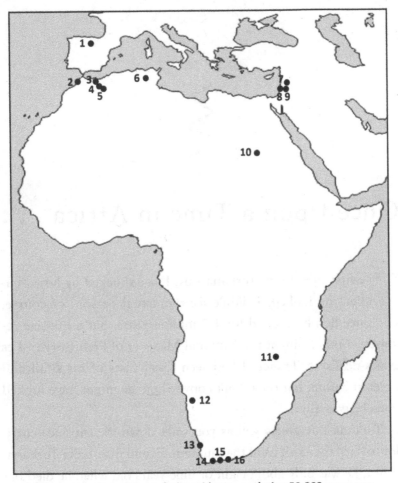

Stone Age sites with symbolic evidence predating 50,000 years ago
(chapters 2, 3, and 4)

1. Sima de los Huesos, Spain (burials)
2. Contrebandiers, Mor. (shell beads)
3. Ifri n'Ammar, Morocco (shell beads)
4. Rhafas, Morocco (shell beads)
5. Grotte des Pigeons, Mor. (shell beads)
6. Oued Djebbana, Algeria (shell beads)
7. Berekhat Ram, Israel (figurine)
8. Es-Skhul Cave, Israel (burials, ochre, shell beads)
9. Qafzeh Cave, Israel (burials, ochre, shell beads, abstract marks)
10. Sai Island, Sudan (ochre)
11. Twin Rivers, Zambia (ochre)

12. Swakop Valley, Namibia (abstract marks)
13. Diepkloof Rock Shelter, SA (abstract marks)
14. Blombos Cave, SA (shell beads, ochre, paint kits, abstract marks)
15. Pinnacle Point, SA (ochre, abstract marks)
16. Klasies River Mouth, SA (abstract marks)

2.1.

As an archaeologist, I spend a lot more time around burials and skeletal remains than the average person, but something about the death of a child, even if it happened in the remote past, always touches me more deeply than that of an adult. I felt it even more as Turkana Boy and I stood face-to-face. I became a parent myself four years ago, and I can't help but wonder how those around him felt about his death. We have no evidence of *Homo erectus* burying their dead, but that doesn't mean they didn't mourn him or remember him after he was gone. However, we just don't know. Because as much as Turkana Boy may have looked like us, he wasn't human.

It's difficult enough trying to understand how early members of our own species might have thought, but the exercise becomes far more difficult when trying to delve into the minds of prehuman species ancestral to our own. As the prominent paleoanthropologist Ian Tattersall has suggested, "We modern humans find it virtually impossible to imagine any state of consciousness other than our own."[2] And yet, to better understand the origins of our own abstract capabilities, that is exactly what we must do. As we try, it's important to remember that earlier species such as *Homo habilis* or *Homo erectus* were not creatures with incomplete minds, nor were they lesser versions of us. They were highly successful species in their own right, and any developments they made in cognition were because those changes benefited them and their survival. They were not working toward turning themselves into something different, or indeed into us.

But even though we scientists recognize our limitations here, we can still glean information from these species to help us better understand ourselves. We are their descendants, and some of those evolutionary changes were foundational in the development of the modern human brain. Certain key changes that took place have been beneficial for our species. Indeed, if it weren't for these alterations, we probably wouldn't exist.

Brains, being soft tissue, don't survive in fossil form. If we're lucky, though, we paleoanthropologists sometimes find a fossil skull that's sufficiently intact that we can measure the overall size of the brain by measuring the volume of the interior of the cranium. This is helpful in determining how brains have gotten progressively bigger over time—for example, Australopithecines like Lucy, who lived between three and four million years ago, had brains that weighed about a pound and were the size of an orange, whereas modern human brains average around three pounds and are about the size of a cantaloupe. But this way of studying the brain doesn't give us any idea of how it may have been wired. And even more than size, it's the wiring that matters.

Understanding how neurons in the brain are interconnected, and the way different regions of the brain interact, is critical in determining the level of complexity of thought of which any given brain is capable. Obviously we cannot study the activities of the actual brains of these earlier species directly, but we *can* explore them indirectly.

This is where archaeology comes in. Another way to look at brain development is to look at what that brain was able to produce. And luckily for us, stone survives for a very long time. Beyond Turkana Boy, in the main exhibit halls of the Les Eyzies museum, many of the gleaming glass cases are filled with an array of stone tools, everything from delicate arrowheads to older, cruder, chopping tools. While the museum also has an impressive collection of symbolic artifacts—jewelry, portable art, figurines—the majority of finds from any given site are stone tools. People used these items on a daily basis, and as they wore down or broke, they made replacements. At many ancient sites the ground is carpeted with bits of stone from the workers creating objects.

The best example I've seen of this detritus was at the site of Roc de Vézac, a cave perched atop a high wooded hill nestled in a gently curving bend of the Dordogne River. The view from the

entrance is stunning. We visited this cave on a warm, sunny day in April 2013. In the river valley below, there's a small traditional French village surrounded by lush cultivated fields, and the crumbling ruins of a brooding medieval castle enfold the top of another hillside across the river. You immediately get the sense that people have been living here for a very long time.

We were there to confirm the geometric art previously observed at this site. And while the cave was not filled with an abundance of paintings or engravings, the images were intriguing. In physical structure, Roc de Vézac is pretty much the opposite of muddy El Portillo in Spain. A tall, straight passageway plunges straight back into the yellowy limestone, there's a dry, sandy floor underfoot, and, as you go deeper, several groupings of small red dots come into view along the walls. After a short, comfortable walk, the passageway opens up into the one and only chamber of the cave—translucent formations of stalactites hang down from a lofty ceiling that disappears into the gloom overheard.

While Roc de Vézac doesn't require squelching through mud on your belly, it has dangers of its own. In fact, a large section of the floor in the main chamber is in the process of collapsing into another cavern beneath it. Given its spherical shape and steeply angling sandy floor, standing inside the main chamber of Vézac feels a bit like being inside a giant hourglass.

The art—wouldn't you know it—is on the far side of the sinkhole, and the only way to get to it is to edge across the thin strips of floor still left intact along the walls—definitely nerve-wracking, especially while sand is crumbling beneath your feet. Because of the sinking floor, all the images are now located at least thirteen feet above ground level, though when they were made they were more likely around chest to head height.

On the left, two negative handprints—one red, one black—are clearly visible, even after so many millennia. Negative handprints

are made by placing the hand flat against the wall and then blowing or spitting paint around it to create an outline. These two prints are nearly overlapping, and the use of two different-colored hands side by side is unusual. But the pièce de résistance at Roc de Vézac is even more uncommon, almost unique in the annals of Ice Age art.

Opposite the hands on a projecting piece of limestone wall are two bas-relief sculptures (yes, I really am talking about bas-relief at around 30,000 years ago!). While this particular sculptural technique is rare during the Ice Age, what makes these images even more unusual are their strange shapes. Described by some early researchers as "reniforms" (from the Latin for kidney-shaped), these two abstract images are found side by side on the wall. Both are about twelve inches wide, and each is made up of two adjoining circular/oval shapes, which is what gives them their kidney-like appearance (though I doubt that is what the artist was trying to depict).

Even stranger, the reniforms are enclosed in a large engraved rectangle (thirty-five inches by ten inches), and this rectangle includes a space on the right for a third reniform (see fig. 1 in insert). When I examined the panel closely, I could see where the artist had started to shape the third reniform, but for some reason he or she never ended up finishing it. Whenever I see partially finished art, I always wonder: Did the artist lose interest? Did he or she run out of time before their tribe had to move on to another camp? Did they mean to come back and finish it? Bas-relief sculpture is more time-consuming than other techniques, and the artist took great care over the two completed reniforms, so it seems unlikely that the art was made on a whim and abandoned out of indifference.

Stone tools can sometimes help us get a better sense of the story. The amount and variety of tool types at a site can often provide us with clues as to how long people lived there and what sort of activities they were engaged in (e.g., short-term hunting camp versus long-term living site). While this has worked at many

cave art sites, unfortunately the entrance passageway at Roc de Vézac—the most likely spot for people to have lived—was dug out in the 1800s by farmers who wanted to use the bat guano–rich soil as fertilizer, and who inadvertently took most of the tool evidence with them. However, what they left behind is still instructive.

Along the edges of the lower walls in the front passageway, the ancient floor levels are still intact. All through that remaining cross-section we saw an abundance of tools and stone pieces, suggesting a more intense occupation than a quick overnight visit. An excavation right outside the entrance to Roc de Vézac also uncovered several tools dating to between 25,000 and 35,000 years ago. This tells us that those bas-relief sculptures inside the cave are probably some of the oldest in existence, useful information for better understanding the development of different artistic traditions.

Because tool designs change over time, tools are useful artifacts for identifying different time periods. But beyond being useful for dating sites, what do stone tools have to do with art? Well, they also happen to be an important key to understanding the longer development of cognitive thought and the origins of artistic ability. In fact, the one could very well be an unintended by-product of the other.

As I give you some context for my quest to make sense of the geometric signs, I need to take you much further back in time than 40,000 years ago. The first glimmers of symbolic thought are found deeper in our history, so to really understand what was going on in Europe during the Ice Age we need to start our journey long before the emergence of our own species, which dates to about 200,000 years ago. In fact, we need to go back almost 3.5 million years, to a time just before our ancestral *Homo* line made its first appearance.[3]

The archaeological record from the time of early ancestral species like *Homo habilis* is spotty, but enough examples of stone tools and other artifacts have been found to give us an idea of

what was happening when and where. Imagine how much sediment can build up over a couple of million years and you can see why the discovery of anything from that period involves a lot of serendipity as well as skill and tenacity.

The very first stone tools may appear rudimentary, but they represent a huge leap in cognitive ability, as well as the development of a whole new suite of mental abilities. This is why paleoanthropologists get so excited about little chunks of old rock. The oldest tools, found in Kenya in May 2015, date to about 3.3 million years ago.[4] They open up intriguing new possibilities since the tools predate the emergence of our own ancestral *Homo* line. Before this recent find, the oldest known tools dated to 2.6 million years ago and were thought to have been created by the first species in our direct lineage, *Homo habilis*. But these earlier tools, which are a little cruder than their later counterparts, were made when Australopithecines like Lucy roamed the landscape. The tools from around 2.5 million years ago already appear more refined than first attempts would have been. However, this latest find now allows us to connect the dots even further back to learn more about how this skill may have developed.

Other species, like chimpanzees, have also been known to use tools, but what makes these nonhuman tools different is the mental work involved in creating them—before any physical action on them. Tool use in other species seems to be more opportunistic. For example, when chimps want to raid a termite mound for a snack, they find a thin branch in the vicinity, use it to dip for termites, eat their fill, and then discard it. The only example we currently have of what could be considered preplanned use of tools in chimpanzees is found specifically among troops living in the Taï Forest in Ivory Coast. Every year, these troops return to the same location in the forest, where they use existing rock slabs as anvils in concert with collected hammerstones to crack open

seasonally available nuts. This practice is transmitted intergenerationally, with mothers teaching their young how to accomplish this difficult task over the course of several years. By comparison, making a stone tool, even a simple one, requires preplanning and forethought as well as some understanding of fractal mechanics (even if you don't realize that's the science you're working with). Toolmaking is a multistep process that involves planning out a sequence of actions in advance. Tools became more complex over time, requiring ever more complicated production methods.

Let's just look at the basic steps for making a simple cutting tool. First, you have to find suitable stone material that will fracture in such a way that striking it will create a cutting edge. Second, you need to find another stone, of the right shape and size that is strong enough to be used as a hammerstone without breaking. Third, before you even start making the tool, you have to envision what you want the end product to look like and plan where you will strike the stone to get the desired effect. Fourth, as you begin making the tool, you need to hold the vision of that tool in your mind as you physically shape the stone. You may also need to adjust your strategy if the stone doesn't fracture the way you thought it would. You need imagination and the ability to think sequentially in order to follow even these simple steps.

You also need occasionally to replace your tool as it wears down. Chimps and other tool-using species generally find temporary tools for each new task, but our distant ancestors took a different route. The right kind of stone was not available everywhere, so they started carrying the raw materials with them as they traveled across the African landscape.[5] For them to have bothered to cart around chunks of rock, they must have had the capacity to plan ahead and envision a future when their current stone tools would no longer be useable, and they must have remembered past times when this situation had arisen.

So tools can tell us a surprising amount about the mental capacity of these early hominins.[6] Toolmaking seems to have encouraged new cognitive skills, the type that would lead to the later development of math and physics, as well as abilities like imagination and memory, both of which are integral to the creation of art. The key to interpreting the various examples of tools is the concept of utilitarian versus nonutilitarian behavior. We all need shelter, heat, food, and water, so any material associated with achieving these goals is considered utilitarian. Conversely, by *nonutilitarian* I mean activities that aren't really necessary for basic survival. Stone tools fall into the utilitarian category, since their purpose is to improve the acquisition of food, either directly, as weapons, or indirectly, through the processing of meat from a carcass, or through the preparation of plant matter.

Stone tools could also potentially streamline the building of a shelter. They could be used to cut the materials for the construction of the shelter (trees, branches, grasses, etc.), for the shaping of posts and the preparation of perishable materials, like hides, which may have acted as coverings as well as clothing. Stone tools can also be used to make other tools of perishable materials (e.g., wooden spears, digging sticks, tool handles). And flint is an important component in making fire.

By about 1.5 million years ago, the original simple stone cobble tools began to be replaced by a more refined tool called the Acheulean (pronounced a-shoo-lee-an) hand axe (see fig. 2.2). These axes were the invention of a more recent ancestor in our lineage, best known as *Homo erectus*. *Homo erectus* was the first of the hominin species to leave Africa and spread out across the rest of the Old World (Europe and Asia). There is some debate as to whether a group of *Homo habilis* may have made it as far as Dmanisi, Georgia, by 1.8 million years ago, or whether these hominins were just a smaller-brained early population of *Homo erectus*. But in general,

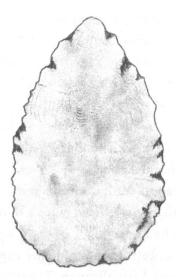

2.2. *A typical teardrop-shaped Acheulean hand axe. Often associated with the development of higher cognitive capabilities, these symmetrical tools were first created by our* Homo erectus *ancestors around 1.5 million years ago.* ILLUSTRATION BY K. FORELAND.

the evidence points to *Homo erectus* being the first species to leave Africa in any significant numbers, and their remains can be found throughout the Old World. Their success in a variety of environments with different available resources suggests they were an adaptable species, able to react to change. As we saw with Turkana Boy, the *Homo erectus* body already looked very much like our own from the neck down (fully upright, capable of long-distance running, and with adult heights close to ours). Above the neck, *Homo erectus* was intermediate between us and the first toolmakers. They still had fairly heavy brow ridges and more rugged features, but their brains had grown to a weight of around two pounds—about the size of a modern human toddler's brain.

These ancestors' hand axes were carefully worked—all over, not just on one cutting edge—and had a symmetrical appearance. While the earliest versions were still a bit crude in appearance,

they represent an important cognitive change in the way tools were made. The only requirement for the first tools was that they had a sharp edge for cutting. Hand axes, however, were rather more versatile, with two cutting edges and a point. They had a distinctive teardrop shape, which was the most efficient way to achieve the edges and point, and over time this form became increasingly standardized, with similar-looking hand axes appearing in Africa, Europe, and Asia.

Double-edged hand axes have more aesthetic appeal and are also more efficient than single-sided cutting tools. Preplanning the steps for shaping a hand axe is a longer, more complex process, which means these ancestors had a greater capacity for memory, imagination, and spatial visualization. The toolmaker would have kept a clear blueprint of the finished tool in his or her mind, both before and during the making of the tool. Certain sites in Africa even contain evidence of large-scale hand axe–making operations; some scholars have wondered whether these could be considered the earliest workshops in existence.

By one million years ago, some oversized hand axes began to appear that were too large and unwieldy to have been useful, but which had been created with care and precision. Possibly they were some sort of teaching tool, or had a ceremonial function, or conveyed status; they may even have been used to attract mates (i.e., my hand axe is bigger and more symmetrical than his hand axe!). A teaching tool is still utilitarian, though creating a model for others to work from definitely includes an element of the abstract. The tools may also have carried some sort of symbolic significance, which would make them nonutilitarian, perhaps even artistic.

We don't know why *Homo erectus* started making these oversized hand axes, but repeatedly making something that was not technically useful—or ever used—is the first suggestion that more

was going on inside the minds of these ancient people. Nonetheless, interpretations of *Homo erectus* as a species capable of abstract, symbolic thought remain uncertain. It takes another half million years, and the emergence of a new species, before we find any more hints that something resembling our own cognitive abilities is beginning to emerge.

While oversized tools could have had some practical use we just haven't thought of yet, it is more difficult to explain a hand axe that has been carefully shaped out of rare rose quartzite and then never used. This red axe was deposited in the same pit where a group of hominins, known as *Homo heidelbergensis*, disposed of their dead. *Homo heidelbergensis* is our immediate ancestor, and branches of them lived in Europe as well as in Africa. The group who made this unusual red hand axe lived in the entrance of a cave in Spain around 450,000 years ago. They deposited the remains of their dead in a vertical shaft, dubbed Sima de los Huesos (Pit of Bones), down a side passage in the cavern. Over time, twenty-eight individual bodies were placed in this pit; most seem to have died of natural causes and they varied in age from toddlers to mature adults in the thirty-five-to-forty-year-old range. This is by far the oldest evidence we have of any hominin species disposing of their dead in a deliberate way. Paleoanthropologists don't consider this a burial because no actual grave was dug. Instead, we refer to this type of behavior as funeral caching, because while they weren't digging an artificial hole, they were deliberately placing the body in a specific location.

Why they were doing this remains under debate. *Homo heidelbergensis* had a brain only slightly smaller than ours at about two and a half pounds. These ancestors may have wanted to remove the dead to avoid attracting predators, but this doesn't seem like a typical garbage pit—we don't find the butchered bones of game animals, or broken and used-up tools, mixed in

with the hominin remains. There is just that unused red hand axe, which archaeologists at the site have called "Excalibur." This is the only tool to have been found in the pit since the site was first discovered in 1984.

Finding the bones of twenty-eight individuals from a single species that far back is an impressive discovery in its own right— most of the time we only find fossils from a single individual, not a series of near-complete skeletons representing an entire population, and certainly not ones that seem to have been deliberately placed in the same spot. The researchers at Sima de los Huesos were already wondering whether this was early evidence for symbolic behavior when Excalibur was found. For them, the inclusion of this pristine tool, fashioned out of rare material of an unusual color, really increased the chances that they were witnessing the emergence of a new way of thinking.[7]

Modern humans, and to a lesser extent their Neanderthal counterparts, regularly disposed of their dead in graves with grave goods. At the very least it suggests that certain goods were thought to "belong" to specific people, which could indicate a growing awareness of personal identity—a fairly abstract concept in itself. The addition of grave goods may also be a marker of belief in an unseen world or afterlife, where certain tools, jewelry, and food offerings would have been of use. This concept requires imagination and an ability to conceive of time beyond the present (which is often called "mental time travel").

Some anthropologists believe that the *Homo heidelbergensis* who placed their fellows in Sima de los Huesos had these capabilities. Many would agree that this practice points to a new level of empathy for members of the group, but most would stop short of considering it a fully symbolic practice. The presence of Excalibur, however, complicates the issue. Assuming it didn't fall into the pit by mistake, the inclusion of a special item, which

would still have been useful as a tool and may have been trea-
sured for its unusual color, implies that a member or members of
this group wanted one of the dead to be able to keep this item of
value with them, even after death.

In all likelihood, then, the first invention of stone tools 3.3
million years ago ties into the development of certain brain ca-
pacities that led to the emergence of the modern mind. But stone
tools aren't the only potential evidence we have for early sym-
bolic thought in premodern humans. Three further clues take us
beyond stone tools. They also take us into different geographical
terrain: Indonesia, Zambia, and Israel.

A recent find, in late 2014, halfway around the globe from
Sima de los Huesos, also supports the possibility of early abstract
capabilities: an engraved zigzag pattern on a seashell from the
island of Java in Indonesia at a late *Homo erectus* site.[8] Using mi-
croscopic analysis, paleoanthropologists confirmed that the pat-
tern was purposefully and carefully incised into the shell.[9] Dating
to between 430,000 and 540,000 years ago, this is a stunning
find, because the next known engravings don't occur until at least
300,000 years later. And these were made about 100,000 years
ago in Africa by modern humans. An isolated example like this
of a single, purposeful, geometric engraving is not much to go on,
but it does seem to support the idea that the first stirrings of ab-
stract thought reach far back into our ancestral family line.

Not long after the people of Sima de los Huesos began plac-
ing their dead in their final resting place, another group of *Homo
heidelbergensis*, this time in Zambia, began collecting colored
minerals from the landscape around them. They not only pre-
ferred the color red, but also collected minerals ranging in hue
from yellow and brown to black and even to a purple shade with
sparkling flecks in it. Color symbolism—associating specific
colors with particular qualities, ideas, or meanings—is widely

recognized among modern human groups. The color red, in particular, seems to have almost universal appeal. These pieces of rock show evidence of grinding and scraping, as though they had been turned into a powder.

This powdering of colors took place in a hilltop cave called Twin Rivers in what is present-day Zambia between 260,000 and 300,000 years ago.[10] At that time, the environment in the region was very similar to what we find there today: humid and semitropical with expansive grasslands broken by stands of short bushy trees. Most of the area's colorful rocks, which are commonly known as ochre, contain iron oxide, which is the mineral pigment later used to make the red paint on the walls of caves across Ice Age Europe and beyond. In later times, ochre is often associated with nonutilitarian activities, but since the people of Twin Rivers lived before the emergence of modern humans (*Homo sapiens*, at 200,000 years ago), they were not quite us yet. If this site were, say, 30,000 years old, most anthropologists would agree that the collection and preparation of these colorful minerals had a symbolic function, but because this site is at least 230,000 years older, there is room for debate.

Part of this uncertainty is owing to the fact that ground ochre is also useful for utilitarian reasons. It can act as an adhesive, say, for gluing together parts of a tool. It also works as an insect repellent and in the tanning of hides, and may even have been used for medicinal purposes, such as stopping the bleeding of wounds.

If the selection of the shades of ochre found at this site were for some mundane purpose, then the color shouldn't matter, right? Yet the people from the Twin Rivers ranged out across the landscape to find these minerals, often much farther afield than necessary if they just required something with iron oxide in it. Instead, they returned to very specific mineral deposits, especially ones containing bright-red ochre, then carried the ochre

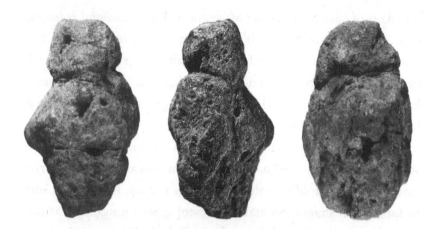

2.3. *The Berekhat Ram figurine (Israel) may well be the oldest symbolic artifact in the world. The pebble from which this 1.5-inch-tall figurine was carved already naturally looked a little like a human female when one of our immediate ancestors—*Homo heidelbergensis*—picked it up and enhanced those features with a stone tool.* PHOTOS BY F. D'ERRICO AND A. NOWELL.

with them back to their home base. This use of ochre, and the preference for certain colors, particularly bright red, may have been part of a much earlier tradition, and it is currently one of the oldest examples we have of potential symbolism in an ancestral human species.

Berekhat Ram is an archaeological site located in the Golan Heights region of northern Israel, near the crater of an extinct volcano. An unusually shaped pebble—less than an inch and a half in length—was found here in the 1980s in an excavation layer with a variety of ancient stone tools. The site had been dated to around 230,000 years old, so you can imagine no one was expecting to find anything other than tools. When the archaeologists working at the site first announced they had found a nontool object that appeared to have been modified to look like a human female, others were skeptical. The debate went back and forth until the late 1990s, when paleoanthropologists Francesco d'Errico and April Nowell received permission to remove the pebble from its

bulletproof case in the Israel Museum in Jerusalem and transport it to a nearby government building that had a scanning electron microscope on-site. April told me that until she saw the tool marks under the microscope, she'd assumed that this would turn out to be another case of natural processes being mistaken for deliberate human activity (see fig. 2.3).

The artifact in question is a type of volcanic rock known as scoria, which is ejected as a liquid from volcanoes during eruptions and then rapidly cools when it hits the air, forming all sorts of fantastical shapes. So many archaeologists thought it was possible that the marks had been formed during that rapid cooling process. But when they looked through the microscope April and her colleague Francesco saw distinctive V-shaped grooves left by a tool (natural indentations tend to have more rounded sides).[11]

Even without the minor modifications, this small pebble has a humanlike form. The person who picked it up 230,000 years ago may have seen it this way as well. In any case, he or she then made three incisions into the pebble using a stone tool. The first created a groove around the "neck" of the artifact. The other two engraved markings, both U-shaped, emphasized the "arms," which, if you accept this pebble as a representation of a human, are hanging down with a slight curve on either side of the upper body. There also seems to be some scraping with a tool in the "chest" area, possibly to accentuate the "breasts." While it's hard to say with certainty exactly why the carver made these marks, there is no doubt they were deliberate.

The result of these engraved marks is an object that looks vaguely like a voluptuous female figure, and it may well be the oldest example of representational art in the world. This far back we're not talking about modern humans yet, but we are getting pretty close. The little piece of volcanic rock from Berekhat Ram

was never meant to be a tool, so its purposeful markings certainly qualify as nonutilitarian.

Still, this female figurine is not nearly as clearly defined as the later ones we find in Europe, such as the carved ivory statuette of the Venus of Hohle Fels. Later figurines tend to be quite a bit more elaborate and were generally carved from prepared pieces of stone, bone, or ivory that were purposefully cut and shaped to fit the artist's vision. The Berekhat Ram figurine, meanwhile, was a piece of rock that already looked vaguely human, on which someone made a few incisions to enhance that resemblance. It may have been a superficial recognition ("Hey, this looks kind of like a woman"), but it is also possible that the shaping of this artifact carried a deeper meaning (for example, if it was meant to represent a deity or some concept of fertility). And while it seems representational to us, it's not quite the same mechanism as the purpose-built figurines of the Upper Paleolithic. Since the Berekhat Ram figurine stands virtually alone in the archaeological record and the next identifiable statuette doesn't occur for nearly another 190,000 years,[12] it seems unlikely that carving was a widespread tradition or cultural practice at that time.

Even if the Berekhat Ram figurine was just created on a whim by an observant individual, it is still important. The cognitive capacity of the figurine's maker was approaching that of modern humans, and this tantalizing find does suggest that our immediate ancestral species may have started to develop an understanding of the world similar to our own.

So an aesthetic sense may have existed in human ancestors prior to 200,000 years ago. The examples we have are few and far between, but there are enough hints to suggest that a new way of thinking was starting to emerge. While it's not until the arrival of our own species, *Homo sapiens*, that we really start to

find evidence for a major shift in cognitive thought, it's fascinating to realize that some of these abilities may have developed earlier, paving the way for our forebears to eventually become us.

But now it is time to leave these distant ancestors behind and turn our attention closer to home—to minds that, while still mysterious, are much less alien than the ones that came before.

Glimmers of a Modern Mind

When I started learning about the Ice Age, the oldest known cave art dated to about 35,000 years ago—now it's closer to 41,000 years. And while they seemed like a fairly intelligent species, Neanderthals weren't thought to have been capable of creating art (the first confirmed Neanderthal cave art—an engraved crosshatch—was announced in 2014). Most researchers didn't think our ancestors interbred with Neanderthals (but a number of them actually did around 60,000 years ago), and we definitely didn't know that there was a third separate humanlike species called the Denisovans living in Ice Age Europe—and that some of us carry their genes, too. (For the record, I'm about 4 percent Neanderthal on my mother's side and just over 3 percent Denisovan through my father's line.) Through initiatives like National Geographic's Genographic Project, you too can trace the movements of your own ancestors across time and space while also contributing to the study of the genetic diversity of our species. The remarkable fact is that all of us living today are the end product of an incredible story of success against all odds: each of us carries DNA that stretches back in an unbroken line to the beginnings of humanity and beyond.

So this is an exciting time to be working in the field of paleo-anthropology. But paleoanthropologists have to be fairly flexible and open-minded about our theories, as we just never know when a new discovery or innovative research project could reveal previously unknown possibilities. I encountered this ground-shifting experience firsthand while working on the initial stage of my database of Ice Age symbols. At that point my goal was to gather all available information about the signs from existing sources (archaeological reports, academic articles, cave art books, etc.) and build it into inventories that I could then use to compare signs between rock art sites.

The prevailing opinion in Paleolithic art at that time was that Europe was the birthplace of art, invented by the first modern humans soon after their arrival on the continent. Based on this time line, the cave signs were thought to have started out around 35,000 years ago as simple, crude markings. Only much later—say, around 20,000 years ago—did the number, variety, and sophistication of the abstract motifs supposedly increase as the artists mastered this new ability. This was the assumption I was working with when I first started to compile those inventories back in 2007/8. I thought I would find only a small number of rudimentary signs at early sites, followed by the predicted increase over time.

I was wrong.

At first I had only a hunch that I was wrong—along with much of the literature. The thing with building a database is that you can only do it one site at a time, and it's not until the end, when all the data have been assembled, that you can finally run tests to see larger patterns emerge. However, even as I sifted through hundreds of pages about the art, I sensed I was seeing a fairly wide variety of signs, even at the earliest sites. I resisted the urge to run the data before they were all in and complete, though.

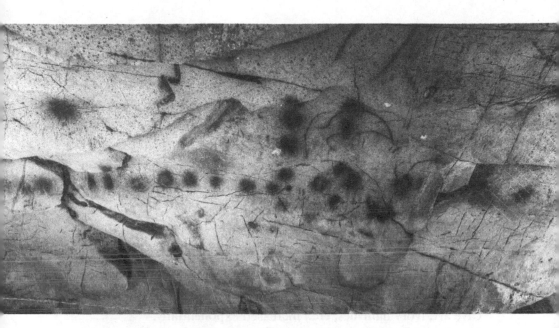

3.1. Rows of large red dots in the depths of El Castillo Cave in Spain. These images have been dated to at least 35,000 years ago, making them part of the earliest graphic culture in Europe. PHOTO BY D. VON PETZINGER.

After several months of data entry, the day finally arrived when I could search the database for the oldest geometric signs. As the results of my query showed up on the screen, the hair on the back of my neck literally stood on end.

Two-thirds of the signs were in use at the earliest sites. Even as early as they were, they were already distributed across a large geographic range. My first thought when I saw this astonishing result was, "There's no way this is the beginning of the signs."

These results got me pretty excited, because for much of the twentieth century the majority of paleoanthropologists thought the modern mind emerged somewhere around 40,000 to 50,000 years ago, in a rapid event known as the "creative explosion." Some people believed this transformation occurred because of a

genetic mutation, others that it was environmentally driven, or a sociocultural change, or some combination of the above. Africa was seen as the place of incubation for the human species, but Eurocentric paleoanthropologists assumed that all the interesting changes took place either during the migration out of Africa or after these ancient colonists had spread out across the Old World. Earlier waves of people had already left, but this is the time when the main waves of human migration moved into Europe, Asia, and beyond.

The arrival of modern humans in Europe around 40,000 years ago marks the beginning of an era known as the Upper Paleolithic (meaning late Stone Age and often referred to as the Ice Age in Europe). At the start of this era, the invention of new types of tools accelerated and the creation of symbolic artifacts (jewelry, cave art, ivory figurines, etc.) increased exponentially.

There were some sites prior to 40,000 years ago in Africa where a hint of symbolism might have occurred on some well-designed tools or on a bone with a few scratch marks (though these were usually dismissed as being a by-product of butchering prey). Overall, though, most twentieth-century scientists believed that the people who lived before the "creative explosion" were not fully modern like we are.

Now, however, these attitudes are changing. African examples of art from the Ice Age remain comparatively few, but more discoveries are being made, and more frequently than ever before. In the past two decades the traditional perception of where and when the creative explosion took place has been seriously challenged. There's even some doubt now about whether it was an explosion at all.

Seeing how well-established the geometric signs were at this early date, and given the conventional wisdom of that time, I felt as if a piece of the puzzle had just clicked into place. The ancient age of the signs also raised some very interesting questions. If producing abstract markings was already a widespread practice when

the first humans arrived in Europe, where and when did it start? And, if people were already fairly fluent in their use of the signs, doesn't that mean they were already able to think symbolically?

Although my main focus was on the European Upper Paleolithic, I realized that in order to really comprehend the symbolic capacity of those first arrivals in Europe, I needed to delve into the cognitive origins of our species and trace the roots of these abstract abilities back to their birthplace in Africa. So let me take you on a brief history of the times of our ancestors.

Homo sapiens first emerged as a distinct species in Africa somewhere around 200,000 years ago. Of course, this doesn't mean that one day our ancestors were one species, and by the next day—or year, or even generation—they suddenly became modern humans. Evolution is a slow process. But geneticists and anthropologists have, nevertheless, been able to pinpoint a time frame in which most of the distinct genetic traits that make us human appeared—that made us different enough from other existing species that we became a species of our own.

So by around 200,000 years ago, people were living in Africa who were just like us: anatomically modern humans. Physically they looked the same as we do, and their brains were identical in size to ours. What we don't know is if they were already thinking like us—or when they started to. They don't appear to have been burying their dead, or wearing jewelry, or making decorative marks on their tools, or anywhere else for that matter. We don't find evidence for any of these practices for another 80,000 years.

In other words, they were us, but at the same time maybe not quite us.

I often wonder what it must have been like to be one of the first modern humans to walk this earth. Frankly, even as a paleoanthropologist, I find it hard to wrap my head around what that question actually means: If they didn't yet know how to use their

imaginations, or make art, or use symbols, then what did they think about? Did they experience self-awareness? How did they interact with each other? Could they tell jokes? Did they believe in worlds beyond what they could see?

Since we are looking for evidence of mental changes that took place within the soft tissue of the brain, we can't identify them directly, but luckily there are other ways to gauge how our ancestors' minds may have been developing. To this end, researchers have compiled a list of practices and artifact types that strongly hint that symbolic thought processes are at work. Evidence includes the selection and preparation of specific shades of ochre, burials with grave goods, personal ornamentation, and the creation of geometric or iconographic representations. If most or all of these elements are present, the chances are good that you're dealing with fully modern humans. Let me give you some examples.

PINNACLE POINT, SOUTH AFRICA

East of Cape Town, down along the curve of the southern coast, is a tranquil U-shaped cove called Mossel Bay, with a town that bears the same name nestled on a triangular headland forming one end of the bay. The land here is relatively flat and open, and it slopes gently down toward the Indian Ocean before coming to an abrupt end at the top of the cliffs that form the sides of the promontory. This area is known as Pinnacle Point. Honeycombed with dark cave openings, these cliffs contain some of the earliest habitations of modern humans found to date.

During the early days of our species, Earth was in the grip of a severe climatic downturn. Around 160,000 years ago, much of North America and Europe were under ice, and the climate in the North had a dramatic ripple effect on the environment in Africa. Most of the interior of the continent was arid and

uninhabitable, driving the small populations of humans living at that time to seek refuge in coastal habitats.

What our early human ancestors were up to during this time was not well understood even as late as 1997, when two local archaeologists happened to survey the Pinnacle Point caves as part of an environmental impact study for a golf course development planned for the land above the Mossel Bay cliffs.[1] They found evidence of Stone Age living sites, but it took another three years before they could form a collaboration with American paleoanthropologist Curtis Marean and an international group of researchers. This team was using environmental and marine data, trying to reconstruct the ancient landscape of the southern coast of South Africa, and looking for suitable locations where early people might have settled down. This area had long maintained a temperate climate with abundant marine resources, making it a good place to ride out the more extreme environment of that time. Archaeological excavations began in the Pinnacle Point caves in 2000, and turned up some of the earliest evidence of modern humans, who started frequenting these sites around 170,000 years ago. Besides evidence of modern humans, they also found evidence that modern behavior emerged much earlier than previously thought.

The cave in which we are particularly interested is known as Pinnacle Point 13B. Starting around 160,000 years ago, the people living here began collecting pieces of ochre.[2] As with the earlier people at the Twin Rivers site in Zambia, they weren't just picking up any piece of ochre; they were very selective in their color choice, and bright, saturated red hues were their favorite. If they couldn't find the color they wanted, they altered the natural shade of the pigment by heat-treating it. Somewhere along the line they had discovered that if you heat up pieces of ochre to a certain temperature and for a particular length of time, the color changes: yellowish ochre becomes red; red ochre becomes redder

and darker. They may not have had a word for chemistry yet, but that is exactly what they were doing. Instead of just accepting what they could find naturally in the landscape, these people had begun to shape the world around them to their needs.

More than three hundred pieces of ochre, many of them showing signs of having been ground for powder, have been found to date at cave 13B and its neighbors. This ochre may have been used for some everyday activity, but based on the inhabitants' preference for bright-red ochre and their deliberate heating of some pigments to alter their color (there wasn't a lot of naturally occuring bright-red ochre in the neighborhood), it seems more likely that these powders had a symbolic purpose. In another striking development, starting around 100,000 years ago, the residents of Pinnacle Point began to use a broader range of red colors—every shade from deep crimson to dark brown. This increased complexity in color choices could mean that cultural activities, such as body decoration or ritual use, were influencing their preferences for specific shades. The ochre powder could have been used for individual body painting or some type of ritual performance. If true, these ancient people were certainly behaving in a very modern way.

On top of that, a piece of red ochre with three notches on one edge and another ochre pebble engraved with a single open-angle chevron on its side were found in layers dating to around 100,000 years ago. These are not the only geometric engravings from this era. Pinnacle Point is one of a growing number of early sites forcing us to rethink when and where early humans made the transition to being like us in mind as well as body.

THE CAVES OF ES-SKHUL AND QAFZEH, ISRAEL

The caves of Es-Skhul and Qafzeh are two sites near each other, the first on the southwest side of Mount Carmel, and the other

fifteen miles to the east, near the town of Nazareth in Lower Gal-
ilee. Their similarity in age and in the types of symbolic activities
found there, however, lead most researchers to talk about them
together. These are the sites of the oldest intentional burials cur-
rently known in the world. Located within what is now the Nahal
Me'arot Nature Reserve, the dark entrance to Es-Skhul can be seen
among the craggy cliff faces of Mount Carmel, many of which are
composed of the remnants of ancient fossil reefs. It is one of several
ancient sites discovered in close proximity to each other.[3] Qafzeh
is more isolated, its large rounded entrance situated halfway up the
side of a valley just outside Nazareth in a strategic location with a
sweeping view of the fertile Plain of Esdraelon below.

Burials with grave goods indicate symbolic behavior, impor-
tant signals for the presence of fully modern minds with a lot of
abstract thought processes in place. For humans, death is a sym-
bolic event as well as a physical ending. When someone we know
and care about dies, we don't just dump his or her body some-
where away from our living space and forget about the person.
No, we filter this experience through multiple areas of our brains,
including memory, imagination, and mental time travel, which
give death a whole other level of meaning. We remember people
after they are gone, we imagine the existence of unseen worlds
where they may now reside, and we can project our minds into the
future to see the inevitability of our own deaths as well as those
of the people around us. The inclusion of grave goods in a burial
suggests a culture that was thinking about these things.

Throughout human history, each culture has developed its own
specific set of funerary rituals. Many people believe that the life
or essence or spirit of an individual extends in some form beyond
death, and the way in which people are laid to rest often reflects
how different groups envision this unseen world after life. The idea
of an afterlife where loved ones go is very old, and a wide variety

of ancient cultures developed elaborate ceremonies to mark this transition, including placing material goods, both valuable (e.g., gold) and practical (e.g., food offerings), in their burials. Several burials with elaborate grave goods date back almost 30,000 years to the Ice Age period in Europe.

But can we trace this practice back even further? Symbolic burials are likely to mirror the development of culture as well as broader cognitive changes. Not many earlier burials have been found so far, but the ones we do know about offer some tantalizing clues.[4]

An archaeological layer at Skhul dating to between 100,000 and 130,000 years ago contains the remains of seven adults and three children.[5] Even though some of the remains were found in a fairly disturbed state—spread out from their original resting place with bones missing—others were found intact in shallow, purposefully dug graves. One of the burials, an adult male known as Skhul 5, was found in a small oval grave, arranged in the fetal positon with the lower jaw of a large wild boar placed between his chest and his arms. The intentional inclusion of the jawbone makes this the oldest known burial with grave goods anywhere in the world.

Four pieces of bright-red ochre collected from a nearby mineral source were also found in the cave.[6] Three of the four pieces had been heated to at least 575° F in order to convert them from yellow to red. The inhabitants of Skhul had prospected the landscape specifically for yellowish ochre with the right chemical properties to convert into red pigment. The selective gathering of materials and their probable heat-treatment almost certainly indicates a symbolic aspect to this practice, possibly similar to what we saw with the people at Pinnacle Point about 30,000 years earlier.

And that's not all. Two marine shells were found in the same layer as the burials. Unfortunately, when this site was excavated early in the twentieth century, clear records were not kept as to whether the shells came out of one of the burials or were just found

in the vicinity, but we do know that they are from around the same period. During that time, the ocean ranged in distance from two to twelve miles from Skhul (depending on how much water was locked up in the European and North American ice sheets at the time), which makes it likely that the shells were brought to the cave intentionally. Both shells have perforations in locations that rarely occur in nature but are well-positioned for stringing. They were either picked specifically because of this feature or the holes were man-made, using the point of a tool. In either case, they were probably strung and worn.

The combination of the oldest burial with grave goods; the preference for bright-red ochre and the apparent ability to heat-treat pigments to achieve it; and what are likely some of the earliest pieces of personal adornment—all these details make the people from Skhul good candidates for being our cognitive equals. And they appear at least 60,000 years before the traditional timing of the "creative explosion."

Qafzeh Cave also contains intriguing finds with symbolic potential. Buried there are the remains of at least fifteen individuals, dating to between 90,000 and 100,000 years ago. Unusually, eight of the burials are of children. The graves are all clustered near the entrance and the south wall of the cave's interior, and all come from the same archaeological layer, making it likely that these interments occurred within a fairly short period and that these specific areas of the cave had been designated for burying children.

At Qafzeh, three burials contain grave goods and ochre. Below the feet of an adult skeleton is a large ochre block with an incised cupule (a circular hole made with the point of a stone tool) along with other scrape marks on its surface. Two shaped flint pieces and several fragments of ochre were found nearby. Since the area surrounding the burial does not contain anything similar, these are thought to have been intentional inclusions in the grave.

Around the skeleton of a twelve- or thirteen-year-old adolescent (sex unknown), large blocks of limestone line the grave, possibly to keep out scavengers or to mark the burial. A deer antler still attached to part of the deer's skull was positioned by the head and hands of the child, and another large limestone block was placed on top of the body itself before the grave was filled. A large quantity of ochre was also found within the burial but not in the surrounding area. The variety of materials found in this grave makes this burial the richest one known prior to the start of the Ice Age.

The third interesting grave may be the oldest known double burial. It contains an adult female and a six-year-old, possibly a mother and her child. The two sets of remains are technically separate though in very close proximity (the child is located below the woman's feet). Fragments of red ochre were found in both burials but not in the surrounding soil. The placement of two people in the same burial suggests that those doing the burying recognized the existence of a relationship between the two individuals and symbolically extended this connection into death and possibly beyond by keeping them together.

Besides the bits of red ochre that appear to have been purpose-fully deposited in certain burials, eighty-four other pieces of ochre have been found so far at Qafzeh.[7] These are from the same time period, and 95 percent of the ochre is a strong shade of red. Many of these pieces were found in the western section of the cave along with ochre-stained artifacts, suggesting that this may have been an ochre-processing area. Given the presence of ochre in some of the graves, the ochre processing may have been specifically for their funerary practices. Yellow and brown ochre was also readily available in the landscape around the site, so a cultural color pref-erence for red may have influenced the selection of ochre pieces.

Another set of artifacts from Qafzeh, which may have been used for symbolic purposes, are several clamshells, most coming

from the layers below the burials.[8] During the time early humans were frequenting Qafzeh, the ocean was almost twenty-five miles away, making it very unlikely that the shells ended up there accidentally. All the shells have a hole in the hinge area, but there is no definitive evidence of them having been made by humans, and this type of shell often has naturally occurring holes in this location. Microscopic analysis, however, shows that many of them were strung and probably worn. An analysis of the material found on the inside and outside of several of the shells suggests that they may have contained or come into contact with both red and yellow ochre. A stone core (a leftover piece of toolmaking rock) that may have been used as a rough mortar for mixing and preparing the ochre was also discovered.

The people of Qafzeh were engaged in quite a few symbolic activities: burials with grave goods; the collection and curation of ochre pigment; evidence for personal adornment. Another possible example of a geometric representation recovered from the burial layer is a piece of stone with two parallel, intentionally made incisions engraved on it. These markings, along with the circular cupule incised in the ochre block, were likely created for some symbolic purpose.

Between Skhul and Qafzeh, all the conditions for being fully modern have been met. We seem to be getting very close indeed.

DISCOVERIES IN NORTH AFRICA

For decades the complex behaviors revealed by discoveries at Qafzeh and Skhul in the first part of the twentieth century were treated as curious exceptions rather than as part of an early human trend toward symbolism and creativity. More recent discoveries, such as those at Pinnacle Point, suggest that researchers just may not have been looking in the right places.

The landscape of North Africa adjoins the region where Qafzeh

and Skhul were found, so it seems like a logical place to look for other early sites. The problem is that presently the upper area of the African continent is the arid, inhospitable Sahara Desert, which acts like a natural boundary. It is so difficult to survive within its borders that it seemed an unlikely area for early humans to have settled. And with so much sand covering any potential sites, it was hard for researchers to even know where to look. But thanks to the modern research techniques of paleoenvironmental reconstruction (such as the study of lake sediments, the analysis of pollens from plants and trees, and the identification of bones from different animal species), we now know that, over the course of the past 200,000 years, the Sahara has gone through many different ecosystems. In fact, around 120,000 years ago, it was actually lush grassland with stands of trees, a multitude of rivers and lakes, and was populated by a wide variety of animal species. At other times, it looked like it does today, or something in between. Over quite a few periods, the Sahara was a perfectly pleasant place to live or to travel across.

Within the last fifteen years, several sites have been identified in North Africa that contain artifacts similar to those found at Skhul and Qafzeh. The first is Sai Island, in Sudan, located in the Nubian region of the Nile River. This is the very earliest site with evidence of ochre use by modern humans. Occupied off and on by people throughout the Paleolithic, this island has many archaeological layers. The period we are most interested in dates from about 180,000 to 200,000 years ago, and excavation of this layer yielded large quantities of both red and yellow ochre.[9] While red is almost always the dominant color at early human sites, the inhabitants of Sai Island seem to have preferred yellow pigment. To me this suggests that these people already had some sort of culture that was influencing their choice of ochre. Sai Island also yielded an even more intriguing artifact: a rectangular sandstone slab with a depression carefully hollowed out in its center. The

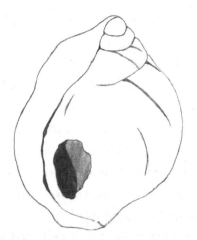

3.2. *Example of a marine shell with a perforated hole like those found at Middle Stone Age sites in Africa and the Near East dating to around 100,000 years ago. While some of these holes may have occurred naturally, others appear to have been purposefully drilled, and many show signs of having been strung. Associated with modern humans, these shells are currently the oldest known examples of personal adornment in the world.* ILLUSTRATION BY K. FORELAND.

slab appears to have been a grinding stone, with evidence of ochre powder within the depression. Two small pieces of chert stone with fragments of ochre still attached were found nearby. The pieces of chert were used to crush the ochre into a fine powder on the slab, like an early mortar and pestle. This could very well be the earliest example in the world of an ochre-processing kit.

Personal ornamentation and jewelry are a key type of symbolic behavior. Whether for purely aesthetic reasons or imbued with more complex ideas of identity and ownership, the emergence of collecting and displaying curated items points to a new way of thinking and interacting with the world. So far we have only looked at the two perforated marine shells from Skhul and the four clamshells with holes from Qafzeh. However, there are at least five occupation sites in North Africa, dating between 70,000 and 90,000 years ago, that also contain evidence of shell beads: four are located in Morocco and one in Algeria.[10] Almost all the

shells come from the same species of marine snail (*Nassarius gibbosulus*) or very closely related ones with a similar shell shape—the same type of shell species that was also found at Skhul. Most of these sites are a significant distance from the prehistoric seashore (25 miles or more, with the site in Algeria almost 125 miles from the ocean), leaving no doubt that the shells' presence at the caves was intentional. The shells of these tiny marine snails are anywhere from a quarter to a half inch across—about the size of a corn kernel—and the snails themselves were much too small, even in bulk quantity, to make a good meal.

The shells were most likely being collected to be worn. All twenty-eight found at these North African sites have holes located in the appropriate part of the shell for being threaded. Microscopic analysis has proved that at least some of them were perforated using the point of a tool (scrape marks where the tool slipped can be seen in several cases). Holes in this location rarely occur in nature, so even the ones where the hole occurred naturally were probably selected precisely because of this feature. The interior edges of many of these holes also show signs of being polished, which is what you would expect a string or cord to do as it rubbed against the shell. The exterior of many of the shells also have a polished appearance consistent with the type of finish you would get if they had been worn against skin or clothing over time.

At least some of the shells from each site also bear traces of red pigment, and one shell in particular from the Moroccan site of Grotte des Pigeons was found completely covered in ochre. Neither ochre powder nor ochre pieces were found in the vicinity of the shells, so it is unlikely that they picked up the pigment by chance. Finding these two hallmarks of cognitive modernity together—personal adornment and ochre use—strengthens the argument for a symbolic motivation. These shells could have

conveyed some type of agreed-upon meaning between group members and may well signal a burgeoning cultural tradition.[11]

The deliberate burials at Qafzeh and Skhul along with mounting evidence for a widespread tradition of wearing shell beads as ornamentation in North Africa and the Near East are pretty clear evidence of symbolism. The number of new sites with symbolic artifacts found over the past two decades has really rewritten the time line for the emergence of the modern mind. Now it's not so much a question of *if* the date of the "creative explosion" should be pushed back as a question of *how far* it should be pushed back. It is starting to look more as if this suite of symbolic practices from the "fully modern checklist" developed slowly, in Africa and the Near East, over a long period of time, rather than in a sudden burst.

Here in the present, we've been building on the mental achievements of those who came before us for so long that we rather assume that certain capacities, or ways of thinking, have always existed. That's one of the things I find most compelling about researching our deep history. If you study the time period when many of the cognitive skills we take for granted (communication, art, abstract thinking, etc.) came into being, you realize that these people didn't have the shoulders of any giants to stand on—they were the original shoulders.

Intermittent Signals

The Carranza Valley is a perfect snapshot of pastoral northern Spain. Nestled in the lower reaches of the Cantabrian Mountains, the narrow valley floor is a lush green patchwork of leafy trees and farmers' fields split by the rushing waters of the Carranza River. This verdant landscape is speckled with the red-tiled roofs of stone farmhouses and the fuzzy white dots of grazing sheep. From ground level, the sides rise steeply upward, first as slopes of slippery grass, before becoming near-vertical cliffs. Stark white limestone rises abruptly from this line of green, forming ridges that wall this valley in, their rocky faces punctuated by a number of cave openings.

Straddling the provincial border between Basque country and Cantabria, this river gorge has one of the highest concentrations of cave art I've ever seen. In a one-mile stretch, right where the valley narrows, there are seven cave art sites on one side, with two more facing them from higher up the flanks of the mountain opposite. These caves range in size from small and shallow to deeper and more cathedral-like. Morro del Horidillo is the smallest—a single small chamber accessed by squeezing through a low, narrow crack in the cliff side. Inside, high up on the curving back wall,

is a single red disk about the size of a dessert plate, its purpose a mystery. The most extensive of these caves is Pondra, which sits high along the ridgeline; it's a tough climb up there, but the view is stunning. The distant sound of sheep bells, barely audible, drifts up from the valley floor that stretches below.

Pondra has the oldest documented art in the vicinity: researchers were able to date an engraved horse in a low alcove off the main passage to over 35,000 years ago. Pondra also happens to be the only site where I've ever come close to hitting my limit for tight spaces. After winding through several passageways where I could comfortably walk upright (as long as I ignored the dark, deep drop-off beside the path), I got to the very end chamber of the cave. According to the notes I was working with, there was supposed to be some red paint back there. Dillon and I found a couple of traces, which we photographed, but as with any cave, I like to really look around to make sure we're not missing anything. My eyes were drawn to the sloping ceiling at the back: an unbroken row of limestone columns seemed to form a small corridor between there and the rear wall.

"Hmmm, I wonder . . ."

Taking a camera and one of the smaller lights, I found a gap between two columns that allowed me to enter a narrow space that ran the length of the sloping back wall. The ground was wet here and the carpet of little calcite points that were forming on the floor were surprisingly sharp. It was low enough that the best way to move was by lying on my back and wriggling along as I examined the walls and ceiling with my light for any signs of human activity. To be honest, it didn't seem likely that I'd find anything, considering how confined and uncomfortable the space was, but then a red mark up near the ceiling caught my eye. The mark was dotlike but didn't seem as deliberate as the more perfectly formed ones at many other sites. This one almost seemed

more like someone with a bit of paint on his finger had grabbed a column to help pull himself along—kind of like what I was doing here in the present. I found two more red marks on columns farther along before reaching the far side of the back wall. Amazing to think that I wasn't the first person here. But now I needed to turn my attention to getting out.

The idea of slowly wriggling back fifty-plus feet along the soggy, spiky floor to the main chamber wasn't terribly appealing. Then I noticed that the gap between the last column and the wall looked a little wider than the others. When I moved closer to examine it, it did look like I could fit through, even though it was fairly narrow on the far side of the column, where the wall and ceiling were most angled. I'd just fit if I lay on my side, and I could see that the gap quickly widened out into the main chamber beyond. As at El Portillo and Cudon, this was a confined space, but it seemed like a much better option than the slow slog behind me, so I decided to go for it. I repositioned myself on my side in order to jackknife my body feet first around the curve of the end column. Inch by inch, my back brushing the wall, I squirmed my way around the bend, until I hit the halfway point—right then, with my stomach tight against the column, and bent a bit like an open-angle chevron, I remember thinking, "Okay, I think I just hit my limit of how small a space I'm willing to be in."

Luckily it only took a bit more squirming before my head followed my body past the column and I was able to edge backward out into the comparative openness of the main chamber beyond. But the next time I see a space that tight, I think I'll take the longer way.

Most of the caves in this valley contain art, or their entrances were living sites, or in some cases they were even used for both purposes—this is pretty high density by Paleolithic standards. Which makes sense: this was a strategically good spot with abundant freshwater and game. And in the next valley over is the Los

Tornos mountain pass, which, at three thousand feet, is the lowest pass through the Cantabrian Range at the western end of the Pyrenees. We have evidence of both people and trade items moving through these mountains, even during the Ice Age.

Several of the sites in this valley have only been found within the last twenty years. In Cantabria alone there are now more than seventy known cave art sites, many grouped together as we see here in Carranza. In the neighboring Basque province, a colleague of mine, Diego Garate, has also recently started actively looking for new sites, and he and fellow team members rapidly identified so many that they had to put the search on hold while they documented what they'd already found.

In many ways, this mirrors the situation in Africa, where newly discovered early human sites like those we saw in the previous chapter are regularly being found now that we modern people have a better sense of where our ancestors tended to settle. What interests me most, of course, are our forebears' initial attempts at geometric representation, which provide important insights into what prompted people to start making signs in the first place, as well as how things may have developed by the time the geometric imagery was created on the cave walls in Europe. So far we've looked only at the fairly isolated abstract engravings found at sites like Pinnacle Point and Qafzeh, but now it's time to turn our gaze southward once again and visit two special South African sites that may very well contain the first stirrings of a graphic culture.

BLOMBOS CAVE, SOUTH AFRICA

Blombos Cave sits on the side of a hill in a wild, windswept section of the Southern Cape of South Africa, only fifty miles to the west of the Pinnacle Point caves where the earliest ochre associated with modern humans was found. Its entrance is low-hanging but fairly

wide, and it overlooks the Indian Ocean, only 110 yards away. Between 70,000 and 100,000 years ago, early modern humans occupied this place, and water levels were a little lower, so that the cave would likely have been about a half mile from the shoreline. This distance does not seem to have deterred Blombos's inhabitants from taking advantage of the nearby marine resources, and there is plenty of evidence of both marine and terrestrial animal remains at the site.

The cave itself is embedded in a limestone cliff and has only one shallow chamber with a sloping back wall. Circular fire pits and areas of toolmaking activity tell us that for varying lengths of time over that 30,000-year span, people called this cave home. Up until about twenty years ago, the floor was blanketed with a shifting cover of windblown dune sand, but since then this innocuous little site has changed our entire understanding of the cognitive capacity of early humans.

Virtually overnight, the date at which people were considered to have become fully cognitively modern was pushed back by at least 50,000 years. Chris Henshilwood, the lead investigator at Blombos, originally explored this cave on his family's property as a child, without realizing the secrets that lay below his feet.[1] As a PhD student studying the end of the African Stone Age he decided to excavate the cave, and made the initial discovery of very ancient stone tools buried near the back wall. However, because his dissertation project focused on a later time period (the sites he was interested in were more in the 5,000-to-6,000-year range), he ended up reburying the tools and working at other, more recent sites on the property. After he finished his PhD, he came back to properly investigate what he thought he'd found, not realizing that this little seaside cave would become his life's work. Annual excavations started in the early 1990s and continue to the present day. Almost every year new and astounding artifacts are discovered. Blombos has been dubbed the "smoking gun" for early cognitive complexity.[2]

One of the most recent discoveries, and also the oldest, was of two 100,000-year-old paint kits that had been left on the cave floor.[3] Abalone shells were used as containers for mixing the compound, which consisted of ground red ochre, crushed bones that had been heated to extract the marrow oils, ground charcoal, quartz grains, stone chips, and a fluid such as water or urine to liquefy it for use. On the inside of the shells, multiple "watermarks" suggest they were used more than once. Right next to the shells, Henshilwood and his team of archaeologists found the stones used to grind the ochre, as well as a slim bone, stained red, which was used to apply the resulting mixture to whatever object or person was the end product. Assembling the equipment and ingredients to make this pigment compound would have required quite a bit of planning, as these materials are not available in the immediate vicinity: the closest ochre source is thought to have been at least one and a half to three miles away.

The paint kits were not found in a layer with other artifacts, which suggests a brief visit rather than a long-term occupation. Perhaps a small band of hunter-gatherers came to the cave for a day or two, bringing with them all the supplies they needed to make their ochre mixture. They heated the bones to liquefy the marrow, ground the ochre on the grinding stones they'd brought along, mixed the charcoal and other ingredients together with the crushed bones and ochre, and then used their "stir stick" bone to scoop out the compound they'd created. Once they were done, they left their paint kits, shells, and supplies organized together, lying on the cave floor.

The preparation and creation of the paint mixture would have required at least a basic understanding of chemistry, since materials such as the bone had to be heated in very specific ways to get the desired results. These steps point to this being a standardized

process that may have been part of a wider tradition. Whatever the final purpose—whether glue or paint—the fact that people living 100,000 years ago were able to follow a recipe to create a pigment compound is impressive. This by itself is pretty strong evidence that they were fully modern.

Many researchers believe that the paint mixture was used for something with symbolic or ritualistic significance, because Blombos also happens to be the oldest site in the world with evidence of abstract designs. Of all the discoveries made there, these markings are probably the most significant. For, in many ways, the creation of art is the most abstract ability of all. Together with engraved examples like the notched edges and chevron from Pinnacle Point and the cupule and two parallel lines from Qafzeh, the engraved artifacts from Blombos have pretty much put an end to uncertainty that people from 100,000 years ago had fully symbolic minds like our own.

At Blombos to date, at least fifteen pieces of red ochre rock, which have been shaped, smoothed on one side, and then incised with geometric patterns using a stone tool, have been found in archaeological layers dating from 75,000 to 100,000 years ago.[4] (These were the source pieces that the inhabitants of Blombos had collected from ochre-rich spots in the landscape and brought back to grind into pigment powder as needed.) Some patterns are simply rows of lines; others are crosshatched or fan-shaped in design; and one fragment of ochre seems to show a small part of what may once have been a complex geometric pattern. These are very different in nature from the isolated markings on the pieces from Pinnacle Point or Qafzeh: these are organized, deliberate designs incised onto specifically prepared surfaces. And the fact that we find these motifs repeated on multiple pieces of ochre at different times shows this to be an established practice.

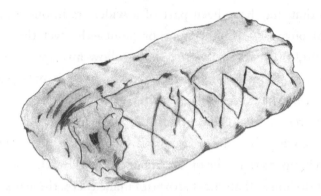

4.1. *Engraved ochre from Blombos Cave, South Africa. Dating to between 75,000 and 100,000 years ago, the geometric markings on the side of this red pigment block, along with others found at Blombos, may well be part of the first graphic tradition ever developed by our human ancestors.* ILLUSTRATION BY K. FORELAND.

Since most of the geometric patterns at Blombos were engraved on red ochre pieces, a pretty strong case can also be made for a preexisting concept of color symbolism. And while these abstract motifs now blend into the background, when they were first engraved, the markings would have stood out as a deeper blood red against the duller surface color. As at other early sites, there is almost always a distinctive color preference. And our distant ancestors didn't choose a specific color simply because it was readily available: they were quite willing to travel long distances to have access to particular ochre deposits, or to undertake complex heat treatments to get what they wanted.

The people of Blombos weren't just decorating pieces of ochre. A fragment of jawbone incised with eight parallel lines was also found in the cave. Here, too, microscopic analysis has confirmed that these lines were deliberately made. Several bone tools with evenly spaced markings on them appear to be intentional as well. These engravings on bone, along with many of the markings found on the pieces of ochre, all appear to be variations of the same pattern, which may indicate a symbolic component.

The team that studied the geometric designs at Blombos, which included Chris Henshilwood and Francesco d'Errico, was very methodical in its analysis of the objects before it announced it had identified the oldest symbolic markings in Africa. Having already identified the marks as man-made, the team needed to figure out whether the engravings were accidental (e.g., lines on a piece of rock being used as a sharpening stone, or cut marks on bone made during butchering) or deliberate (i.e., specific marks made on purpose), and then determine if they were utilitarian (say, the addition of striations to a tool handle to give it a better grip) or meant to serve some other, more abstract purpose. Using microscopic analysis and experimental archaeology, the team was able to determine that the engravings were not only deliberate but also didn't seem to be utilitarian. Although this in-depth study has convinced others that the abstract markings were purposefully made, what does remain under debate is what their purpose may have been.

If some of the early African engravings were representational art like animal or human depictions, it would be easier to guess at the intention. Yes, there could be multiple layers of meaning attached to an animal image, but at least we'd have a recognizable figure to start with. Instead, we've got abstract markings that appear to be part of some sort of system. Our job is to try to parachute in from 100,000 years away and figure out why they might have been doing this there, and at the later Ice Age rock art sites in Europe. Not an easy task—and in all likelihood it will be impossible ever to say with any certainty exactly what the marks meant. But paleoanthropologists have taken some educated guesses.

So let's look at some possible meanings. The first option is that the engraved marks could have been decorative—made on the ochre and bone pieces because people liked the way they looked. First, though, in order to appreciate something like abstract

patterns for their decorative value you have to have an aesthetic sense. Second, since the same patterns are repeated on different pieces and across time, this suggests that the choice of what to depict was influenced culturally. In other words, people shared an aesthetic appreciation, and what was considered decorative—as well as what wasn't—was mediated by groups of people rather than just by individual taste.

Another option is that the patterns were doodles. Doodling is usually an unconscious activity done by someone while thinking about other things. However, the images still have to be familiar ones or we wouldn't know how to make them; thus, doodling is actually culturally based. This applies just as much today as it would have back then. People doodle images of things they know, and for this they need to have an awareness of image-making as well as an understanding of symbolic representation. Even if the people at Blombos and elsewhere were just doodling, this would still provide pretty good evidence of an underlying symbolic system. Chris Henshilwood and Francesco d'Errico, along with the rest of the team at Blombos, believe that these markings may well signal the presence of a symbolic culture in southern Africa long before people started decorating the caves of Europe.

Other than doodling, another intriguing possibility is that the engravings were some sort of owner's mark. In order to even think of marking something as being yours, you have to have a lot of modern cognitive concepts. You have to be self-aware as well as have a sense of personal identity. This could lead you to want to keep certain prize possessions or particularly useful items to yourself, and one way to do that would be to use a specific series of personalized engraved markings. We do this all the time today, from passwords and serial numbers to labels in kid's clothes to personalized license plates. We put a lot of thought and effort into establishing our ownership of material possessions, which can be

functional and symbolic at the same time. There is also a certain level of practicality to labeling something as your own. It's a very human thing to do. It strikes me as quite a reasonable motivation for people to start making marks on things, and it fits in nicely with our ancestors' pattern of inventing through necessity, which we have repeated throughout our own history.

The engraved artifacts at Blombos suggest that our ancestors had purposeful symbolic practices and a growing sense of personal identity, but that's not all we have to work with. The marine shells at the sites in North Africa and the Near East point to a tradition of personal ornamentation having developed early on there, but the shells found at Blombos are the first evidence that this practice extended all the way to the other end of the continent. The people of Blombos also chose to string shells, and in larger quantities than found at other sites. So far, forty-nine marine shells have been found at Blombos, dating to around 75,000 years ago.[5] The shells they chose to wear were from the same genus of snail (*Nassarius*)— and so the same shape—as those worn by the people to the north.

This particular species of marine snail lives in estuary environments, but during the last Ice Age, the closest estuary to Blombos was over twelve miles away, down the coastline. The snails were too small to eat, yet people had purposefully gathered and brought them back to their cave site. The Blombos perforations were man-made, with a tool, and they bear evidence of wear as well as traces of ochre. These remnants of pigment could either have come from the shell being decorated directly, or they may have rubbed off onto the shell from the body or clothes of the person wearing them.

As with the making of engraved markings, the shells may have been worn by the people from Blombos purely because they thought they were aesthetically pleasing. Even if this were the case, some sort of cultural influence was governing their preferences since they all found the same shells desirable and were willing to

travel long distances to collect them. More shells have been found at Blombos than anywhere else to date, but it is doubtful that forty-nine tiny little shells would have been enough to dress up the whole tribe. In all likelihood, only specific people were wearing these shells. If we were to discover burials from this time that contain shell beads—none have been found to date in the vicinity of Blombos—we might be able to figure out if the shells were worn all the time or only for special occasions, and whether status, age, or sex made a difference.

If only some people in a tribe wore shells, the shells may have served to distinguish certain individuals (e.g., shaman, tribal leader) and communicate this identity to others within their community. Personal ornaments may also have been used to signal membership in a particular culture group so that they were recognized by other relatives or members as well as by nonmembers. We still use jewelry to send all sorts of social messages about ourselves today. A ring can say "I'm married," "I belong to a fraternity," "I graduated from college," or "I won the Super Bowl," messages communicated without saying a word. A piece of jewelry can be an ornament or a symbol, but other people need to know how to interpret the message through a system of agreed-upon meanings that convey the significance of the information. Personal adornment can be a powerful and symbolic method of communication. And, as we shall see, this type of symbol system is not just limited to jewelry.

DIEPKLOOF ROCK SHELTER, SOUTH AFRICA

To the north of Cape Town, on the Western Cape, a site called Diepkloof Rock Shelter has yielded unique symbolic artifacts from this time. Throughout prehistory, in Africa and across the Old World, rock shelters were popular as temporary, seasonal, and, in many cases, permanent home bases. With an overhang of rocks as

protection from the elements, and a wide entrance to provide good ventilation and visibility, rock shelters have a long history of being preferred housing for our distant ancestors.

The Diepkloof Rock Shelter is particularly beautiful. Carved by wind out of red-streaked sandstone, it sits astride the flat top of a butte that dominates the landscape. Surrounded by an expanse of undulating, open countryside, the hilltop has a commanding view, and a river flows at its base, providing a source of water and food. People lived there for over 100,000 years during the Stone Age, and left behind all sorts of detritus from everyday life, including tools, animal bones, hearths, and—fairly specific to this site—a large number of ostrich eggshells. These enormous eggs appear to have been a major source of protein for the people who lived here, and in some cases they were repurposed after consumption to become sealable containers, perhaps for holding water and transporting it from the river at the foot of the hill. But the exterior surfaces of some of these eggshell containers have an even more interesting story to tell.

Fragments of engraved ostrich eggshells have been found in archaeological layers dating to between 52,000 and 85,000 years ago at Diepkloof. Some of the engravings at Blombos are so simple that it makes it more challenging to determine their purposefulness—for instance, ochre pieces with just one or two lines engraved on them. But the geometric patterns on the eggshells from Diepkloof are certainly intentional. To date, more than four hundred pieces of ostrich eggshell inscribed with abstract motifs (rows of lines, crosshatched markings, fan-shaped clusters of lines, etc.) have been found.[6] What makes this discovery even more unusual is that only five different designs, with minor variations, were repeated on artifacts throughout the 30,000-plus-year span they were created. Finding essentially the same patterns duplicated across so many millennia suggests that these people

4.2. *Geometric motifs on ostrich eggshells from Diepkloof Rock Shelter, South Africa. Dating to between 52,000 and 85,000 years ago, these abstract patterns may well be part of the same graphic tradition as those from Blombos Cave and other sites in the region. At Diepkloof, though, the designs are more complex, and there are only five patterns that repeat across many generations with minor variation, suggesting that this tradition may have begun to develop further.*
ILLUSTRATION BY K. FORELAND.

were purposefully standardizing their markings. This could only happen if the inhabitants of Diepkloof were sharing these patterns intergenerationally, which the lead investigator at Diepkloof, Pierre-Jean Texier, believes is a clear signal of the presence of a modern mind.

The Diepkloof engravings are the earliest graphic tradition currently known anywhere in the world. Just as the shell beads at Blombos were designed to send a message about the person wearing the jewelry, the engraved patterns at Diepkloof also conveyed messages. Dr. Texier and his colleagues believe these patterns may have encoded social information intended to be shared with other individuals and groups, and that these markings could have helped create a sense of cultural identity. This would mean that the geometric designs were embedded in a culture that could both recognize and manipulate symbols. Over time, the popularity of different patterns rose and fell, but what remained steady throughout was the conscientious effort of the engravers to replicate existing

patterns. It follows, then, that these particular geometric markings must have been meaningful to their creators.

As with the engravings on the ochres at Blombos, these patterns may have had a functional as well as a symbolic role. Based on more recent examples of local people using engraved designs to mark their ostrich eggshell containers, Dr. Texier and his colleagues have proposed that these ancient motifs could have been owners' marks on individual water containers, with families or other affiliated groups using the same patterns over time. Repetition across time and on multiple eggshells implies a developed sense of individual ownership and identity as well as a concept of group belonging. While we need to be cautious about using the practices of modern hunter-gatherer groups to interpret prehistoric artifacts, the people who live in this region today still use ostrich eggshells as water carriers, and they, too, inscribe them with their own geometric patterns to identify individual ownership.

The ostrich eggshells are the earliest documented example of something other than ochre, bone, or stone being used in a symbolic way; and one of the hallmarks of the Ice Age in Europe is the wide range of materials that our ancestors used as "canvases" for their art. The complexity of the designs on the eggshells is also significant—it's not much of a jump from the engravings at Diepkloof to the later geometric signs found on the cave walls of Europe.

Let's review the criteria for cognitively modern human behavior. People engage in most or all of the following activities: using pigments with some sort of symbolic intent; wearing personal adornment; burying their dead with grave goods (the inclusion of which lowers the chances of the burial being a simple case of keeping away scavengers); and creating geometric or iconic representations. Beyond just the collection of ochre, which dates back to the origins of our own species and probably even earlier to our

Homo heidelbergensis predecessors, there is ample evidence for color preference and the preparation of pigments across a wide range of ancestral sites. Between 75,000 and 100,000 years ago, people began wearing personal adornment in the form of perforated marine shells, many of which they modified using tools specifically to make the shells wearable. The recurrence of the same shell at multiple sites points to a symbolic aspect. While only a few of the early burials in Israel, from between 100,000 and 130,000 years ago, include grave goods, other indicators such as a probable double burial make it likely these interments were by humans with modern minds. And, finally, evidence of the creation of art with the discovery of so many artifacts engraved with geometric markings from sites like Blombos and Diepkloof really completes the list. When you look at it this way, it's hard to see our African ancestors as anything other than fully modern.

After the finds at Blombos and Diepkloof, similar types of engravings on artifacts from the same period have been identified at several other sites in the region (some at new sites, some as the result of revisiting earlier finds, before scientists were really looking for purposeful markings). These include a crosshatched pattern engraved on a small stone from the Swakop Valley in Namibia, similar to the ones from Blombos, and branching and parallel lines found on bone artifacts at Klasies River Mouth in South Africa. Thus, marking portable objects with geometric patterns was not just an isolated occurrence at one site or by one person but a widespread practice that was shared between groups and was, in all likelihood, symbolic.

For these people to have had these practices, they also must have already had the capacity for full syntactic language.[7] In other words, they were talking in full sentences with the same sort of linguistic breadth that we have. Of course they didn't have the same vocabulary as we do, since a lot of the objects for which we have

words hadn't been invented yet. However, many paleoanthropologists who study the earliest symbolic artifacts from this era—people like Chris Henshilwood and Francesco d'Errico from Blombos, as well as Pierre-Jean Texier and his team from Diepkloof—believe that these early humans could discuss the world around them in a fairly comprehensive way. Otherwise, how could they have shared information that included such abstract concepts?

Language, in many ways, is the ultimate proof of people being fully modern. Language's functions are complex, so if people had full language capacity, it's a pretty good bet they were just like we are in mind as well as body. Spoken language does not leave any traces, so paleoanthropologists are always looking for evidence of activities and practices that would have required communication to accomplish. Since many of the artifacts I've been discussing seem to have had symbolic significance, our distant ancestors may have already had modern cognitive "tool kits" long before they ever left Africa to spread out across the Old World.

Somehow *Homo sapiens* got from those African markings to early European cave art sites like Chauvet Cave in France. Even at 37,000 years ago, the artists at that site were capable of creating panels of masterfully painted animals (you may be familiar with them from Werner Herzog's film *Cave of Forgotten Dreams*). Even more intriguing, from my perspective, is that the inhabitants of Chauvet were already using seventeen different types of geometric signs—almost 50 percent of all known signs from the entire Upper Paleolithic period. This does not look like a beginning; instead it seems more like a continuation and refinement of a previously developed skill. In reality, the geometric engravings at sites like Blombos and Diepkloof fit the criteria for the earliest attempts at graphic representation much better than does the first art in Europe.

The intervening steps between Blombos and Chauvet may be lost forever, especially if they were produced on perishable

materials like animal skins or wood. At the moment, we have no sites with portable art or other symbolic artifacts to provide us with clues as to how our ancestors progressed from those first manifestations of abstract expression in Africa to the skillful imagery on cave walls in Europe and beyond. However, it's certainly possible that ancient rock art sites in Africa and along the migration routes (of 40,000 to 60,000 years ago) through the Near East and into the Balkans and Central Asia exist but just haven't been discovered or properly dated yet. Western Europe has been the subject of intensive research for over a century, but in many of these other regions, things are just getting started, and a lot of territory remains to be surveyed and studied.

It is as if we are tuning in to a radio station. The first signals are intermittent, with a lot of static, but slowly, as we turn the knob, the signal starts to become clearer. We don't have a clear signal yet, but the sites I've discussed in the last two chapters have inspired more researchers to turn their attention to our original homeland in Africa. The signals are starting to get stronger.

With all this in mind, it is now time to leave Africa behind and make our way, as did some of those who came before us, to the frozen lands in the North.

7

Welcome to the Ice Age

The physical geography of Europe has changed substantially since the end of the Ice Age. The United Kingdom used to be part of the mainland, connected by a vast plain that is now submerged beneath the English Channel. The Scandinavian countries and much of Siberia were buried under immense sheets of ice that towered above the landscape, sometimes reaching heights of two to two and a half miles. With so much water locked up in the ice, sea levels dropped, and new coastal plains were exposed around the edges of the Mediterranean Sea and Atlantic Ocean.

I've seen these landscapes displayed on maps many times, but I truly understood the enormity of the changes the data represent one sunny June day in 2014 while I was sitting on the golden sands of the Playa de Ris in northern Spain.

It was one of our rare days off from the caves, and Dillon and I had decided to take our two-year-old son, Marius, down to the sea near where we were staying in the town of Noja. The sun was shining, and the gentle curve of the beach followed the coastline in either direction in a long pale ribbon. We happened to be there near low tide, and a shining expanse of gleaming wet beach stretched far out in front of us toward the blue-green Cantabrian Sea. Breaking

up the uniformity of the sand were hundreds of rocky outcroppings, some no more than a couple of feet above the water, others jutting upward several stories. Many of them were jagged and riddled with shallow caves, and various people were climbing over and through them, exploring the many nooks and crannies.

Being naturally drawn to cavelike structures, we began to walk through these islands of rock. Something looked very familiar about them. They reminded me of the tops of the mountains we'd seen while climbing farther inland in order to reach the caves. Dillon agreed that their serrated contours did seem similar—many of the mountains in this region have large exposed sections of the same type of rock. And that's when it hit me.

The beach we were standing on was actually on top of what used to be inland mountainous terrain. During the Ice Age, the sea levels along this section of northern Spain were much lower and the edge of the ocean at that time would have been anywhere from six to ten miles farther out on the continental shelf. Conceivably there could even be a cave art site buried somewhere below me, beneath the thick sandy layer that had built up over the millennia since the ice sheets receded. I was suddenly seeing the beach from a completely different perspective, and all those changes I had read about in books and articles, the maps I had pored over, tracing the ancient lines of this coast, all felt real in a way they just hadn't before.

The Europe of our distant ancestors was in many ways a different continent from the one we know today. Its animals, landscape, climate—none were the same during the Ice Age. To really understand our prehistoric ancestors, we need to understand the world in which they lived, because these people shaped the land they found, but the land shaped them as well.

The picture of how and when we left Africa has changed quite

a bit over the past few years, thanks mostly to better dating technology and to genetic sequencing.[1] In a nutshell, the main waves of migration out of Africa started around 60,000 years ago with environmental conditions in the Near East playing a key role in opening up this route. Genetic evidence points to this being the time and place where some of our ancestors—mine included—interbred with Neanderthals living in the Levant (eastern Mediterranean) region. The recent discovery of stone tools at some sites in India dating to around 75,000 years ago suggests that a few hardy adventurers left sooner, but the archaeology and genetic evidence point to the main exodus starting 15,000 years later.

None of these groups had a specific destination in mind, and their expansion across the Old World happened slowly. As hunter-gatherers, they lived in groups of about twenty to fifty people, and each band needed a territory of around one hundred square miles to support them. Whenever numbers grew too large to be sustainable, groups had to split, with some people carrying on into new, unclaimed territory. In other cases, people may have just followed good food sources, then moved on again when those ran out. In this slightly haphazard way, we humans colonized Europe, Asia, and Australasia.

Having arrived in the Near East, some people chose to stay. Others turned right and slowly made their way along the coastlines of India and Asia, with a few traveling by boat to Australia. In many cases they made this journey with impressive speed. Symbolic burials dating to at least 40,000 years ago in the arid southeastern region of Australia, near the prehistoric Lake Mungo site, suggest quite an early initial departure from Africa.[2] And recently rock art in a cave on the island of Sulawesi in Indonesia was dated to around 40,000 years ago.[3] That means this Indonesian art is contemporary with the oldest known art in Europe! And it also

confirms the widespread presence of modern humans throughout Australasia at this early date.

Using a combination of archaeology and genetics, scientists have mapped several routes north around the Black Sea and through Central Asia, with the colonization of Siberia and northern Asia happening before early humans headed west and spread out across Europe.[4] Thanks to the recent genetic sequencing of a 45,000-year-old man from Siberia, we know that our ancestors had already established themselves in the eastern part of the region by this time. Soon thereafter, small groups started filtering into the western part of the continent (rather than the assumed direct path from Africa, it appears those early Europeans took a much more scenic route).

The Upper Paleolithic period spans from 10,000 to 40,000 years ago. Its starting point matches the arrival and dispersal of modern humans across the European landscape during a warmer glacial phase. The massive ice sheets and tundra-like conditions had temporarily receded northward—though nowhere near as far as the present-day Arctic—and these initial colonists encountered large tracts of birch and pine forests divided by wide swaths of grassland.

These first arrivals would have been thrilled to discover an animal-rich environment, almost a "Northern Serengeti,"[5] as nearly a dozen species of large-bodied animals inhabited the landscape at that time. In fact, Ice Age Europe contained a higher animal biomass than any landscape in which hunting-and-gathering people live today. In pursuit of the large herds of mammoths and reindeer that migrated north every summer, some of these bands even followed them to the sweeping tundras of the far north and learned how to hunt on the open steppes. These pioneering groups rapidly adapted to this chilly lifestyle, developing new techniques for producing fire, clothing, and shelter, along with innovations in hunting strategies and related weaponry.[6]

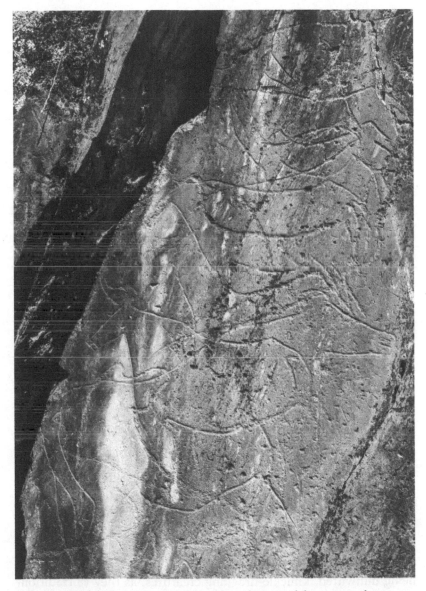

5.1. Animals of the Ice Age—aurochs (wild ox), horse, and deer engraved on a stone block at the open-air site of Penascosa in Côa Valley, Portugal, thought to date to about 25,000 years ago. Farther north, bison, mammoth, and reindeer also roamed the European tundra at this time. PHOTO BY D. VON PETZINGER.

Tools dramatically improved during this era, too. Humans had been using tools that were well adapted for the African environment and its food sources, but new surroundings and different animals to hunt presented new challenges for which they needed to update and adapt their technology. These first settlers devised a tool kit that was customized for their adopted home. They increased their production of small, shaped flint pieces called microblades, designed for fine cutting, as well as more composite tools—that is, tools made up of multiple components. (Composite tools also indicate a capacity for higher symbolic thought processes because of the complexity of the finished product.) The widespread production of bone, antler, and ivory tools begins around this time as well.

People also began to regularly embellish their tools by adding carved designs and animal depictions, and certain types of weaponry, such as atlatls (spear-throwers), were even shaped to look specifically like an animal while still being functional (such as the antler atlatl from Mas d'Azil, France, with a deer looking back at two birds). This is a very different type of tool kit from any that had come before.

Of course, another hominin species was already living in this continental neighborhood when our modern humans arrived: the Neanderthals. These close relatives are fascinating in their own right and deserve a lot more space to do their story justice than I can give them here. But very briefly, this sibling species to our own (we are both descended from the same ancestral *Homo heidelbergensis* hominins) emerged in Europe around 250,000 years ago. Far from being dimwitted, knuckle-dragging creatures, as they've traditionally been depicted, Neanderthals had many of the same cognitive traits and abstract capacities as their human contemporaries, including the making of complex tools; the potential for language; burial of the dead (including a couple of possible examples of grave goods); and some personal ornamentation. They were also making at least

some art, which was proven in 2014 with the discovery of a cross-hatched engraving at a specifically Neanderthal site in Gibraltar.[7]

But around 30,000 years ago, they became extinct. There isn't a lot of evidence that violence between humans and their Neanderthal neighbors or interspecies warfare can explain what happened. Shortly before they vanished, the Neanderthals fell victim to worsening environmental conditions as the weather became colder, shrinking their useful territories and causing a shift in animal resources. These were all things they had experienced before, but now with the addition of competition from us—new, innovative rivals with different hunting techniques and strong social networks. A combination of these factors may have led to their demise.

Around the time that Neanderthals vanished, the ice sheets had begun to expand once again. Human living sites across northern Europe were abandoned as the glaciers expanded southward to their maximum extent, known as the Last Glacial Maximum (LGM). These towering walls of ice made it down into Britain, Belgium, Germany, and Poland, turning the swath of land immediately south of them into a polar desert. The LGM reached its peak between 18,000 and 20,000 years ago, but there were several thousand years of bitter cold on either side of this event, and the glacier sheets didn't start to retreat appreciably until after 16,000 years ago.

During this long cold snap, groups of people across Europe moved into what are called refuge areas, basically sheltered valleys or areas with temperate microclimates, where they could survive the glacial expansion. This brought large numbers of people into regular contact with each other for the first time. They also began making more symbolic artifacts, both in number and variety. Whenever large groups of people are brought together, they seem to start brainstorming new ideas and building upon each other's inventions, and it may well be that this convergence was one of the world's original think tanks.

So what would it have been like to actually live during this time and place in our history? Let's imagine ourselves for a moment as cavemen and women. We lived in Europe—let's say in the Dordogne region of France—25,000 years ago during the height of the last Ice Age. But—and let's get this out of the way right now—we didn't live in caves as some of our earlier ancestors had. A cave is not exactly an ideal dwelling: think bat colonies, big unfriendly bears, meager lighting, damp walls, and poor ventilation. The smoke from our campfires alone would have made a cave almost uninhabitable. We did sometimes live in the entrances of caves or under rock overhangs, but in general we lived out in the open in animal hide tents or other semipermanent structures, which suited our hunter-gatherer lifestyle very well. Our Europe was a lot colder than today's, the landscape more tundra-like, with large plains and scant tree cover, but the water from the glaciers and the resulting plant growth attracted large herds of animals like bison and mammoths, and we followed their migrations in order to survive.

If we lived in Eastern Europe then, we could have been some of the first people ever to live in a village. The animals were so plentiful in this region that we didn't really need to move around. These permanent settlements were innovative: there were virtually no trees this far north, so the inhabitants made dwellings out of stone and mammoth bones, then covered them with earth for insulation. They also invented pottery kilns—not to make pots and jars, as later farming cultures did, but to fire hundreds of clay figurines of men, women, and animals. They were the first artisanal potters.

And what did we look like? As much fun as it is to conjure up an image of Grog, the stereotypical caveman with his jutting brow, blank stare, and slack jaw, we actually looked exactly the same then as we do now . . . though with rather less access to showers and razors. We would have been about the same height

and build, and, significantly, our brains would have been exactly the same size, or even a little larger. We led quite healthy lives of forty to sixty years, and we didn't have any of those nasty illnesses like colds and flus, as they hadn't come into existence yet—that didn't happen until we started hanging out in close proximity with animals following the Agricultural Revolution 15,000 years later.

We didn't wander around naked or in moldering furs haphazardly tied onto our bodies, either. Treated animal hides and furs made up the majority of our casualwear, but we were already expert with a needle, and some of our contemporaries in Eastern Europe wove plant materials and invented clothing dye. All across the continent, wearing "bling" was the newest trend: we made necklaces, headdresses, and ornaments to sew onto our clothes out of such materials as amber, seashells, and ivory beads. Some of our neighbors fashioned ivory beads from mammoth tusks and produced beads by the thousands for trade. (This involved cutting a little piece of ivory from the tusk, sanding it down into a spherical shape, and then using a sharp tool to drill a hole through it.)

We had a lot of downtime; hunting happened in short, intense bursts, and because winter dominated our lives for almost six months of the year, there wasn't a lot of gathering to do. After we had planned ahead and stocked up on all the foods we needed, we had long stretches where we could sit around and invent new and interesting things to occupy ourselves with.

We were particularly fond of music. Bone or ivory flutes have been found at sites across Europe, and we played them much as we would play a recorder today. At several cave sites, specific rock formations or places on the walls may have doubled as drums, and show signs of having been struck repeatedly, so that deep reverberations filled these underground chambers with a resonant sound that could be felt throughout the body.

We were preoccupied by death and went to a great deal of trouble to bury our loved ones with mementoes of their lives, including tools, jewelry, and elaborately decorated clothes adorned with beads and shells. We put food offerings into the graves and usually covered the body in bright-red ochre pigment before burial. If a mother and infant died during the birthing process, we buried them together and arranged their bodies so they would be in each other's embrace forever.

Our crowning achievement—the awe-inspiring paintings and engravings found on the walls and ceilings of caves throughout Europe—may have been at least partially inspired by a belief in the supernatural. To create these images, we braved the darkness and danger of these portals to the underworld. In many caves we traveled far underground, skirting sudden drop-offs or negotiating low, constricted passageways to find the ideal placement for our art. Sometimes we decorated cavernous galleries with soaring ceilings; at other times we chose narrow little niches, secret places meant only for private viewing. We put a lot of work into making these images: we fashioned mortars and pestles so we could grind up the pigments we used to make these vibrant paintings and in some caves we even built scaffolding so we could paint huge panels well above eye level. We also invented stone lamps that gave off minimal smoke so we could stay underground for longer. (These lamps were generally made by hollowing out a depression in a small stone and then filling it with animal fat and using moss or another plant as a wick; some even had carved handles with art engraved on them.)

We were obsessed with depicting large game animals, such as horses and bison and mammoths, which is not surprising considering we relied heavily on them for survival. We may have painted them in order to invoke magic to improve the hunt, or as evocations of spirit animals with whom our shamans spoke on our

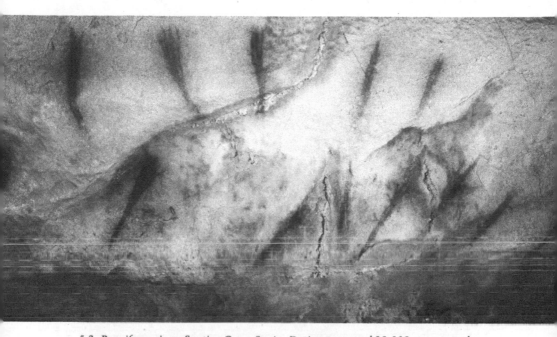

5.2. *Penniform signs, Santian Cave, Spain. Dating to around 20,000 years ago, the fifteen red penniforms in this panel are the main paintings at this site, along with a few red dots and a single cruciform on the opposite wall. Not only are the shapes of the penniforms (three- and four-point tridents) themselves uncommon, but the collection of art at Santian is unusual due to its lack of animal or human imagery.* PHOTO BY D. VON PETZINGER.

behalf. We depicted humans in the caves, but much less frequently, and when we did, we often left their faces blank, suggesting a taboo around depicting this part of the human body.

We also liked to draw geometric shapes. We drew them on and around the animals, and in panels by themselves; in fact, we liked these abstract markings so much that we drew them more than any other type of image. We kept replicating many of the exact same ones at sites across Europe and throughout the huge time span of the Ice Age. We may have lived a long time ago, but there can be no doubt that we had fully modern minds.

9

Venuses, Lion-Men, and Signs Beyond the Mundane World

At many of the rock art sites we visited, we found new signs that had never been documented before. At others, like El Portillo, we discovered that some of the noted signs did not in fact exist; and in still other cases we found that images identified as signs turned out to be something else entirely.

At the site of Las Chimeneas in Spain, for instance, a black painted image that looked a bit like a square root sign had previously been noted, but once I saw it in person, it looked to me more like the hind leg and part of the belly of an animal—maybe a horse or a bison (see fig. 6.1). These things happen sometimes to ancient art. Water can flow down a surface and erase part of an image, or a piece of a wall might fall off, leaving an incomplete marking behind, or, as at Las Chimeneas, an artist started a painting or engraving, but then, for reasons of his or her own, left before finishing it.

At a different site in Spain, called Chufin, I found another case of uncertain identity. This cave is particularly stunning, both inside and out. To get to it, you wind up into the foothills of the Cantabrian Mountains, along narrow roads that curve around the base of limestone cliffs, through little clusters of traditional stone

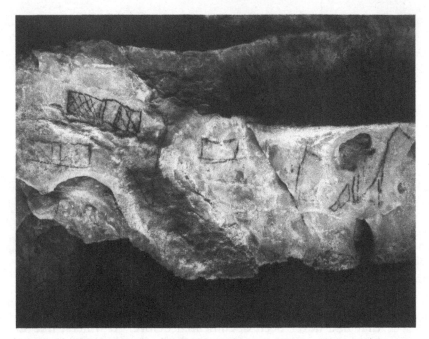

6.1. Panel of black Spanish tectiforms, Las Chimeneas, Spain. Along with the black rectangular shapes that dominate this panel, other abstract shapes were also listed. However, if you look closely at these two curvilinear configurations, they both appear to be partial representations of four-legged animals; why they were never finished remains unknown. PHOTO BY D. VON PETZINGER.

houses. Once you park the car, you still have a bit of a walk, but the view is stunning—down a path along the shoreline of a modern reservoir that now sits near the convergence point of two rivers that have flowed through this deep valley since prehistoric people lived here during the Ice Age. Near the spot where the two rivers meet, the jagged mouth of Chufin is an eye-catching break in a waterfront cliff. The cave overlooks the slow-moving water from this prime location, and while water now laps at the base of the entrance, prior to the creation of the reservoir it would have sat about a hundred feet above river level: a person living there would not have worried about flooding and still had easy access to water.

A large open space extends back from the entrance into the cliff. Several layers of stone tools found below ground level in this area suggest that people frequented this exterior rock shelter between 20,000 and 25,000 years ago. Large limestone blocks rise out of the dirt floor, and near the back of the overhang, a number of engraved deer, aurochs, bison, and even a few lines are still visible on several rocky surfaces. At first glance, you could almost miss the low, narrow entrance on the back wall that leads into the depths of the cave. After crawling through, I emerged into a low-ceilinged passageway. Old bear hibernation pits from the Ice Age era were visible around us as we moved forward in a half crawl another sixty feet or so before finally emerging into a larger passageway. With the floor sloping downward, we soon reached the main chamber of the cave. The walls and ceiling here are a pale, almost luminescent, limestone, and there's a serene underground lake—the kind with clear, blue-green water that you only seem to find in caves—at the far end. It was so beautiful that I just had to take a moment to admire my surroundings before getting down to work.

Most of the art is located near the edge of the lake. Large rows of vibrant red dots, arranged in long horizontal lines and stacked to form rectangular and elliptical shapes, decorate the walls on both sides. On the lefthand side, the artists scaled a sloping flow of cream-colored calcite to gain access to a high limestone ledge that runs the length of the chamber near the fifteen-foot ceiling. Here they created their complex configurations of red dots on the wall and ceiling overhead, along with a couple of animals, which have now faded to faint outlines. A few fine engravings of bison and horse appear near the end of the wall where it drops off to the lake below. The art on both sides of the chamber seems to end abruptly at the water's edge, which is not necessarily surprising, as the lake only filled when the reservoir raised the water levels in

the area. The art at this site may well have continued farther into the cave—and, standing on the ledge, looking out across the lake, I found my eyes drawn to the dark underwater passage on the far side that vanishes off deeper into the cave complex, an area that has yet to be explored. I have to admit that I don't love the idea of cave diving, but at the same time, if there's art to be discovered, I'd definitely be willing to do it. But before I started planning my next project, I had work to do in the dry parts of the cave.

According to the site records, near a panel of faded red horse and bison, there was a series of vertical lines arranged in a fan shape low down on the right wall. Measuring about 10 inches tall by 4.7 inches wide, these red lines are clearly visible. But what was less clear was how they related to the two faded, curving red lines that extended upward from them for another fifteen inches or so before meeting at the top. Standing in front of this panel with Raul Guti- errez Rodriguez, a local government cave art expert and our guide that day, we agreed that the shape seemed vaguely human, but ev- erything was so faded it was hard to tell. Dillon and I photographed it with the intention of later using some new technology I had at my disposal to see if we could clear up the uncertainty once and for all.

Once we returned home later that summer, I ran these photos through special software designed to enhance faded red pigment. Called DStretch, this software was invented several years ago by American researcher Jon Harman to study North American rock art. The program oversaturates certain shades of red, enhancing faded marks that are almost invisible to the naked eye. Not only has it allowed me to find new signs at a number of sites, but I even found a surprise deer at another Spanish site using this program (see fig. 2 in insert). We'd photographed a faint curving red line on a wall that looked vaguely like the back of an animal, and when I ran it through the program, it was incredible to watch the distinc- tive shape of a deer emerge from the rock.

Using DStretch, I was also able to finally see what was on that wall at Chufin. It did indeed appear to be a human shape—what we often call an "anthropomorph"—and it had many of the features frequently found in human depictions from the Ice Age (see fig. 3 in insert). As with the deer, there was something almost magical about seeing this image reappear after being hidden for millennia. Its stylized, narrow legs ended in a point with no feet; its rounded body had poorly defined arms, and the head was faceless. Based on the shape of the body, I would say it was female, but this wasn't clear, either.

As Raul and I had surmised, this was not just a fan of lines but an example of the vague human images we find in many regions across Europe. While Ice Age artists were masterful in their representation of animals, for some reason they didn't depict humans with the same detail or precision. It certainly wasn't for lack of talent, and many Paleolithic art researchers have speculated about what might have prompted this widespread stylistic decision to create a more ambiguous, archetypal form.

Jean Clottes, one of the preeminent rock art researchers in the world, has proposed that origin stories and myths may be present in European Ice Age art.[1] He believes, and I agree with him, that if we are talking about fully modern humans, they likely were interested in where and how they originated. We're limited in interpreting from a cave painting or figurine what a people's culture or beliefs were, but these people likely wanted to better understand the seemingly inexplicable things happening in the world around them, and maybe even attempt to control some of these occurrences through supernatural intervention. This idea is worth exploring for a moment.

In 1939, a lion-human figure was found at the site of Hohlenstein-Stadel in Germany. Carved from mammoth ivory, this figurine dates to 40,000 years ago, making it the oldest figurative art in the world (everything else from this time frame or earlier is geometric). Standing about twelve inches high, this hybrid

figure has the head of a European cave lion and the body of a man.[2] Obviously there is no such species in the natural world, so this figure must have sprung from the imaginative mind of a person or group of people. This lion-man could represent something as intangible as a story or a god (like the hybrid Minotaur in Greek mythology, or the part-animal, part-human gods of ancient Egypt), or something more concrete like a shaman in his regalia. Even if the image were intended to represent an actual person in costume, it would still be depicting a spiritual act, which hints at a belief in worlds beyond the visible. Or it could represent something completely different that we just haven't thought of yet.

There is also the possibility that it was made purely for its aesthetic value and had no deeper meaning embedded in it, but I doubt that's the case, because a one-inch miniature version of this statuette was found at the site of Hohle Fels in the next valley over. There is also a vaguely similar two-and-a-half-inch ivory figurine from the nearby site of Vogelherd. While this statuette is not as close a match (it doesn't have nearly as much detailed carving to define the features), both the form of the body and the shape of the head are reminiscent of the larger lion-man from Hohlenstein-Stadel.

And then there is the one-and-a-half-inch bas-relief carving of a human figure found on one side of a flat piece of mammoth ivory from the site of Geißenklösterle in the same region. Called the Adorant (i.e., worshipper), this carving is an outline of a full-length human with arms raised, legs apart, and what may be a tail. German researchers have noted certain similarities between this piece and the lion-man figurines from other nearby sites, leading them to conclude that it could be part of the same cultural tradition. The most suggestive thing for me is that both the large lion-human figurine and the Adorant carving include a row of incised parallel lines down the arm. They may have represented armbands, tattoos, or tally marks, but the similarity is striking.

The discovery of different versions of this hybrid figure at multiple sites, all roughly the same age, suggests that this image was significant to several or even many people. Its meaning, though mysterious to us, must have been understood by the groups of people who settled in the river valleys of ancient Germany soon after their arrival in Europe. It is possible that Hohlenstein-Stadel was the main site linked with the lion-man—whether deity, ancestral being, or powerful shaman. The miniature replicas may have been related talismans, clan tokens, or even souvenirs from a visit to Hohlenstein-Stadel, but it seems clear that the other sites, while certainly connected, were not as central to this particular cultural image.

There are also a couple of good examples of the hybrid figure of a bison-woman, such as the famous image from Chauvet, in France. This black painting features the detailed head of a bison on top of the lower half of a female body (she is nude and her pubic triangle has been emphasized by the artist). Another panel of red-painted bison-women is from the French site of Pech-Merle. This set of eight stylized female outlines appears to show different transformative stages between woman and bison. Some researchers have proposed that it could represent a story about a woman transforming into a bison (or vice versa); others have proposed that the animal depicted is actually a horse and not a bison at all; still others have rejected the bison part completely and just see a series of schematic female images with no hybridization.

Welcome to the wonderful world of interpretation in ancient rock art. Since we don't truly know why they were making the art, there really is no wrong answer—which can lead to all sorts of fun speculation, though not always a lot of consensus. Obviously, some proposed meanings are more likely to be right than others, and I will offer a selection of the most widely held theories (but, sorry, alien involvement is just not on the table!). I may tell you which one I favor, but there are usually two or more that are fairly plausible.

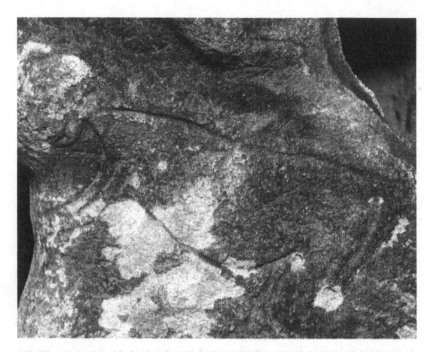

6.2. *Human-animal hybrid, St. Cirq, France. With its clearly visible facial features in profile and humanlike arms and upper body transitioning into the hindquarters of a four-legged animal with a tail, this engraved image is a classic example of the human-animal hybrid found occasionally at sites across the continent.*
PHOTO BY D. VON PETZINGER.

Male figures were also being hybridized with bison. At two other French sites, Les Trois-Frères in the Ariège region and Gabillou in the Dordogne, there are images of bison heads atop human male bodies. As with the bison-women from Pech-Merle, while the bodies are predominantly human, they display some animal characteristics, such as hands and feet that seem to end in hooves. Both of these images have been interpreted as a shaman wearing bison headpieces in some sort of ceremonial context, but it is also possible that they represent a spirit guide, or a deity, or a mythological character. Other animal-human hybrids can be found at rock art sites and on pieces of portable art across Europe; everything from a mountain goat to a reindeer has been blended with

human representations. Interestingly, the animal half of the image is never an African species—no gazelles or hippopotamuses. All represent animals that were present in Ice Age Europe. We may very well discover that combining human and animal images precedes the arrival of people in Europe, but in order for an image to have remained relevant to them, it needed to reflect the reality of the surrounding world, and this is exactly what we see them doing.

Apart from the cave art, probably the most widely known collection of symbolic artifacts from the Ice Age are the Venus figurines, part of a collection of carved statuettes of voluptuous nude women made by the people who lived throughout the Eurasian continent. They have been found at some of the earliest sites and were produced until the end of the Ice Age. Most of them are quite small, between about one to four inches in height. They were shaped out of many different materials, mammoth ivory being probably the most common, but there are also many figurines carved from teeth, bone, antler, or stone. There's even a special group from Eastern Europe that were being fashioned out of ceramic—more on these shortly. Some of the figurines have perforated holes to allow them to be worn as pendants.

While the Venuses tend to be shown in books and featured in articles about the Ice Age, they represent only a small percentage of all the figurines that were being produced then. A larger number of animal figurines have been found at sites across Europe, including the same early sites in Germany where the lion-man figures were found. The animal species found there include bears, lions, bison, birds (including owls and waterfowl), reindeer, horses, and mammoths.[3] Similar animals were being depicted in other regions as well, with the occasional addition of other game animals such as aurochs, woolly rhinos, and deer, as well as some less common

species. Some of the more unusual ones that I've seen or heard of include a fox, a wolf, a hedgehog, and a stone carving of what may be a marine shell, a beetle, or a botfly larva (depending on who you talk to). Most sites with concentrations of figurines included both animal and human subjects, and at only a few sites were the curvaceous Venus figurines in the majority.

Now that we've given the animals their due, let's look at these Venuses that seem to get so much attention. A common misperception is that most of the human figurines fit the classic Venus model with a featureless face, a protruding belly, exaggerated sexual characteristics (large breasts, well-defined pubic triangles), and poorly defined or nonexistent arms, legs, and feet.[4] But, actually, for every curvaceous female figurine, there are just as many that are slender, or male, or have no identifiable sex whatsoever. Additionally, the Venus figurines with blank faces are matched by a fair number of statuettes with facial features. Some of the most clearly visible features I've ever seen are on a series of more than twenty figurines from the site of Mal'ta in Siberia. These Venuses look more like they were meant to represent individuals, as the features vary between statues. Some have very well-defined faces; others are more stylized. A few of the Mal'ta figurines have no body at all and are just carved heads on curved cylindrical pieces of ivory. Those that do have bodies tend to be leaner, and many have hair and clothing suggesting that individual statuettes were a reflection of daily life, not some sort of mythological archetypal female.

Blank-faced or even headless figurines are found more commonly in France, but even there we also find statuettes like the one carved from a horse's tooth at Mas d'Azil, with a clearly defined nose, or the ivory head of La Dame de Brassempouy, with distinctive facial features. Some figurines are a blank sphere set

on top of a fairly unformed body and are only suggestive of being human due to their overall shape. Perfect examples of this type are four from the site of Predmostí in the Czech Republic, each of which was carved from mammoth toe bones. Their feature-less, rounded heads are attached to triangular-shaped bodies that appear to depict them in a seated or kneeling position. There are many others. Just as the animal figurines differ widely, so do those in the human category: they're not all Venuses; they don't all look the same; and they weren't all made for the same purpose.

When paleoanthropologists refer to the figurines as Venuses, we usually do so with air quotes, because this name is not terribly accurate. It's more out of habit than anything else that we still use this term; the discoverer of one of the first human figurines in the 1800s called it a "Venus" because it reminded him of a sculpture by Michelangelo. But labeling all the human figurines with this title connotes an association to the goddess Venus (of love, fertility, and sexuality). This just doesn't make sense when talking about male or sexless statues, nor about a fair number of the female ones that don't fit the Venus profile.

Nonetheless, it is rather curious that there are quite a few depictions of voluptuous women when the skeletal remains of women from this period show that they were muscular and lean. So perhaps these statuettes were meant to represent a female deity or mythological character just like the lion-man or bison-people. Other common interpretations are that they were fertility sym-bols, or self-portraits of pregnant women, or talismans to protect women during childbirth, or even Paleolithic pornography. While the pornography suggestion seems to me to be more a reflection of our own perception of nudity and sexuality in modern West-ern culture, the other proposed meanings all seem fairly plausible. And more than one of them may be correct. Since we are talking

about a massive geographical area and 30,000 years of prehistory, it's entirely possible that the Venus figurines had different meanings in different times and places.

Some of the figurines, both animal and human, also have the added feature of geometric signs carved into their surfaces. The most common ones seem to be lines and cupules (engraved dots), though there are also several examples of cross and open-angle engravings. In some cases, these may be meant to represent actual characteristics of the entity being portrayed. On an animal, the carver could have added lines to give a sense of the creature having fur, or used cupules to add spots to the animal's pelt. With some of the human statuettes such markings seem to have been included to show hair, clothes, or other natural features.

But there are also figurines on which the abstract markings just don't make sense from a practical standpoint. Vogelherd Cave, in the figurine-rich southwest region of Germany, has some great examples of both. More than twenty animal figurines, either whole or fragmented, have been excavated from the floor of this cave site. All the pieces are carved from mammoth ivory and are at least 35,000 years old, so we are definitely talking about the earlier stages of this tradition. Starting with the representative examples, there is a mammoth figurine with several lines in the cheek region thought to represent the tusks, and a bear with several horizontal lines running in a row down its neck that may represent the folds of its skin. Both of these seem pretty straightforward—they certainly speak to the talent of the artist at creating realistic representations, but nothing beyond that. In contrast, there is a lion figurine with thirty crosses running down the length of its back from head to tail; another lion head with a vertical row of crosses behind its ear; a third lion with crosses on its side; a mammoth with one row of crosses running across its shoulder and another near its hindquarters; an unidentified animal with lines, crosses,

and other abstract designs incised all over it; and, finally, a miniature version of the lion-man that has rows of cupules engraved along it vertically, as well as some incised lines.[5] In these figurines the geometric signs seem to embody an additional layer of symbolic meaning.

Even though these artists were fully modern humans, it's not easy to figure out what was going on inside their heads. Human culture varies widely from place to place. We have no single model to guide us in understanding how groups of people organize themselves and understand the world around them (in their family structures, ways of life, traditions, or belief systems). This is one of the reasons why interpreting the meanings of Ice Age art is so fraught with uncertainty and why many questions remain to be answered.

And while we know they had the same cognitive capacities as us, what we don't know is the extent to which these Ice Age people had developed specific mental skills or ways of thinking. Just because their minds were capable of inventing a super computer doesn't mean they were ready to do so as they lacked a whole lot of intermediate knowledge, the result of cumulative learning. Since the last person who could have answered the question of where they were intellectually died about 10,000 years ago, we have to work with artifacts and archaeological sites. These not only show us what technological advances and innovations were under way, but they also provide insight into the development of the underlying mental skills needed to shape these objects—things like imagination and abstract thought. Whether tools or art, both have the capacity to teach us about the way these people were understanding and interacting with the world around them.

Music is another excellent indicator of the presence of complex symbolic thought and also has interesting ties to the development of mathematical abilities. Almost forty flutes have now been found at sites across Europe, with the oldest ones coming from

that incredibly artifact-rich site of Geißenklösterle in southwest Germany. Two flutes made of swan bone have been found, along with another flute whose two halves were carved out of ivory and then glued together with an adhesive to make a seal (not a technologically easy task). All these flutes were recently dated to between 42,000 and 43,000 years ago.[6] This proves that music, as well as the technical skill to make musical instruments, was already known right from the time that people started settling in Europe. So music-making likely existed prior to people leaving Africa, but whether they had invented flutes or other instruments at this earlier stage remains to be discovered.

Widespread practices among humans in more recent times can also guide us in understanding what may have been in our prehistory. Every society on earth has some type of spiritual practice, usually including belief in an unseen world, and most cultures have some sort of narrative to explain their origins. Many of these beliefs and stories are represented in physical form—figurines, portable art pieces, rock art, etc.—and knowing that all these types of artifacts were already in existence during the Ice Age, we can cautiously assume that some of the Paleolithic art may have been created for similar reasons. And even if definitive answers about the exact meaning (or meanings) of the figurines remain beyond our reach for now, these little statues have certain other secrets they are willing to give up more easily.

Life and Death in the First Villages

I n the French province of Aquitaine, the Château de Commarque sits atop a low limestone cliff. Surrounded by a leafy green forest, the twelfth-century stone tower rises above the partial ruins of a fortress, looking out over an expansive, lush meadow to the river Beune beyond. This has been a strategic location for a long time—in fact, much longer than most people who visit the castle grounds realize. At the base of the cliff facing out toward the river is the entrance to a cave that was used as cold storage in the Middle Ages; but long before then, Paleolithic people lived in the entrance and embellished its interior walls.

Unlike many of the sites Dillon and I visited, Commarque is a shallow cave, with a single, rounded front chamber that splits into two narrow passageways like a T-junction at its rear. These passages are short—both tapering off in less than fifty feet—but there are quite a few engravings and bas-relief sculptures decorating this small space. I was there to document the non-figurative imagery (crosses, rows of lines, triangles), but Commarque is best known for a series of nine naturalistic horses spread throughout. In the entrance chamber, there is another figure that has produced

some debate. It's carved in bas-relief and oriented horizontally, and some rock art researchers believe it to be a view from the back of a reclining female figure. Having inspected it up close, I can see why they've proposed this, but it's one of those cases where it's hard to tell if that's what it is, or if it's more a case that our eyes are finding a familiar shape for us.

The biggest argument in favor of it being a sculpted woman's body comes from a rock shelter on the other side of the meadow, beyond the Beune River. About three hundred yards across the field, the Château de Laussel sits opposite Commarque. Whereas Commarque has always been French, Laussel was inhabited by English soldiers during the ongoing conflicts between France and England during the medieval period; these two strongholds have kept watch on each other for many centuries. And at the base of the cliff below Laussel is a rock shelter with almost 100,000 years of history buried under its floors. In 1911, archaeologists excavated a large block of limestone that had fallen from the back wall at least 25,000 years ago. On it they discovered an eighteen-inch-tall bas-relief sculpture of a voluptuous female figure—originally covered in red ochre—which they dubbed the Venus of Laussel (see fig. 7.1). This sculpture is a well-known image from the Ice Age, and with her blank face, exaggerated breasts and hips, and holding an upward-curving horn aloft in her right hand, she is often touted as the classic example of a Venus/mother goddess image. There are thirteen lines engraved in a row across the side of the horn (some scholars have speculated about lunar cycles) and the Venus has an engraved penniform, or Y-sign, on her right hip.

With these two sites so close together, it is certainly possible that the sculpted form in the entrance chamber of Commarque is also a nude female figure, and that this style of female depiction

7.1. *The Venus of Laussel, Abri Laussel, France. This nude female sculpture with its blank face and voluptuous figure is one of several types of human depiction found throughout Ice Age Europe. While people tend to focus on the possible fertility aspects of this image, what I find particularly interesting is the row of thirteen lines on the upheld horn and the engraved penniform sign on her hip.* ILLUSTRATION BY K. FORELAND.

was part of a local cultural tradition. However, it's important to remember that not all female depictions across Europe fit within this framework.

A common misconception about the human figurines is that they were all nude. In fact, a fair number incorporate markings that indicate one or more articles of clothing, including headdresses, belts, and skirts, and several figurines from Eastern Europe and Russia appear to be wearing hooded as well as other cold-weather gear (see fig. 7.2). While the figurines' purposes remain enigmatic, they have provided useful information about what clothing may have looked like during the Ice Age and how skillful the new arrivals in Europe were at producing it.

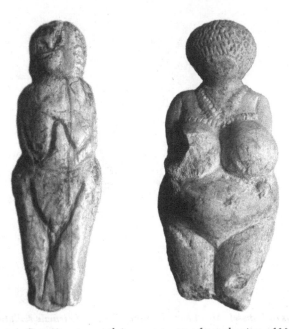

7.2. *These two Russian mammoth ivory statuettes from the sites of Mal'ta (left) and Kostenki (right) exhibit some of the variety found among Ice Age figurines. Standing almost ten inches tall, the Mal'ta figurine, with its narrower build, un-usual facial features, and carved hair, is a good example of a more realistic-looking figurine. Slightly taller at just under twelve inches, the Kostenki figurine is more typical in some ways (voluptuous figure, blank face), but what makes this figurine so interesting is the unusual detailing on the head and upper body, which many scholars believe could be items of clothing.* PHOTOS BY ALLISON TRIPP, COURTESY OF THE HERMITAGE (RUSSIA) AND SCHLOSS MONREPOS (GERMANY).

Clothing is in fact a great example of how the environment can influence technological/cultural change. Africa contains a range of environments, but nothing would have prepared those first human migrants for the bitterly cold reality of a northern Ice Age winter. People may have already been wearing articles of clothing prior to arriving in Europe, for either protective or cultural reasons, but there surely would not have been the same life-and-death urgency for these coverings to function properly.

People may also have been wearing footwear beforehand, but it is only after they arrived in Europe that we start seeing changes

in their physical foot structure that signal that they were regularly wearing some type of shoe or boot.[1] This is confirmed by the type of footprints we sometimes find in caves where the paleo floor has been preserved (i.e., where modern archaeologists have been careful not to step everywhere and damage evidence of Ice Age activity). At certain cave sites, the floor was muddy during the Ice Age, and those who ventured in left imprints of their feet behind. These are not bare footprints, but instead those of a soft-soled shoe.

Not only were these people wearing foot coverings around the time of their arrival in Europe, they also invented bone needles, which allowed them to create finely made, weatherproof garments. In some instances they may have been sewing with sinew or gut string, but there is also evidence of twisted flax fiber from a site in Georgia (Dzudzuana Cave), in the foothills of the Caucasus Mountains.[2] The very dry conditions there have led to the unusual preservation of more than eight hundred fragments of worked flax fiber, with the oldest dating to around 36,000 years ago. What I love most about this discovery is that these ancient people didn't just spin the flax and use it. They dyed many of these fibers all sorts of colors, including black, gray, turquoise, and pink. The archaeologists studying this rare discovery think they may have been processing the flax to make string, and maybe even sewing some of their clothes with this material—which conjures up for me a mental image of these distant ancestors strolling around the tundra in their new winter collection with stylish pink and turquoise detailing.

And this cave in the Georgian mountains is not the only site in Eastern Europe to contain surprisingly early evidence of inventions we normally associate with more recent times. Located in the Czech Republic, the neighboring sites of Pavlov and Dolni Vestonice are in many ways the Blombos of Europe. They sit less than two miles apart on the gently sloping Pavlov Hills, with

streams at their doorstep and the river Dyje flowing several hundred yards below. Both were occupied by large groups of skilled mammoth hunters off and on between about 25,000 and 30,000 years ago. With the edge of the towering glacial sheet only a few miles away, Pavlov and Dolni Vestonice were pretty much as far north as people could get at this time, drawn by the large herds of reindeer and mammoths that migrated up to the edge of the ice sheets every summer to gorge on vegetation that flourished around the melting glacier water. The landscape around their settlements would have been the type of open tundra in the Arctic today. Near the upper limits of the tree line, they would have looked out over undulating grassland steppes, the uniformity of the horizon broken only by the occasional clump of bushes or a small stand of spruce and pine trees. Wood was so rare this far north that the inhabitants instead fueled their fires with dried-out bone.

Bone also happened to be a main building material in this area, unlike elsewhere in Europe, where perishable wood was more commonly used. Here the outlines of their homes and settlements have survived the ravages of time. In other regions, people were frequently nomadic, following herds of animals, creating temporary campsites before moving on. But here in Moravia, a different way of life emerged with permanent settlements. Dolni Vestonice and Pavlov are two of the oldest villages in the world. They may have only been occupied for part of the year, say as a summer hunting settlement, with a winter home farther south, but the size and permanence of the living structures points to at least some of the people living there year round over long periods of time.[3] Here in these village sites we find what is usually thought to be a product of the Agricultural Revolution, but happening almost 20,000 years earlier than expected.

In a Paleolithic village like Dolni Vestonice, the first thing you would have noticed as you walked up the hill from the river to

the settlement would have been a fence made of mammoth bones, brush, and earth partially enclosing a series of dwellings spread out over more than an acre. You would see hundreds of mammoth bones stacked in mounds inside this perimeter. A big fire pit in the center of the settlement may have been kept constantly burning with fuel from the nearby bone piles. At different times there may have been as many as four or five houses in use simultaneously, large communal dwellings, each accommodating somewhere between fifteen and twenty-five people. This would have put the population of Dolni Vestonice somewhere in the neighborhood of eighty to a hundred people.

These dwellings were oval in shape, the largest being about fifty feet long by twenty feet wide. Flattened floors were carved out of the earth, making the dwellings partially subterranean. Wooden poles were sunk into the ground and stabilized with rocks at their base. These poles all leaned inward toward a central spine, and it is thought that the walls were made of stretched and sewn animal skins, affixed to the poles and anchored to the ground with large rocks and mammoth bones. All the homes had multiple hearths, with the largest having five in a row, aligned down the middle. Food preparation, toolmaking, and the production of other artifacts all took place around the hearths inside the houses as well as around the bonfire outside. The excavations at Pavlov show the same sort of pattern of settlement. Researchers have so far identified eleven different dwellings of similar type, though some of these may be from different periods of occupation. If I was alive during the Ice Age in Europe, this is definitely the region where I would have wanted to be.

A bird bone flute was recovered near one of the hearths at Dolni Vestonice. It's exciting to find a flute so far to the east of previous finds in France and Germany as it shows that music-making was a widespread tradition among Ice Age people. What's more,

a resin block was found intact inside this flute. In order for a flute to produce sound, there needs to be some sort of interior block for the air to reverberate against. This is one of the only examples we have where the block material is still present and it has allowed music evolution specialists[4] to better understand the intricate production process people had developed to create these instruments.

Once larger groups of people begin living in a more permanent setting, a greater level of task specialization usually seems to follow. With more people to take care of the needs of the group, individuals who possess valuable and specialized skills are supported without their needing to participate so often in daily subsistence activities—this is what we see happening at Dolni Vestonice. One or more members of their tribe knew how to make ceramics. And I'm not talking about just shaping some mud found near the river then leaving it in the sun to dry. They were making kiln-fired ceramics.

Like village living itself, pottery is usually associated with the later shift to agriculture and the time when people began collecting large stores of grains and other crops. They needed ways to store these items, and many early farmers began making pottery vessels to fill this need. Recent studies of ancient Chinese and Japanese ceramic containers have dated some of them back to between 18,000 and 20,000 years ago, long before agriculture had taken hold. To find out what people might have been doing with containers this far back, an international team of researchers working in Japan analyzed the residue inside some 15,000-year-old Japanese pots, which showed they were used to cook fish. It seems totally logical, but it's still amazing to think that people from so long ago were already cooking in such a modern way. While it was certainly brutally cold at times back then, I don't think their lives were as nasty, brutish, and short as we have long

thought they were. These people were using their big modern brains to come up with all sorts of ways to make life easier and more comfortable.

In Dolni Vestonice they weren't making ceramics to use as containers; they were firing hundreds of figurines and clay balls in a kiln.[5] The pottery workshop at Dolni Vestonice was its own structure, situated about three hundred feet from the main living area. It was partially built into the hillside with the back wall cut straight out of the earth and its sides made of low walls of stone, dirt, and clay, with evidence of postholes sunk right into this stable base. In all likelihood, animal skins were used to form the roof and the front wall/door. This hut was almost twenty feet in diameter, and appears to have been someone's home as well as a workspace. Toward the back of the structure was a sophisticated kiln. Made of shaped and hardened soil and clay, the kiln was almost fully enclosed, just like a modern one, and could fire clay at temperatures of 1,000° F or more.

After what I am sure was some trial and error, the potter had come up with a recipe to produce more durable figurines—the secret was to add powdered bone to the clay to make it heat more evenly. This mixture also seems to have sometimes created a sort of self-glazing finish, which is why some of the figurines from this site, including the glossy "Black Venus of Dolni Vestonice," have a polished appearance. Even so, many of these terra-cotta statues have heat fractures on them from the firing process, and hundreds of fragments of broken or exploded figurines were found on the floor around the kiln, along with thousands of clay pellets (many with visible fingerprints) that may have been bits of clay pinched off from the figurines during the modeling process. What no one can quite agree on is whether the broken figurines were the product of poor technology or if breaking them was part of

their purpose (perhaps as some sort of ritual killing?). Other ce-
ramic figurines have been found intact elsewhere at the site (or if
they were broken, it happened after they'd been deposited into
an archaeological layer). As at other sites, here too we find both
animal and human representations. Animal species identified so
far include mammoth, bear, fox, lion, horse, and woolly rhino.

Whole and broken ceramic figurines have also been found at
Pavlov and other smaller sites in the immediate vicinity. It's possible
they were all the product of the same kiln, or maybe we just haven't
found the other kilns yet. In either case, this technology had become
an important part of the region's culture, and the people who were
able to make these terra-cotta representations probably occupied
a special place within the group. Farther afield, thirty-six ceramic
figurines dating to around 17,500 years ago were recently found
at the cave of Vela Spila in Croatia.[6] The later date and different
geographic location are the first evidence we have of this practice
continuing beyond the time and place of the earlier Czech sites.

Along with the ceramic figurines at Dolni Vestonice and Pavlov,
there are also many examples of more typical ones fashioned out
of ivory, bone, and stone. So it's not that the one replaced the
other, but rather that the pottery statues were an important ad-
dition to an existing category of symbolic artifact. Once again it
is fascinating to see the amount of effort, thought, and creativity
that early people expended on things that were not technically
necessary for survival.[7]

Thanks to another discovery related to the ceramics at these
arctic villages, we now know that the flax string from Dzud-
zuana Cave in Georgia was part of a much broader practice of
cord-making, along with the production of other types of textiles
and basketry from plant materials. Archaeologist Olga Soffer was
working with ceramic fragments found at Pavlov and Dolni Ves-
tonice when she spotted something unusual. Other researchers had

already noted the occasional fingerprint on clay pieces (thought to have happened during the preparation process and then been baked into the clay when it was fired), but Dr. Soffer was the first to notice that there were other types of impressions—patterns—as well. She and her colleagues identified thirty-six different imprint patterns that they recognized as early examples of textiles and basketry. The shaped pieces of clay likely came into contact with these materials while still wet (maybe by touching the potter's clothes or by being placed in a basket or on a mat), and as with the fingerprints, once the clay was heated, they were permanently imprinted into the finished product.

By studying the impressions they'd identified, Soffer and other specialists in perishable materials have determined that these Ice Age people were making cords, textiles (including open and closed twine, and plain-weave fabric requiring the use of a loom with battens or weaving sticks), baskets, and nets.[8] All of this was happening almost 30,000 years ago. Because the weaves and variety of techniques show a high degree of mastery, Soffer and her colleagues feel that this was already a well-established tradition, even though these materials are 20,000 years older than the long-accepted consensus that textiles originated during the Agricultural Revolution. This really goes to show how limited our knowledge can be when we only have stones and bones to work with, and how much is potentially missing from the archaeological record because of the fast decay rate of perishable materials like plants.

Along with being the frontrunners in the development of several new technologies, the people of Dolni Vestonice and Pavlov were also some of the first in Europe to begin burying their dead. Unlike other symbolic practices that were common to the first modern humans who arrived in Europe, elaborate ritual burials may have taken longer to develop, with the earliest known graves across the continent dating to between 30,000 and 32,000 years ago.

For about the first 10,000 years that people were living in Europe, we have no evidence of burials whatsoever. Most of the human remains that we currently know of from this time are premolars and molars found at several early French living sites. These teeth had been perforated and appear to have been strung and worn as personal ornaments. They were often found alongside the teeth of other species. While all the teeth appear to have been prized items, it doesn't appear that the human ones were being treated any differently from those sourced from animals. Had these teeth fallen out of the mouths of the people who then wore them, or were they removed from the corpse of another person specifically for this purpose? We don't know, but these examples are the oldest evidence we currently have of people wearing human relics as ornaments. In a few other early European locations some human skeletal remains have been found, but none of them appears to have been purposefully interred, and a few even show signs of having been defleshed with stone tools. Whether these remains were processed for cannibalistic reasons or as part of some sort of defleshing ritual (for example, if people wanted to preserve the skull of an honored relative) has yet to be determined.

Just because we aren't finding early graves doesn't necessarily mean that people weren't disposing of their dead in a meaningful way. It could be that we just haven't found those elusive graves yet. Many different methods don't leave any clues—such as placing the dead in a specific location outside (like a sky burial where people leave the deceased's body in a high place for birds to consume), cremation, or even caching them in trees. An early grave from Australia, dating to at least 25,000 years ago, is actually a partial cremation, and for all we know the first people of Europe may have been doing something similar. There are also burials with

a small number of grave goods from Egypt dating to just over 40,000 years ago, so I tend to think that the first modern humans in Europe were not just tossing aside their dead.

Around 33,000 years ago, something changed. We go from having no graves at all to finding them fairly regularly at sites across Eurasia. These burials, often separated by hundreds or even thousands of miles, have a lot of things in common. Paul Pettitt, a paleoanthropologist who has studied death and burials during the Paleolithic, believes this pattern proves that "widespread shared belief systems underpinned [the] funerary practices of this period."[9] This may indicate the rise of a shared cultural practice that spanned most of the continent, possibly disseminated through the extensive trade networks in place at that time.[10] Almost every grave found so far has traces of red ochre in it. In some cases it may have been sprinkled over the body, but in others it appears to have been painted on the person—before or after death—or on the clothes he or she was wearing. Many of the burials include at least one stone tool, and some contain what appears to have been a food offering. Additionally, a good percentage of the graves include some type of personal adornment. Sometimes it was a necklace or another piece of jewelry, but frequently the ornaments seem to have been sewn right onto the clothing. We can often tell the difference by the way these pieces have settled in the grave. The ornaments include items like pierced marine shells, perforated teeth, beads made from ivory, bone, or stone, and occasionally even more exotic materials like carved amber.

The grave goods in the oldest burials tend to be a bit simpler, but it didn't take long for this practice to become increasingly complex. Dolni Vestonice and Pavlov have produced some of the oldest known burials in Europe, and while they aren't the most elaborate, a number of them do include a few unusual features

in addition to the more common grave goods.[11] There are burials with red ochre, especially concentrated around the head and pelvic area, and some of the skeletons were buried with items such as stone tools, small numbers of fox and/or wolf teeth, and ivory beads; one burial even included some marine shells. More unusual additions include the placement of mammoth scapula (shoulder blades) over some of the bodies, specialized bone tools, and a fragment of a clay animal figurine. Wooden structures seem to have been erected over two of the burials while the graves were still open and then lit on fire.

There is also a very unusual triple burial at Dolni Vestonice of three young adults—a female flanked by two males—where the bodies have been arranged in such a way as to perhaps tell the story behind their deaths. While DNA testing has yet to be attempted, a physical comparison of the three suggests they may have been related, based on some unusual traits, such as missing frontal sinuses and impacted upper wisdom teeth.[12]

In the burial itself, one of the males has his hand across the pubic area of the female, while the other male was buried facedown with his head turned away from the other two, but with his arm linked with the female's arm. Red ochre was found throughout the grave and was especially concentrated around their heads and the woman's pubic region. The male buried faceup may even have been wearing an ochre-covered mask. The woman has no ornamentation but did have a stone tool and several stone flakes buried with her, while the two men were wearing some sort of simple headdresses made of fox and wolf teeth and some ivory beads. The female in the middle seems to have suffered from quite a few developmental issues, such as a deformed skull, curvature of the spine, and other bone deformities. One of the males had a wooden spear or stake driven into his hip, while the other appears to have died from a blow to the head. There is not a lot

of evidence for violence between humans during the Ice Age in Europe, so to find two male individuals in one grave who seem to have died violently around the same time raises many questions about this Paleolithic family.

Two burials from Sungir, in Russia, dating to around 30,000 years ago, currently hold the title for being the richest Ice Age grave sites anywhere in Eurasia. One is the burial of an adult man estimated to have been somewhere around sixty years old at the time of his death. The other, even more elaborate grave is a double burial of an adolescent boy and a female child, both of whom have the same mitochondrial DNA (i.e., they are either brother and sister, or cousins through their maternal line). More than 13,000 ivory beads were recovered from these graves, with the young people accounting for the largest share, with about 5,000 beads apiece. Most of these were sewn onto the clothing of all three in wide bands, and each of them also wore heavily beaded caps on their heads. The adult male and the adolescent boy both had polar fox teeth mixed in with the beads on their headdresses, and the boy seems to have been wearing a belt decorated with 250 additional fox teeth. The adult was wearing several mammoth ivory bracelets on each arm and a stone pendant painted red with a black dot around his neck. The children had more items buried with them, including straightened mammoth tusks that were each over six feet long and may have represented ritual spears (the natural curve of the tusks was eliminated by soaking them in water and then slowly straightening them in increments); carved ivory figurines; flat ivory disks with carved lattice patterns; and worked antler drilled with a series of holes.

All these items were very labor-intensive to produce, and experimental reproduction of the ivory beads has shown that each bead would have taken about an hour to make—a significant time investment from a community of people. The wealth of the artifacts

in the older male's burial makes sense in a way, as he would have had a lifetime to accumulate those goods, but this doesn't explain why there are so many in the children's graves. There are only 8,760 hours in a year, so the more than ten thousand beads from the double burial of the children would have taken a single person working twenty-four hours a day almost fourteen months to produce. The children may have been part of some sort of ritual sacrifice, but many scholars see the children's grave goods as one of the earliest examples of social stratification, the rank of their family or their place within the tribe's hierarchy giving them the right to be buried so richly. Whatever the actual reason, the amount of effort expended to create such beautiful items only to bury them forever, at Sungir and elsewhere in Europe, hints that these people didn't see death as the end of life's journey, but as the beginning of a new stage of existence.

While we tend to focus on the stunning burials with their elaborate grave goods, all graves from this era were not created equal. Besides the two rich burials at Sungir, there are several other burials at this site, including two outside the settlement with no grave goods whatsoever. Indeed, for every Ice Age grave we have found containing lavish artifacts, there are at least two more that have little to nothing included in the way of grave goods, although almost all the burials do contain some red ochre. There is also variation between regions, with the richest burials coming from Italy, the Czech Republic, and Russia. France has its fair share, and a few sporadic burials have been found in Portugal, Austria, Germany, and Poland. Strangely, Spain, a country with a large number of stunning rock art sites and lots of evidence of occupation during the Ice Age, doesn't have any to speak of.

As with the burials, there is a wide distribution of portable art at the sites across Eurasia. I chose to use Dolni Vestonice and Pavlov to talk about portable art not as a slight to any of the other sites,

but because it is rare to find one location that has every category of symbolic artifact represented (minus the rock art, of course, but we'll get to that shortly). Also, the technological innovations found here are unusual, and the excellent preservation of the settlements gives us a rare snapshot of everyday life in Ice Age Europe.

The question of what was being developed, and when, is going to become particularly important as we start to analyze the rock art in the coming chapters. Not so much because of the technical particulars, as these varied between regions, depending on opportunity and necessity, but rather because these activities hint at a sophisticated ability to engage in abstract thought. When I look at the rock art these people left behind in caves and rock shelters across the cold and windswept landscape of Ice Age Europe, the question I'm really trying to get at is the level of intent. The art did not come out of a vacuum. It did not appear overnight. It is from fully modern people living in a cultural world overlying the natural one. Just as we do, they interacted with these two worlds through a symbolic framework. In many ways the rock art can be seen as the ultimate end product of this new way of perceiving and being in the world.

How to Make Cave Art

In 2013, I had the rare opportunity to see evidence of the paint-making process firsthand at the site of La Pasiega in Spain. At this richly decorated site can be found paintings and engravings depicting a large and varied collection of animals (the usual set of horses, bison, aurochs, and deer, plus even a few birds and fish) as well as more than a hundred geometric images (everything from dots and lines to complex rectangular signs). Based on the diverse art styles found in different sections of the cave, it seems likely that it was visited by several separate groups over the millennia. One set of these visitors happened to leave part of their paint kit behind.

The actual grinding stone used by this artist or group of artists to crush their red ochre into powder some 27,000 years ago is still there inside the cave (see fig. 8.1). The upper surface of the stone is roughly oval in shape with a slight depression and a flat bottom for stability. Traces of pigment are still in place even after so long. As I stood there looking at this artifact, suddenly the artists didn't feel so distant or theoretical. I could almost see them crouched on the floor of La Pasiega, backs bent, the light flickering unevenly from their torch or animal fat–fueled stone lamp, shadows dancing on the walls around them as they leaned over the stone to grind their

8.1. Ochre grinding stone, La Pasiega, Spain. Ice Age artists often brought the ingredients to make paint into the cave with them and then mixed them at the location where they were painting. PHOTO BY D. VON PETZINGER.

precious supply of ochre—that vibrant red mineral used in the creation of paint at so many Ice Age sites.

There is something about the color red. It can represent happiness, anger, good luck, danger, blood, heat, sun, life, and death. Many cultures around the world attach a special significance to red. Its importance is also reflected in many of the languages spoken today. Not all languages include words for a range of colors, and the simplest systems recognize only white and black, or light and dark, but whenever they do include a third color word in their language, it is always red.

This attachment to red seems to be embedded deep within our collective consciousness. Not only did the earliest humans have a very strong preference for brilliant red ochre (except for the inhabitants of Sai Island, in Sudan, who favored yellow), but even earlier ancestral species were already selecting red ochre over other

shades. It may also be significant (although we don't know how) that the pristine quartzite stone tool found in the Pit of Bones in Spain was of an unusual red hue.

This same preference for red is evident on the walls of caves across Europe during the Ice Age. But by this time, artists had added black to their repertoire and the vast majority of paintings were done in one or both of these colors. I find it intriguing that two of the three most common colors recognized and named across all languages are also the ones most often used to create the earliest art. The third shade, though well represented linguistically, is noticeably absent from Ice Age art. Of all the rock art sites currently known in Europe, only a handful have any white paint in them. Since many of the cave walls are a fairly light gray or a translucent yellowy white, it's possible that the artists saw the background as representing this shade, or that its absence could have been due to the difficulty in obtaining white pigment: the small number of sites that do have white images all used kaolin clay to create this color. (Since kaolin clay was not as widely available as the materials for making red and black paint, it is certainly possible that scarcity was a factor in color choice.)

While the red pigment was created using ochre, the black paint was made using either ground charcoal or the mineral manganese oxide. The charcoal was usually sourced from burnt wood, though in some instances burnt bone was used instead. Manganese is found in mineral deposits, sometimes in the same vicinity as ochre. Veins of manganese can also occasionally be seen embedded right in the rock at some cave sites. Several other colors do appear on occasion—yellow and brown are the most common—though they appear at only about 10 percent of sites.

There is also a deep purple color that I've only ever seen in cave art in northern Spain, and even there it's rare. La Pasiega (the site where I saw the grinding stone) has a series of paintings

in this shade of violet in one section of the cave. Mixed in with more common red paintings, there are several purple signs—dots, stacked lines, rectangular grills—along with a single purple bison that was rendered in great detail (see fig. 4 in insert). Eyes, muzzle, horns—all have been carefully depicted, and yet the purple shade is not an accurate representation of a bison's coloring. Did the artist use this color simply because it's what he or she had at hand? Or could it be that the color of the animal was being dictated by something other than a need for this creature to be true to life? We know these artists had access to brown and black pigments, but at many sites they chose to paint animals in shades of red or yellow, or even purple, like the bison here at La Pasiega. These choices are definitely suggestive of there being some type of color symbolism at work, and it could even be that creating accurate replicas of real-life animals was not the main goal of these images. (As an interesting side note, a later set of artists actually fixed up fading parts of the purple bison by redrawing the belly line in black paint.)

Other than black, all the pigment colors I've described derive from ochre. Ochre naturally varies in shade, depending on what other minerals are present; however, as we saw at sites in South Africa, people had already figured out how to heat-treat ochre in order to alter the color to suit their needs as far back as 150,000 years ago.

La Baume-Latrone in France is one of the only sites I can think of where the brown "paint" on the walls is actually just reddish-brown clay that was applied directly to the rock surface. Usually a color pigment is ground into a powder and then combined with other ingredients to create a paint mixture. Some of the French and Spanish paint formulas have been analyzed in recent years and were found to include further ingredients called binders and extenders that were added to make the colored powder easier to apply to rocky surfaces, and to help it stick.[1] Binders

liquefied the powder and turned it into a type of paste. The most common things used were water and animal fat, though based on the chemical analysis of certain samples, it seems the artists were also occasionally using egg white, urine, milk, or blood. Extenders increased the amount of paint being made in a single batch—of particular importance if the supply of color pigment was limited. The most common extenders seem to have been powders ground from such sediments as talc, feldspar, biotite, and clay; and, based on their color and textural properties, it's possible that some of them were being specifically selected to alter the shade of the finished product, or even to add an element of sparkle (e.g., quartz).

Several distinct recipes using different combinations of binders and extenders have been identified at cave art sites in France and Spain, and many of these formulas have been found repeated in multiple locations. The different ways they were being made, and the careful replication of specific recipes at more than one site, may well signal the presence of a cultural paint-making tradition, possibly passed on between generations. Yet however these formulas were developed, the point that's really worth noting is that a lot of preplanning and preparation went into making the rock art. This was not something easily done on a whim; instead it seems to have been a multistepped activity with a definite purpose.[2]

There are three main methods of applying paint to the rock surfaces inside a cave. The first is with some sort of brush. Based on the texturing that is visible in certain locations, along with analysis of minute remnants trapped in the mixture, it appears that the artists often used either a pad of fur (e.g., from a bison or a mammoth) or plant matter (e.g., moss) to spread the paint. The second method involves using the fingers or hand directly. There are quite a few rock art sites where the dots were made by dipping the finger in the paint and then daubing it on the wall (sometimes even leaving fingerprints). Similarly, the image type known as a

positive hand was made by covering the palm side of the hand in paint, then pressing down on the rock surface to leave a handprint behind. Occasionally figures such as animals were also produced using the finger as a paintbrush, but generally the more complex imagery was produced with the aid of some sort of brush.

The third method involves spit-painting. There are two ways to do this: the first is to put crushed charcoal or ochre in your mouth, add a bit of water to liquefy it, swish it around to mix the powder in, and then spit it back out in a controlled manner to coat the wall evenly, either directly from the mouth or through some sort of strawlike implement, such as a bird bone or reed. I can attest from firsthand experience that this is not as easy as it sounds! Spit-painting is most commonly used to make negative hand stencils. These are created by placing your hand flat on the rock surface and then spitting the paint all over and around it. When you lift it up, you are left with an outline, which is why they are called "negative" hands. I have also seen dots made this way at several sites (most likely by blowing through an implement), usually when there are negative hands nearby, so someone who knew the technique probably made both.

The second way to spit-paint is almost more of a paint-blowing method. In this case you put the ochre or charcoal powder in the palm of your hand and blow it straight onto the wall (see fig. 5 in insert). As with the spit-painting, this can either be done with your breath or you can use some type of straw to better direct the spray of powder. Since the walls in many caves are damp, even dry powder will stick and start to liquefy once it makes contact. Blowing the powder does tend to produce slightly clumpier results, but it also means you can avoid putting the pigment directly in your mouth—a compromise that some of the artists may have considered worthwhile, so as to avoid a stained chin and the lingering

taste of pigment. (Note to the reader: if you ever decide to give this a try, I would highly recommend that you don't schedule any important meetings for the rest of the day. . . .)

The other main technique used to make these images was engraving. The most common method was to take the point of a stone tool or some other implement and carve directly into the rock face. Depending on the type of rock and the strength of the arm wielding the tool, engravings can range from being little more than surface scratches to deep incisions. Deeper engravings sometimes show evidence that the stone tool was run over the same line several times to enhance its depth. Faint markings can be incredibly difficult to find and even harder to photograph, as my husband, Dillon, and I have discovered. The trick is to shine the light from the side to create shadows inside the lines. However, at the time the marks were engraved, the lines would have been clearly visible and stood out from the background a lot more than they do today. It's actually pretty easy to tell the difference between more modern engravings at cave sites and the really ancient ones. Recent incisions are a paler color than the rock surface itself, while very old engravings have darkened to match the background color from their prolonged exposure to the air (a process known as oxidization).

Another challenge in identifying engravings is trying to discern whether they are purposeful markings or natural cracks. Engravings on crumbling limestone walls and ceilings that are constantly shedding bits of rock can become blurry and indistinct over time. This isn't such an issue with complex images like animal figures since the curve of the lines and the overall form tend to differ in appearance to natural occurrences (cracks don't usually happen in the shape of a horse or mammoth). But with geometric signs, especially the simple ones (e.g., lines, open angles, triangles, etc.), identification can sometimes be a bit trickier. There is no 100 percent

perfect method, but there are a couple of things that can help you tell the difference. First, if there are other engravings in a less degraded part of the cave, does the style of the lines (e.g., thick, thin, deep, shallow) look similar? Second, do the markings cross over multiple layers of stone? A natural crack in the limestone will usually stop when it hits a harder layer of the wall, whereas a purposeful engraving will cut right across it.

Bear and bat claw marks can also interfere with deciphering cave signs. Now extinct, cave bears lived in caves throughout Ice Age Europe. Their needs and our own were quite similar, and many sites were occupied, at different times, by humans and bears. The bears frequently sharpened their claws on the cave walls, sometimes leaving behind beautifully formed sets of parallel lines (see fig. 8.2). The same can be seen on a smaller scale with bat claw marks, caused by frequent landings in certain locations within a cave. In both cases, though, if you look at the lines closely, it is usually possible to tell the difference, as claw marks leave differently shaped indentations in rock surfaces from those made by stone tools. Claw marks tend to be more squared off, whereas tools usually narrow to a point and create more of a triangular groove.

With paintings, it can be difficult to try to tell the difference between naturally occurring pigments and purposefully applied paint. Both iron oxide (ochre) and black manganese occur in mineral deposits inside caves, and when water runs across them, these deposits can drip or splatter down the walls in all sorts of abstract patterns. In the Roc de Vézac cave, an accumulation of black manganese happens to be shaped somewhat like the outline of a mammoth. For a long time, the archaeological inventory for this site included it as a man-made image, until close analysis revealed that it was in fact naturally occurring. Having been there myself, I can tell you: it really does look like a faded mammoth painting. In fact, many prehistoric paintings

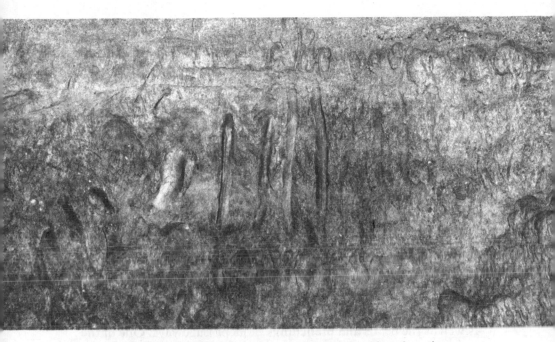

8.2. Cave bear claw marks, Villars, France. Notice the visual similarity between these lines and those created by a human using a tool. PHOTO BY D. VON PETZINGER.

are partially washed away or badly degraded, and identifying imagery can be quite challenging.

Dealing with abstract markings can be even more difficult than working with figurative paintings. I've seen quite a few examples of what appear at first glance to be red or black dots, but which, upon closer inspection, turn out to have coloring that doesn't quite match the other paint at the site, or where the pigment doesn't have the pastelike quality that most paint formulas have. This is one of the reasons I've spent so much time crawling around caves (Dillon and I have calculated that over the past couple of years alone we have each spent over three hundred hours underground!). I purposefully select sites where there are questions about the accuracy of the inventory, and then go and confirm it for myself. False positives don't happen too often, but enough that it makes this a worthwhile endeavor.

In cave sites whose interior surfaces had a softer consistency, artists sometimes used their finger(s) to engrave, a technique called finger fluting. These marks are made by holding out some or all of the fingers on one hand and then running them along the wall, either to make a set of parallel lines, or to produce a more complex abstract shape, or even occasionally a figurative image (see fig. 6 in insert). In at least five sites (Pech-Merle, Gargas, and La Baume-Latrone in France; and Altamira and La Clotilde de Santa Isabel in Spain), animals were created using the finger-fluting technique, and some of them are just as good as similar imagery made using a tool.

Other types of finger flutings—the lines and abstract shapes—have given us new insight into the identity of some of the artists. Rouffignac Cave, in France, was originally carved out by an underground river, which explains its fairly flat bottom and ceiling, as well as the bends and branchings of its passageways. One of the unusual features of Rouffignac is that the art does not start for over two hundred yards, with further decorated sections continuing on for another 650 yards underground. To get to the art, you have to pass through chambers full of hollows dug out by hibernating cave bears. Nowadays, an electric train will take you on a tour of the cave and its art, which is fun, but in prehistoric times our ancestors would have had to trek through damp, rather scary territory, even without resident cave bears.

Not long before you reach the first art in the main passage, a side branch leads off to the right. If you follow this passage for another 130 yards or so, you come to a place with several offshoots known as Chamber A1. In a subchamber on the left, most of the ceiling is decorated with an abundance of finger flutings. Measuring about 1,600 square feet, the ceiling is composed of white limestone covered with a thin coating of red clay. The flutings cut through this layer and stand out clearly: long

parallel rows, zigzags, meandering flutings that look vaguely serpent-like. Hooks and loops and circles also abound, with many of the markings overlapping.

Rock art researchers Kevin Sharpe and Leslie Van Gelder have measured these flutings, particularly the width of the distance between the lines, as well as the width of the lines themselves.[3] And they have determined that most of them were made by small children between the ages of two and five. A handful of flutings on the ceiling were made by adolescents in the six-to-thirteen-year-old range. The ceiling in this chamber is on average almost five and a half feet high, so the youngest children could not have reached the ceiling without some assistance, possibly provided by the older kids, who may have been functioning as babysitters. Why they made these markings, especially in such a deep cave, continues to be debated (possibly killing time while the adults made art elsewhere in the cave, or copying what they'd seen others do?). However, based on the age of most of the finger fluters, it seems likely that the experiential and tactile aspects of making these flutings may have been more important than any intended outcome.

At least two additional sites that I know of (Pech-Merle in France and Altamira in Spain) also have finger flutings that were, in all likelihood, made by little fingers. There are probably more. Many other sites with finger flutings have not yet received a great deal of attention, but as research continues, it may well turn out that children were artistic participants at many of these sites. There are also a fair number of cave art sites that have positive and negative children's handprints. The smallest hand found so far is that of a toddler, but it is located almost six feet off the floor at the site of Cosquer in France. The only way this would have been possible was if someone lifted up the child so he or she

could press a palm on the wall and leave the mark. As with the flutings at Rouffignac, the involvement of adolescents or adults would have been necessary, not only to lift them up off the floor, but also, I suspect, to help with spit-painting or blowing the paint around some of the children's hands. I have seen quite a few of these in person in both France and Spain, and the neat and tidy way the pigment is dispersed on the wall around the hand makes me think that someone else was taking care of that while the child focused on holding still. Based on personal experience with my own toddler, I suspect that that part of it would have been a difficult enough task on its own.

Whether it was something to do to keep the kids busy while the adults made the more serious art, or if this was how younger members of the tribe practiced, I love the idea that children were part of this activity, rather than it being the preserve of only a few select adults. Sections of the sites may well have been decorated in seclusion (e.g., rites of passage, shamanic visions, etc.), and difficulty of access to some would have limited the number of participants. However, I do think that in many instances, making art was a group activity that included tribe members of all ages. There are plenty of child-sized footprints preserved in the mud floor at certain sites. These kids seem to have been quite the explorers, and based on some of the places where their footprints have been found, it doesn't seem like they were afraid of small, dark places, either.

Negative handprints have also proven useful in identifying male and female hands. The index and ring fingers on female hands tend to be of the same length, whereas the ring finger on a male hand is usually longer than the index finger. Dean Snow, a rock art researcher at Pennsylvania State University, has identified the sex of some of the artists at the sites of Gargas and

Pech-Merle in France and at El Castillo in Spain by calculating ratios and measuring the relative lengths of these two digits on well-defined hands at each of the sites.[4] Seventy-five percent of the hands he measured were female. Since artistic ability has nothing to do with biological sex, I'd be hesitant to say this suggests that women made most Ice Age art (though it may have been the case during that particular time period at El Castillo), but what it does confirm is that it wasn't just a small, select group of male artists, as had been traditionally assumed. And while most people could probably become pretty decent artists with time and practice, some are just naturally going to be better than others. For example, my husband and I are both equally bad; I like to joke that that's why I study the geometric signs—anyone can draw a triangle, even me. And while it certainly takes a bit of practice to master spit-painting, the hand images don't require a lot of special skill; what they do give us, though, is evidence that people of both sexes and all ages were involved in making art. It's only when we start talking about the stunning animal and human depictions that ability really comes into the equation. My personal belief is that there were both male and female artists working at rock art sites throughout the Ice Age, and that it was an individual's talent that determined who was making the art rather than their biology.

One of the best features of engraving is its potential longevity. Paint can wash off, and the ingredients can degrade, but engraved lines remain legible for much longer. While we certainly see this happening in cave settings where moisture and dripping water can wash away paint over time, this difference is much more pronounced when looking at other types of rock art sites. The vast majority of Ice Age rock art in Europe has been found in caves; however, this may have more to do with the enclosed and

protected nature of a cave rather than because they were the pre-
ferred or exclusive location for creating art. Ancient engravings
have also been identified in quite a few rock shelters across Europe
and even in a few open-air sites in France and Portugal. There may
have been paint at these sites initially as well, but millennia of
wind and rain have removed all remnants, leaving behind only the
faint traces of engraving. While these markings can be quite diffi-
cult to decipher at less-protected sites, their presence still offers an
important clue to the relationship between rock art and location
(more on this later).

Having had the opportunity to see a lot of engravings up
close, I was impressed by how rarely the artists made mistakes
or had to redo a line. I'm not saying that all the engraved figures
worked out perfectly (a few are pretty terrible), but overall their
mastery of this art form is on par with that of artists today. The
same holds true for most of the paintings. Here again we do
sometimes see a crooked leg or two, or occasions where they
didn't get the paint mixture quite right and it dripped down the
wall, but, those few instances aside, there can be no doubt that
the people who made these images possessed the same levels of
artistic knowledge and skill that we do.

All the art we create today is a legacy of what those people and
other groups of early humans around the world developed during
the Ice Age. As Pablo Picasso said about modern art after seeing
the art in Lascaux Cave in France, "We have invented nothing."

Signs Across the Ages: The Many Styles of the Oldest Art

T he world's oldest known rock art is a red disk about the size
of a teacup saucer. It's located on a yellowish-gray wall over-
hanging the low entrance to a side passage inside El Castillo
Cave in Spain. When first made, it would have been a brilliant
shade of red, but over the course of the millennia, water rich in
limestone trickled across it, encasing it in a milky-white layer and
transforming its visible color to a faint dusty rose (see fig. 7 in in-
sert). When I first saw it in person, I took a moment just to stand
and stare at it. Not so much because of its aesthetic quality—it's
actually a rather modest little painting—but because of what it
represents. It is at least 40,800 years old.

I say at least, because what was dated was not the disk itself
but the calcite limestone layer that covers it, making this date
the minimum age for the art. All we know for sure is that it was
painted prior to 40,800 years ago, when the calcite layer formed.
Archaeologist Alistair Pike and his team of dating specialists used
a technique called uranium-series dating to figure this out.[1] Trace
amounts of uranium are naturally present in limestone, and since
this type of rock dissolves easily on contact with water, when it

liquefies and flows down a cave wall, a little bit of uranium will also be deposited. Over time, the uranium starts to decay into radioactive by-products like thorium. This process happens at a constant rate, and because elements like thorium do not naturally occur in this situation, we can measure the amount of it in the sample and work our way backward to figure out how long it would have taken for this much to be produced from the uranium.

The disk was not the only image in El Castillo to produce astonishing results at this site. A nearby negative red-hand stencil was dated as being a minimum of 37,000 years old. Since the disk and the hand have the same coloring and were made using the same spit-painting technique, Pike and his team have proposed that they could in fact be the same age, and that the time difference might simply be the result of the hand not being covered up by calcite at the same time as the disk. Prior to this study, it was thought that the oldest art in this region was only about 28,000 years old. With this new set of dates, Spain went from being a latecomer on the scene (as compared with the early French cave art) to being considered one of the places where it all started in Europe.

It is really only within the past five to ten years that we have developed the ability to date art this way, and it has yielded a few surprises, such as the red disk. The ability to date the images accurately is central to nearly all aspects of rock art research. If we don't know how old any of it is, then we are just left with a collection of paintings and engravings without any sort of order and no clear way to identify related sites or changes over time.

Some of the first researchers in the field, including French priest and archaeologist Henri Breuil, recognized this major obstacle in the early 1900s. As this was still before the days of radiocarbon dating, they rather cleverly devised comparative methods for matching the art images found on portable objects in archaeological layers with the images on the walls. What they

were looking for were distinct features, like a particular way of shaping a horse's muzzle, or an unusual perspective being used to portray the horns on an aurochs. Many of these artistic styles were short-lived during the Ice Age, so their discovery on portable artifacts, such as stone plaques and ivory batons, opened up the door to creating a chronological order for the rock art as well. This ordering was accomplished by excavating sites with multiple archaeological layers. Older layers are found deeper underground, more recent ones closer to the surface, so if you can match up the rock art with the artifacts from different layers, you start to get an idea of the order in which these stylistic techniques appeared and were then displaced by new and different styles. These could then be compared with similar sequences at other archaeological sites for confirmation. In this way Breuil and others built up a stylistic time line for the Upper Paleolithic, so that even if they didn't know how old the art actually was, they at least knew, by comparison, which styles were older and which were newer. This technique is called stylistic dating.[2]

While portable art did turn up fairly often, stone tools were found more commonly, which makes sense since tools were being used on a daily basis. There were also identifiable characteristics in the tools found in different layers, so even before archaeologists had begun to put the art in a chronological order, they had already created a sequence for the tools themselves. The arctic village lifestyle of the people of Dolni Vestonice, with their mammoth bone architecture, ceramic kilns, and weaving, was probably radically different from that of the first human hunter-gatherers to make their homes in the entrances of caves in the Swabian region of Germany. And both of these would have been quite different from the lifestyles of the societies forced to live in close proximity to each other in southern refuge areas of Europe during the height of the cold of the last glacial advance. Breuil and his colleagues

realized that since particular types of tools tended to appear together in layers with specific styles of art, they could extend their stylistic time line to include rock art sites that had only yielded tools in their floor layers. They figured there was a good probability that the people who had entered the caves and made the rock art probably also left the tools behind. The chances of this being correct were of course vastly improved whenever evidence of paint-making (ochre pigment, grinding stones, etc.) was found in the layer alongside the tools.

The Ice Age period in Europe is subdivided into several cultural phases named after the different types of tools found in those archaeological layers. The addition of new kinds of stone blades along with further technological innovations and improvements seem to mirror changes in other parts of the toolmakers' lives. These cultural shifts often seemed to happen in response to changing glacial conditions as the people had to adapt their tools and other aspects of daily life to weather these changes. These differences are what early archaeologists have used to divide the 30,000-year span of the Ice Age into four main subdivisions that matched the changes in culture, technology, and social organization they could glean from the archaeological record: the Aurignacian, the Gravettian, the Solutrean, and the Magdalenian. These names have also been used to describe the different periods of Ice Age art. Let me quickly lay out the time lines associated with each.

The Aurignacian is the first stylistic period clearly associated with modern humans after their arrival in Europe, and it spans from approximately 28,000 to 40,000 years ago. It's also the earliest time period for which we have evidence of symbolic artifacts and rock art in Europe, the oldest examples dating right back to the beginning. The red disk at El Castillo and the ivory lion-man figurine from Hohlenstein-Stadel in Germany are both around 40,000 years old. Slightly later, between about 35,000 and 37,000

years ago, the Aurignacian period also includes the earliest examples of bone and ivory flutes, as well as the cave site of Chauvet, in France, with its stunningly beautiful and complex paintings.

The Gravettian is often called the "Golden Age" of the Upper Paleolithic, and it spans from about 22,000 to 28,000 years ago. In this period we see a lot of technological advances in toolmaking, as well as elaborate burial practices. There is also an increasing body of symbolic representations, though this phase is more commonly associated with portable art and figurines than with cave art. The artifacts found at sites like Dolni Vestonice are considered classic examples of the Gravettian culture group. Because of a steady decrease in temperature in the north, and a corresponding expansion of the Arctic ice sheets, a southward exodus from northwestern Europe starts to happen toward the end of the Gravettian period.

The Solutrean culture spans from 17,000 to 22,000 years ago and is associated with the Last Glacial Maximum. As groups were forced south, they began to congregate in sheltered temperate zones in southern parts of Europe. Many paleoanthropologists believe that this increase and frequency of intergroup contact might have been the catalyst for the "explosion of art" and the greater social complexity in the latter part of the Ice Age.[3] Cave art sites could have served a role in social integration during this period, acting as aggregation sites where rituals were performed. The dominant art style of this period is complex engraving, built upon the techniques derived from previous periods.

The Magdalenian is the last major stylistic division. Dating to between 11,000 and 17,000 years ago,[4] this period started when the Last Glacial Maximum finished and encompasses the final retreat of the ice sheets as well as the end of the Ice Age. This is the time when people begin to spread back across the landscape and move into new areas in Scandinavia and the British Isles that were

previously under ice. Around 75 percent of all known rock art sites were originally dated to this time period, though some have now been redated to earlier periods thanks to new dating methods.

The traditional stylistic time line tended to automatically categorize all the sites with skillful, well-executed art as being from the later part of the Ice Age, which may have potentially skewed the time line. This was based on the long-held belief that art was invented in Europe, leading to the assumption that it started out simply and grew more complex over time. However, with the discovery of sites like Chauvet, we now know that people were quite capable of great artistic achievement at a much earlier date, so it may turn out that the Magdalenian period does not account for quite as many sites as previously thought. A lot of incredible artwork definitely does date to this time period—like the bison on the ceiling of Altamira Cave in Spain, the collection of mammoths from the cave of Rouffignac in France, and the menagerie of animals adorning the walls at the French site of Niaux. By the end of the Magdalenian period, a time of drastic environmental change, the practice of making rock art had virtually disappeared. Perhaps as a new landscape emerged around them, the reasons these distant ancestors had for adorning the caves were no longer as relevant to their new lives.

The invention of radiocarbon dating in the 1950s opened the door to directly dating pieces of charcoal and other organic materials found in the archaeological layers, along with other artifacts. Many of these layers could now provide actual dates for when key artistic features appeared, a big improvement over the comparative time line ranging from oldest to newest. Considering the lack of data early archaeologists had to work with, they did a surprisingly good job of creating that initial stylistic framework, and quite a few of their deductions have proven to be right. Even today, with access to atomic dating techniques that allow us to

directly date certain images, this is still not an option at many sites where there are no black charcoal paintings or calcite covering the art for scientists to date. For these we have to continue to rely on the stylistic sequences to assess the age of the art, but with a higher likelihood of accuracy since we have reliably dated comparable sites—this is another form of stylistic dating.

Identifying chronological changes in the images, both in theme and technique, enables us to link specific styles with particular culture groups. The ability to sequence the art helps archaeologists reconstruct these ancient societies and measure the development of their symbolic behavior. So far I have only mentioned uranium-series dating and two types of stylistic dating, but there are others. Rather than listing off each of them,[5] I thought we might stroll through El Castillo Cave—where many of these dating techniques have been applied—and I'll tell you about the different methods as we go.

El Castillo is a massive Spanish cave complex with great echoing chambers and spiraling corridors. Since its discovery in 1903, it has been the subject of many different dating programs; the uranium-series dating of the red disk was only the most recent. Nestled in a part of Europe that remained temperate throughout the Ice Age, El Castillo Cave is located in a cone-shaped hill called Monte Castillo in the province of Cantabria in northern Spain. Monte Castillo is a major center of Paleolithic art and, along with El Castillo, contains three other important cave art sites: Las Chimeneas, La Pasiega, and Las Monedas, as well as a minorly decorated cave known as La Flecha. The entrances to all the caves are located in close proximity. The distinctive shape of Monte Castillo would have made it a natural landmark, and its location, where the low coastal plains start to rise into the mountain valleys of the interior, would have made it an ideal living site for hunter-gatherer groups. This strategic spot would have given

them access to the resources from both environments. This craggy mount is on the route that migrating animals would have taken each year to reach the high summer pastures, and the fish-laden Pas River flows by the base of the hill.

From the entrance to El Castillo, about two-thirds of the way up the eastern side of the rocky limestone rise, is a stunning view. As you face outward from the entrance, the rolling green flatlands of the broad valley floor spread out in front of you. The Pas River is a twisting ribbon of flashing blue with glints of sunlight reflecting off the water as it follows its age-old path from the southern mountains to the sea in the north. From here, the cave's inhabitants could have seen everything going on in their domain below. This probably explains why this entrance area was almost continuously occupied for the past 150,000 years.

Jutting out from the side of Monte Castillo, the entrance area is protected by a massive rock overhang, which would have provided a bright and airy rock shelter. Several large-scale excavations have been undertaken here, revealing more than twenty-five separate layers of occupation attributable either to modern humans or their Neanderthal cousins. The front section of El Castillo today has been enclosed in order to protect the site, and immediately inside is an ongoing archaeological project. A massive hole over sixty-five feet in depth is lined with several stories of scaffolding that researchers use to descend to the lowest levels of their dig. Parts of El Castillo are open to the public, and to enter you have to walk across a narrow set of modern stone-cut steps that run along the edge of the active site.

To make access easier, the Spanish government cut a new entrance into the cave at the back of the shelter, but if you know where to look, up on your left, you can still see where the original entrance is. Compared to the large dimensions of the rock shelter at its front, the original entrance to the interior cave section is

quite small, and its inhabitants would probably have had to go in one by one. After a brief walk, a narrow stone passage opens out into a large chamber with a high ceiling that's cathedral-like in its proportions. A wide-open space stretches out into the darkness in front of us, and we start to descend a long set of stone stairs to the cave floor far below. Immense sheets of undulating calcite parallel the stairs on our right and cascade down toward the base of the chamber. When we reach the first level of the cave, we see the initial series of ancient images.

Many of the walls in this extensive chamber are adorned with animal paintings and engravings, including a large red painting of a stag, a group of horses in black, several small but detailed engravings of female deer, and a beautiful black painting of a male aurochs. An aurochs is a prehistoric species of large wild cattle that roamed the landscape of Ice Age Europe. Researchers have used stylistic dating to place this image in the later part of the Ice Age period, probably the Magdalenian (11,000 to 17,000 years ago). No calcite flows cover the art in this area, and the black paint has faded to the point of being a colored stain without enough material left for dating purposes.

From here we follow another set of stairs to the left as it curls down and around a massive calcite formation that extends from ceiling to floor. As we come around the final corner and descend a little farther, another panel of images awaits us. We are now in a narrower passageway, but with a high ceiling at least twenty-five feet above our heads. The whole right wall of this section is decorated with animals and geometric signs and is known as the Polychrome (multicolored) Frieze. Here are the first of the many negative hands found on the walls throughout El Castillo. These particular hands are thought to be from the Aurignacian, just like their fellow calcite-covered negative hand from farther into the cave that was dated to 37,000 years old using the uranium-series technique.

Here also are the geometric signs in El Castillo, and there are some pretty intriguing ones in this panel. First, there is a red oval-shaped sign with an inward-oriented notch—it almost looks like a pie with a slice missing (see fig. 8 in insert). I was quite thrilled the first time I saw this sign as it is incredibly rare and appears only here, at another Spanish site called Tito Bustillo, and at two sites in the Lot region of France—it's one of those intriguing patterns that suggest long-distance cultural connections. There is also a faded red painting of a claviform (a thick curved line with a raised bump or point in the middle) that looks awfully similar to those found at a few other sites in northern Spain. A claviform from Altamira was dated using the uranium-series technique and is at least 35,000 years old. Using stylistic dating and the similarities between the two images, I would guess that this one may have been made around the same time. The claviform dating at Altamira is exciting because earlier time lines placed the first claviform at least 10,000 years later. But it may be that this specific sign originated in Cantabria and was then communicated to people at other sites.

In the top-right corner of the panel, up near ceiling level, is the outline of a large red horse that must have been painted while the artist balanced precariously on the calcite flow that slopes down in front of it. There is also a yellowy-red painting of the front part of a bison (the rear quarters are left to our imagination in the nat-ural shape of the wall). Several female red deer with ears pricked forward seem to prance along the rocky surface. Using a dating technique known as superpositioning, researchers have determined that the delicate red deer were painted over the older set of nega-tive hands, and must therefore have been painted more recently. It shows that more than one group of people made art at this site at different times, employing different themes and techniques.

There's yet another layer to this particular superpositioning example. Four black bison paintings range along the lower part of

this frieze, and two of them are superimposed on top of the deer. The paint used on the bison was charcoal-based and thus suitable for radiocarbon dating—which revealed them to be somewhere between 13,000 and 13,500 years old.

Much smaller sample sizes can now be carbon-tested, and radiocarbon dating has become the main method for directly dating cave art. It works in a way similar to the uranium-series dating but uses a radioactive version of carbon known as carbon 14. A small amount of this carbon isotope is constantly being produced when cosmic rays interact with nitrogen gas in our upper atmosphere. The resulting carbon 14 is then absorbed by plants as part of the photosynthesis process. When animals and humans consume plants directly, or eat other creatures which themselves eat plants, they are also ingesting this isotope. Carbon 14 decays quite quickly, but since the supply is continually being replenished, the amount in the systems of all living things remains fairly constant throughout their lifetime. It is only after death when plants and animals are no longer ingesting it that the ratio starts to change, and this is what we can measure. Unfortunately, unlike uranium, carbon 14 has a fairly short half-life (just over 5,000 years) and the amount in the sample is quickly reduced to minute traces, which is why dates over 40,000 years using the carbon-dating method are not generally considered reliable.

Chauvet Cave in the Ardèche region of France is one of the oldest sites ever to be directly dated using the carbon 14 method. More than eighty different samples were radiocarbon-dated there. While most are from hearths inside the cave (many of which appear to have been made specifically to create charcoal for their artistic undertakings) or from torch marks on the walls, researchers at Chauvet were also able to successfully date seven samples taken directly from charcoal drawings. The average age for the art turned out to be between 35,000 and 37,000 years old,[6] which

completely altered our perspective on how sophisticated Aurignacian art could be. In the case of El Castillo, the results for the black bison were surprising, not because of their age but due to their positioning on top of two older, separate sets of paintings. It's amazing to think that the art in El Castillo spans almost 30,000 years, and that at least three different groups of people ventured inside this cave to leave their mark.

As we continue down the set of stone stairs in front of the Polychrome Frieze, we soon arrive at the Gallery of Hands. Here is a profusion of red negative hands, some a vibrant red with fingers splayed out across the limestone wall, others only faintly visible through their thick covering of opalescent calcite. Here we find the two oldest images in all of Europe: the large red disk, and, nearby, the oldest red hand stencil. The lower part of this wall curves under at roughly shoulder height to become the ceiling of a side passage that runs behind and below the hands and carries on into a lower, narrower part of the cave. To the right is a small chamber—barely big enough for one person to stand hunched over, but the walls here are decorated with long, stacked rows of red dots and a series of red rectangular images known as Spanish tectiforms. (Note: these signs don't actually look much like the five-sided shapes for which the tectiform category is named, which is why they are often differentiated as "Spanish tectiforms.") Measuring anywhere from about twelve to thirty-six inches in width, all of these eye-catching rectangular images are split into three interior sections, many of which contain different designs (see fig. 9 in insert). Some paleoanthropologists have proposed that the tectiforms could be identity markers of some type for a family or clan. If so, it may indicate a local tradition, as this type of geometric sign is only found in northern Spain.

As we follow the passageway opposite the room full of Spanish tectiforms, we soon come to an even lower opening on the left,

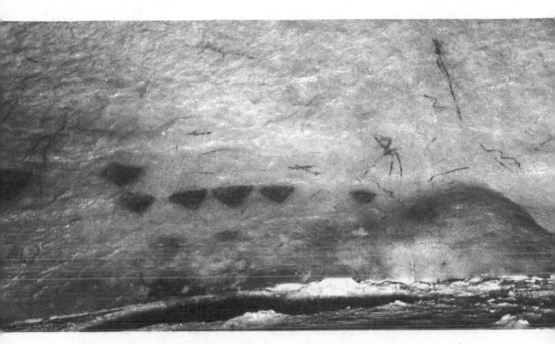

9.1. Panel of black triangles and human figures, Ojo Guareña, Spain. Using radio-carbon dating, these images have been directly dated to 11,000 years ago.
PHOTO BY D. VON PETZINGER.

which slopes down along narrow ridges of calcite toward another decorated chamber below. The floor here has not been leveled or shaped for the public, and small streams of water flow downward, creating little muddy pools between the calcite rows. Along the walls in this section are a sequence of female deer heads, engraved in exquisite detail, which provide us with another example of indirect dating. They are virtually identical in style and technique to a series of deer engraved on flat shoulder-blade bones that were found in one of the layers at the entrance to El Castillo. These bones have been dated to between 14,000 and 16,500 years old, so it's a good bet that the deer in this little passageway were carved by the same group of people, if not the same individual. So here we have proof of yet another period of artistic activity—El Castillo seems to have been a pretty busy place during the Ice Age.

We've now covered the main commonly used dating techniques for rock art, but no journey to El Castillo would be complete without venturing a little farther into this cave. Climbing back out of our muddy side passage, we can stand once again in the Gallery of Hands in front of the large collection of hands, disks, and complex signs, with the occasional superimposed yellow painted bison. The ceiling is high overhead, and dots and hands extend in both directions from the concentration of imagery on the curving wall in front of us. Here again, towering calcite formations glisten in the light, some almost looking like melting chandeliers as they droop down from the ceiling above.

If we turn left, we can climb up another set of stairs and carry on through several more stunning chambers adorned with ancient calcite flows and filled with dancing bison, leaping stags, and majestic aurochs, along with more negative hands and rows of red disks. This cave extends for over a thousand feet underground, and artistic evidence of early humans can be found throughout. Near the end of this level of the cave, a narrow gallery with massive columns of calcite extends downward from the forty-foot ceiling, several delicately enclosed ponds of still, clear water pooling at their base. Called the Gallery of the Disks, this long corridor has a row of red disks that runs the length of the right wall for fifty-five yards or more; they are duplicates of the oldest red disk that we passed on the way to get here (see fig. 3.1). These disks also date to the Aurignacian, though with dates centering around 35,000 years ago. While this just confirms what the disk and hand already told us, their depth within the cave is significant. For a long time it was thought that people from the Aurignacian only ever decorated cave entrances, or the very front sections of caves, and that it wasn't until the Magdalenian that people started to explore the depths of these sites. But here we find evidence to the contrary in the form of a long row of red disks extending deep into the heart of Monte Castillo.

With the announcement of those uranium-series dates for El Castillo in 2012, that simple red hand and its innocuous little circular neighbor suddenly became highly important. The date at which our early ancestors in Europe started to create rock art was pushed back an additional 4,000 years and, maybe even more important, the rock art was now dated to around the same time as when the first modern humans arrived on the continent. Rather than a practice that had developed slowly as these people settled in to their new home and expanded their artistic repertoire—the traditional view—now it seemed clear they had either invented rock art basically as soon as they arrived . . . or they had brought this skill with them.

I suspect that the 2014 dating of several rock art sites on the island of Sulawesi, in Indonesia, will help to answer this question. A series of red ochre paintings found there, including twelve negative hands and two paintings of local game animals, was dated using the same uranium-series technique that was used in Spain. Many of these images had a minimum age of over 35,000 years— and the oldest hand stencil dated to a minimum of 39,900 years old, making it almost the same age as the disk at El Castillo.[7] Paleoanthropologist Chris Stringer has predicted that we will likely discover even older examples of cave art, perhaps in mainland Asia, through which the artists' people would have migrated, and of course in Africa, where we all originated.[8] Based on the prevalence of negative hands among the oldest dated images we currently have, I would bet that any older examples we do find will probably include negative hands as well as painted dots or disks.

ᘜ

Of Animals and Humans and Strange Tableaux

t's mating season. A male deer extends his neck, raising his muzzle toward the sky. With nostrils flared and lips parted, he bellows out his challenge to the world. This is not a scene from a nature program; it's an ancient depiction of this familiar yearly ritual played out on a rock wall at an open-air site in Portugal. The amount of fine detail the artist was able to infuse into this engraving is incredible. This is not a rough approximation—each feature of the deer's head has been meticulously rendered, as has his behavior.

What's even more incredible is that this level of representational faithfulness in the depictions of animals is common throughout the Ice Age era. It's one of the reasons that researchers have been so fascinated with this category of art from the outset. Art is so closely associated with being human, and here was the proof that earlier human minds were already capable of a high level of accuracy and nuance in their artistic creations. These images, along with the figurines and the newly discovered animal paintings from Indonesia, remain the oldest representational art in the world. To date, no earlier examples have been found in Africa, so these detailed depictions almost seem to appear out of nowhere.

10.1. *Black horse painting, Cullalvera, Spain. Situated over three-quarters of a mile from the entrance and thought to date to about 14,000 years ago, this horse is a good example of the silhouette style of animal representation common during the Ice Age.* PHOTO BY D. VON PETZINGER.

While Paleolithic rock art is organized into three main categories—animals, humans, and geometric signs—what springs to mind first for most people are the spectacular animal images: the bulls of Altamira, the horses of Lascaux, the mammoths of Rouffignac, and the rhino and lion paintings at Chauvet. Animal imagery was of central importance to these artists. Large game animals dominate nearly all rock art sites in Europe, with the top prizes going to the depictions of horses and bison. These two species alone account for over 50 percent of all known animal portrayals. Their images are found in every region and time period, and artists continued to depict them even when the bones in the archaeological layers tell us that the people were eating other species, like deer and ibex.

1. Bas-relief reniform signs, Roc de Vézac, France. These two signs are unusual not only for their scarcity—they're found at only a handful of sites across Europe—but also because of the sculpturing technique used to create them. Their name means "kidney-shaped" in Latin, but their meaning is unknown (though some researchers have speculated that they might represent birds or butterflies). PHOTO BY D. VON PETZINGER.

2. A deer hiding in the wall, Salitre, Spain. Using new computer technology, it is now possible to find art that was previously too faint to identify. In Salitre Cave, the software was able to recover the head, antlers, and body (minus the legs) of a deer (bottom) where originally only a trace of red paint could be seen (top). PHOTO BY D. VON PETZINGER.

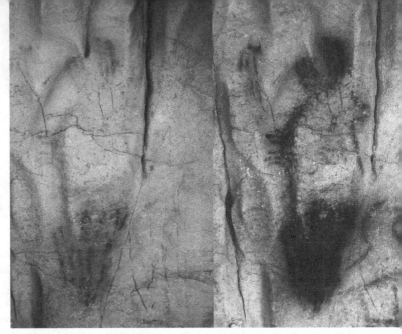

3. Original and enhanced views of possible female figure, Chufin, Spain. What looks to the naked eye like a fan of lines with some faint red markings above resolves into a more humanlike figure once the red paint has been enhanced. PHOTO BY D. VON PETZINGER.

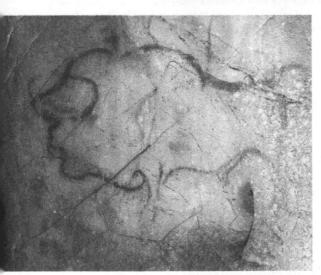

4. Purple bison, La Pasiega, Spain. While bison are commonly depicted in Ice Age art, the purple coloring of this one is unique. PHOTO BY D. VON PETZINGER.

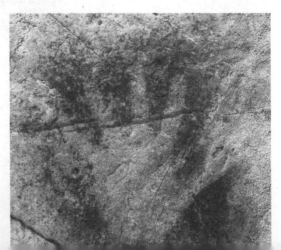

5. Red negative hand, El Castillo, Spain. Made using the spit-painting method, the smaller hand outlined in this photo may well have belonged to a female or adolescent artist. PHOTO BY D. VON PETZINGER.

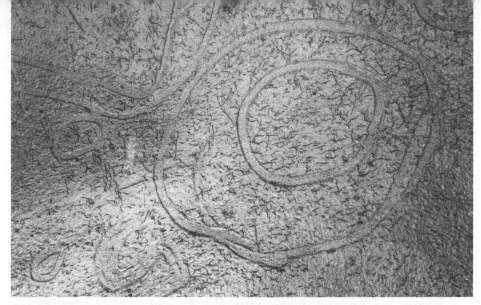

6. *Concentric circles made by finger fluting, Ojo Guareña, Spain. Created by dragging a finger through soft clay on a cave surface, finger flutings are found at sites across Europe; concentric circles, however, are very rare.* PHOTO BY D. VON PETZINGER.

7. *The oldest art in the world, El Castillo, Spain. At 40,800 years old, this modest red disk (visible in both its original form and an enhanced version) is currently the oldest known rock art in the world. Scalpel marks where dating samples were taken are also visible in this image.* PHOTO BY D. VON PETZINGER.

8. *Rare signs, El Castillo, Spain. These unusual reniform-type signs are found only at a handful of sites in northern Spain and southwestern France, suggesting that there may have been cultural connections between these two regions.* PHOTO BY D. VON PETZINGER.

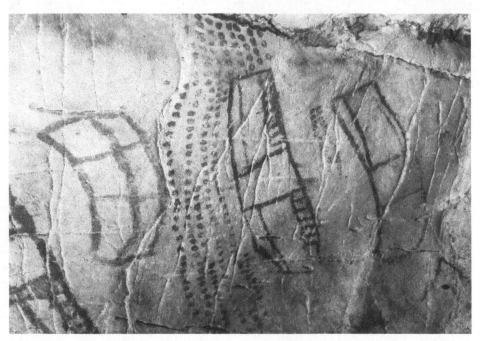

9. *Chamber of Spanish tectiforms, El Castillo, Spain. Made up of rectangular shapes usually divided into three sections with varying internal decoration, these distinctive signs are indigenous to a small region in northern Spain.* PHOTO BY D. VON PETZINGER.

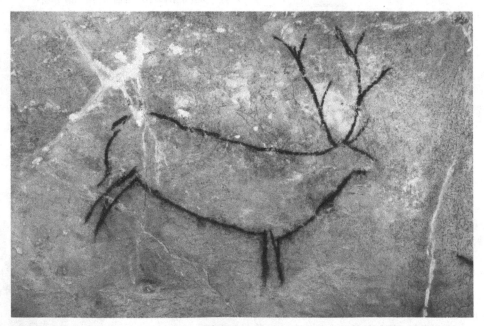

10. *Black deer, Las Chimeneas, Spain. While animal images are generally found in the main chambers of caves, here at Las Chimeneas the largest space is adorned with geometric signs; this deer is found in a narrow passageway hidden behind the chamber.* PHOTO BY D. VON PETZINGER.

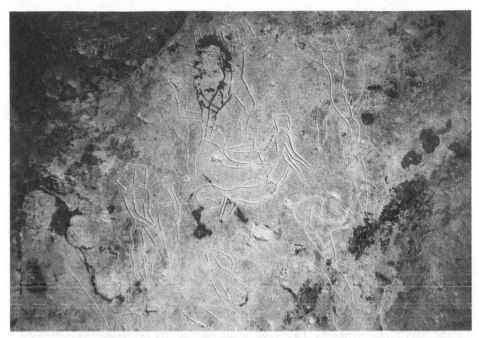

11. *Panel of human figures, Grotta dell'Addaura, Sicily. The naturalistic representation of the people visible in this image is very unusual in Ice Age art, and has led to speculation that this may be a depiction of an actual event or scene from the real world.* PHOTO BY D. VON PETZINGER.

12. *An outlier sign, El Castillo, Spain. This complex geometric sign is unique in Ice Age art, and is one of a small number of signs that do not fit into the thirty-two-sign typology.* PHOTO BY D. VON PETZINGER.

13. The "La Pasiega Inscription," La Pasiega, Spain. Dubbed "the Inscription" by researchers in the early twentieth century, this series of geometric signs is a unique occurrence in Ice Age art. PHOTO BY D. VON PETZINGER.

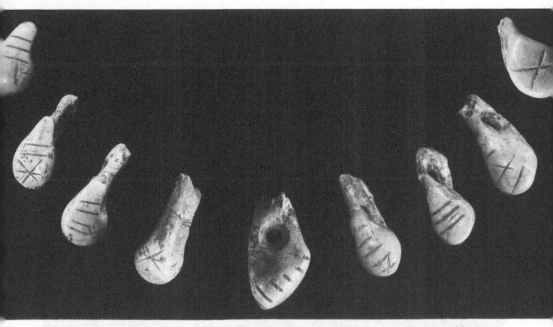

14. The St. Germain-la-Rivière teeth, France. These nine teeth are part of a collection of forty-eight deer teeth decorated with geometric signs. Found in a 16,000-year-old burial site in France, these artifacts are thought to have originally been part of a necklace included as grave goods. PHOTO BY D. VON PETZINGER, COLLECTION MNP LES EYZIES (FRANCE).

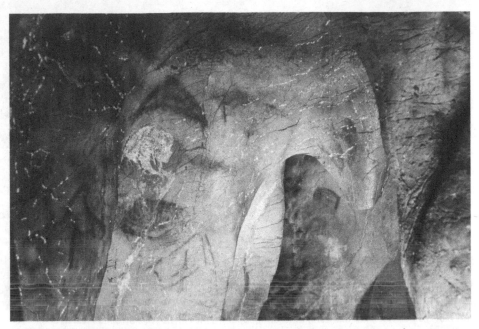

15. *Panel of red and purple signs, La Pasiega, Spain. As we find at so many sites, the geometric signs in this panel far outnumber the animal images; in fact, the only animal present is a red horse in the lower left. Rectangular grids, rows of dots, and aviforms adorn the calcite formations in this section of the cave, and while red paint was widely used throughout the Ice Age, purple pigment is much more unusual.* PHOTO BY D. VON PETZINGER.

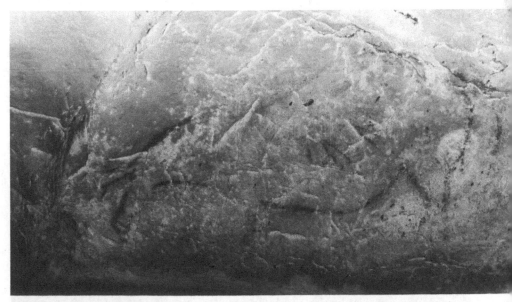

16. *Horse with "wounds," El Castillo, Spain. Could some of the geometric signs found on the sides of animals actually be figurative representations of hunting wounds?* PHOTO BY D. VON PETZINGER.

17. *Dots as possible path markers, El Castillo, Spain. This calcite formation is located deep within the cave of El Castillo, right at the point where the art drops down to a lower level of the cave. The lower passage is accessed by climbing over the edge behind the stalagmites on the right and descending a nearly vertical calcite flow to the floor more than ten feet below. Could the large red dots visible on several pillars of this formation have been left by ancient artists to mark the trail of art?* PHOTO BY D. VON PETZINGER.

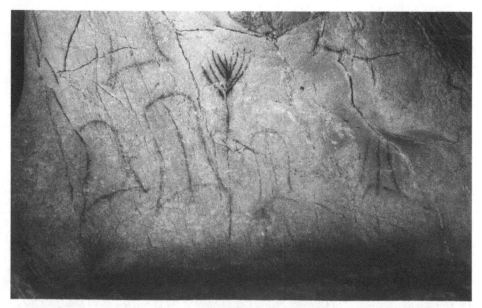

18. *Penniform or tree? El Castillo, Spain. This black penniform surrounded by five bell-shaped signs is one of a number of penniform signs currently classified as non-figurative, geometric images, but is it possible that in certain contexts these penniforms could represent trees and plants, or even projectile weapons?* PHOTO BY D. VON PETZINGER.

During the Aurignacian period (28,000 to 40,000 years ago) there was greater continuity between the cave walls and what was on the dinner menu, so these early horse and bison images could simply be representing important hunting animals whose capture was vital to the group's survival. Some scholars have speculated that they could be depictions of animals killed during a successful hunt (sort of like a prehistoric brag book), and in fact hunter-gatherer groups around the world often depict the animals they hunt. They may have served as learning tools for younger members of the tribe (though the counterargument to that is that they could see the same animals outside and learn about their anatomy from the source, so why bother drawing them in the caves?), or perhaps the creation of these images included a magical aspect that was supposed to guarantee success in the hunt. The disconnect between the animals they were depicting and the animals they were eating is most pronounced in later periods, notably the Magdalenian (11,000 to 17,000 years ago); and in some regions where bison and horse were being depicted, the environment wasn't even right for these species anymore and they would surely have been a rare sight on the landscape, hardly a diet staple.

Why, then, would they continue depicting animals they weren't eating and that weren't even a big part of the local scenery? One possible answer is that many of these tribes moved throughout the year to access different food resources, so maybe they were still seeing and hunting these animals at certain times of the year, then painting or engraving them on cave walls in a different part of their territory. Another explanation may be that these were no longer just images of animals and had taken on a more symbolic meaning as well (like a clan sign). Or it could even be that depicting the horse and bison had become such an entrenched part of their art-making tradition that they just kept on drawing them even though they were no longer around. Personally, I lean toward

a combination of the above—that they had taken on a more symbolic meaning and also had become part of an art-making tradition that involved more than just depicting animals killed.

Along with the bison and horse, several other animal species make regular appearances at rock art sites. Not surprisingly, all are also game animals, and they include aurochs (wild cattle), mammoths, deer (both red deer and reindeer; see fig. 10 in insert), and ibex (wild goat). While not as common, bears, lions, and woolly rhinos also turn up at quite a few sites. Most of the depictions of dangerous animals seem to come from the Aurignacian period,[1] so perhaps the first people to arrive in Europe took a special interest in them, while later cultures focused instead on game animals. Finally, the art contains a wide variety of animals that only appear on rare occasions, including land mammals like fox, wolf (no dogs yet, though domestication may have already been under way), musk ox, hare, and wild ass, and birds such as owls and waterfowl, and several fish—salmon, trout, and flatfish—and even a few depictions of seals.[2]

One of my all-time favorite rare animals is the single black painting of a rather lovely mink or weasel-like creature at the site of Réseau Clastres in France. I've often wondered what prompted the artist to include it. In a way, these types of images offer more insight into the minds of their creators than do the typical game-animal fare. Maybe he or she was feeling a little whimsical that day or getting a bit bored of drawing the usual bison or horse and decided to mix it up a bit? Or could it have been for the benefit of the children who seemed to frequent this site? Multiple little muddy footprints have been found in this cave, so yet another possibility is that one of the children was actually the artist in this case.

Along with astonishment at the fact that these images really are as good as anything a contemporary artist could create, another reason people might choose to focus on animal art could

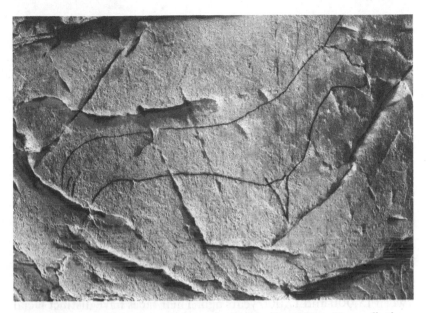

10.2. *When animal depictions go wrong, La Pasiega, Spain. Since it's usually the masterful images that make it into books, I thought it would be fun to share a bad one instead. No one is quite sure what this animal, looking like a cross between a dachshund and a unicorn, is supposed to be.* PHOTO BY D. VON PETZINGER.

be that these creatures seem more accessible (i.e., they represent something recognizable), unlike a mysterious rectangle or a row of dots, where it can be hard to know where to start.

While not nearly as common as their animal counterparts, human figures are another image type we easily recognize and can relate to. The voluptuous and often featureless "Venus" figures really only make up a small subclass. So far there are no confirmed depictions of children in Ice Age art, which is a significant omission, but we do have a fairly even distribution between male, female, and neutral human figures. Some of them are very stylized, sometimes with a focus on sexual characteristics, sometimes a detailed torso with little emphasis on the limbs or extremities. In some examples, the facial features are almost nonexistent, while in others, the artists appear to portray real people. As with the

figurines, some of them are wearing clothing: for example, a male figure from Angles-sur-l'Anglin in France, who may be wearing some type of fur collar. Many of these images have an almost caricatured look to them, though, with exaggerated noses or oversized eyes or jutting muzzle-like faces—what have been called "bestialized faces."[3] We find several of these at the site of Les Combarelles in France as well. (For some examples of human depictions, see figs. 6.2, 7.1, 7.2, and 9.1, as well as fig. 11 in insert.)

While not strictly rock art, a series of portable stone plaques found in archaeological layers at La Marche rock art site in France are the most accurate portrayals of people currently known. More than 150 separate engravings of humans on these plaques have emerged from this Magdalenian site, dating to somewhere between 15,000 and 17,000 years ago. Their faces have distinct facial features, men with beards, women with hair of varying lengths and styles, and many individuals wearing clothing. Even here, though, the faces seem a bit like caricatures. Were the artists portraying them like this on purpose, or were they just not very good at drawing human faces? This type of representation is restricted to this one site only, so we don't know the extent of this practice or why they were engraving all these people onto stone plaques in the first place. But it does provide us with a rare glimpse of how people may have looked back then, or at least how they saw themselves: the types of facial hair that men sported, and an idea of the clothing and jewelry (e.g., headdresses, shirts, bracelets) they wore.

Clear examples of animal-human hybrids are fairly rare in rock art. But then, so are all human representations. I would estimate that no more than 20 percent of rock art sites have any type of human imagery, and at some of these it's hard to distinguish whether an image is meant to be a person or if it's just a poorly drawn animal. Early human depictions also tend to appear alone—they may be near animals or signs, but we

don't find groups of people as we do in later rock art in Europe and elsewhere (e.g., village scenes, hunting scenes, etc.). Unless, that is, you travel to one of the farthest southern outposts of Europe—the island of Sicily.

It's July 2014, and Dillon and I are hiking up the northeastern slope of Monte Pellegrino in Sicily. The village of Addaura sprawls along the shore below, the clear azure Mediterranean Sea beyond. A hot, dusty breeze rustles the needles of the pine forest around us as we climb toward the bare limestone cliffs of the mountain's upper reaches. Nestled into the base of these rock walls is a series of shallow caves. Unlike the other regions I've visited, where the caves were formed by the passage of ancient underground rivers, these caves were carved out by ocean waves millions of years ago, when sea levels were much higher than they are at present.

We are here to see the engravings of Grotta dell'Addaura. Unique in Paleolithic art, these late Ice Age images form a complex composition with deer, horses, and aurochs around the margins and a group of seventeen human figures in the center. All the art is concentrated in one large section on the cave's left-hand wall, not far from the entrance. The panel is almost six feet high by just over three and a half feet wide, and the whole of it appears to have been created around the same time, if not in the same session, with thin, well-defined engraved lines. The human figures average about eight inches in height and have a surprisingly naturalistic feel to them.

While some of the same human conventions we see to the north are present—nude outlines without a lot of internal detail, nearly featureless faces, arms and legs that taper to points—there are also some important differences. For one thing, they actually look like real people—they are much more realistic in terms of physical proportioning and musculature. There is also a definite sense of movement in the panel. Most of the human depictions display some type of motion (walking, dancing, etc.), which, although

common to animal imagery, is very unusual for human portrayals. Rather than the typical stationary poses found at French and Spanish sites, this feels more like a snapshot of a moment in time. A female figure in the lower-right section seems to be walking with her back bent under the weight of what appears to be a large sack, while a neighboring male has been caught mid-step with one foot raised. Many of the figures also appear to be interacting with one another as though this panel was meant to represent a real-life scene, or the reenactment of a story. And it doesn't necessarily have a pleasant ending.

The main composition is made up of ten human figures—most without any identifiable sexual characteristics—loosely grouped around two horizontal males lying facedown with their backs arched (see fig. 11 in insert). Both have lines, interpreted as ropes, stretching from their shoulders to their legs, and one man's body is contorted with feet and legs bent back toward his head as though he's been hog-tied. The surrounding people are all in motion as if marching or dancing, several with arms raised, and at least four have what look like bird beaks extending from their otherwise blank faces. While these figures are sexually ambiguous, the two prone figures are very obviously male (both have clearly visible erections) and may be wearing phallic sheaths.[4] It's definitely a strange scene, and difficult to interpret. A nicer explanation is that the prone men are going through some sort of initiation rite. However, it is also equally possible that this is a depiction of captured enemies or human sacrifice.

The style and dynamic quality of the human figures at Grotta dell'Addaura are currently unique in European Paleolithic art. There's really nothing like this in the countries to the north, and the only other site in the vicinity with human representations is Levanzo, a cave about sixty miles to the west on an islet just off the coast of Sicily (but attached during the Ice Age). There, three human figures are depicted with square heads, blocky bodies, and irregular

limbs; but they're not as realistic or dynamic as the panel at Addaura. The animals at these two sites are quite similar in style, though, so perhaps the people of Grotta dell'Addaura just happened to have a very talented artist who was good at depicting humans. Another possibility is that at Addaura, a very late Paleolithic site dated at around 12,000 to 13,000 years ago, a new rock art tradition was being born. Dynamic human figures become more common in the Neolithic period after 10,000 years ago, and it could be that this site was one of the places where this style developed.

Another site, Grotta Romanelli, about four hundred miles to the northeast, on the heel of Italy's boot, has similar animals (engraved outlines of deer and aurochs) and dates to around 12,000 years ago. There are no clear representations of humans here (though there may be some very abstract, stylized female figures), but there are geometric signs. The thematic link weakens, however, as we move farther north. Of course, Sicily is now considered to be part of Europe, but that doesn't mean Ice Age people had those same close connections. Sicily was attached to mainland Italy during the Ice Age, so there may well have been an exchange of culture and ideas from north to south and vice versa, but these people may have also had ties to Africa.

Some of the sites in northern Italy seem to connect with those in France and Spain, but there's just not a lot in between to help us understand how people or ideas moved around this region during the Ice Age. Sicily and Italy may contain more rock art sites than are currently known, and hopefully more will emerge about this less-studied region in the coming years.

Today Sicily is just over 125 miles from Tunisia, and it may have been significantly closer when water from the Mediterranean was locked up in the Arctic ice sheets. The skillful human engravings from Addaura date to near the end of the Ice Age, and there happen to be naturalistic paintings and engravings of dancing figures from

around the same time or slightly later in both North Africa (e.g., Tassili n'Ajjer and the Hoggar Mountains in Algeria; the Cave of Swimmers in Egypt) and the Near East (e.g., Çatalhöyük in Turkey).[5] We don't currently have any definitive proof of an association with these southern artists, however; and as we refine the timing of these cultures and the thematic similarities across the southeastern Mediterranean, I'd say there's a definite chance that Sicilian art and culture were more closely connected to what was happening in northern Africa than with what was happening in Europe. These stylistic differences don't just apply to the human representations, either. As we will see in a moment, the geometric signs from Sicily are also quite unusual in their own way.

Patterns: Trading Signs and Sharing Symbols

From the time I first started planning my research project, Sicily was always at the top of my list. The fact that Sicily has Ice Age sites is not widely known, and less still is known about the contents of these caves. A handful of local scholars have identified and studied Paleolithic sites on this island, but not much has been published, either regionally or internationally.[1] Even most rock art researchers don't know a lot about these sites beyond the fact that a few exist. As Giuseppina Battaglia, the Sicilian government archaeologist we worked with, explained, in a region where a multitude of cultures—Phoenician, Greek, Roman, Vandal, Moorish, Crusader, and medieval—has left rich evidence of their presence, there's just not as much interest in earlier periods that lack grand architecture and artifacts. Prehistoric caves have to compete with the pristine Doric temple of Segesta in Trapani and the Norman Cathedral of Monreale.

Based on the very limited information I'd been able to glean from some maps of rock art sites along the northern coast near Palermo, a couple of articles in which Sicily was briefly mentioned, and a small number of site descriptions from Paolo Graziosi's 1960

book *Palaeolithic Art,* I requested access to seven caves. Giuseppina very kindly agreed, and I planned our two-and-a-half-week trip to Sicily accordingly. Once we arrived and met up with her, I discovered there were actually quite a few more rock art sites. Giuseppina hadn't thought to mention them in our e-mail correspondence, having assumed I only wanted to study the specific sites I'd requested, but once she understood I was interested in all Paleolithic sites with geometric images in Sicily, the floodgates opened.

Not only were there additional sites around Palermo, I found out about a series of recently identified rock art caves to the south in Argento and was introduced to a knowledgeable local schoolteacher from the neighboring district of Trapani who knew the location of a considerably greater number of sites than have ever been published for that area. I managed to squeeze in visits to five additional sites during our short time in this region, but even so, there are a lot more caves than the twelve we visited just waiting to be studied. I will definitely be going back, but in the meantime, let me tell you about what I've found so far.

The geometric signs at many of the Sicilian sites are almost as unusual as the human figures at Grotta dell'Addaura. Normally we find a variety of motifs in a range of locations within sites, but here the art is surprisingly restricted. All the abstract images are either right at the entrance or just inside the cave—in the daylight zone. On top of that, the majority of the signs are engraved lines and open angles—some alone, some in rows (parallel or angled), some in more complex groupings (stacked rows, overlapping signs, repeated patterning, etc.)—and all made with deeply incised lines. I found these at over half the sites I visited, and in many cases they were the only markings there. The placement and organization of such a limited number of signs makes for a very distinctive pattern. However, it's not unique.

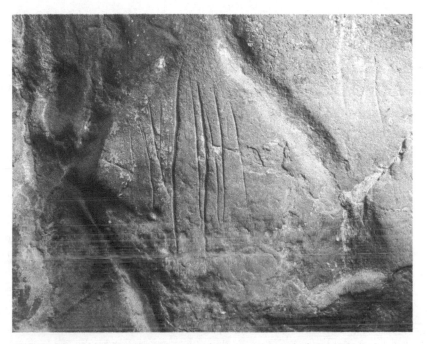

11.1. Engraved lines, Riparo di Za Minica, Sicily. This rock shelter is entirely decorated with linear motifs like the ones shown here—not a common occurrence during this era, and their meaning remains a mystery. PHOTO BY D. VON PETZINGER.

What struck me when I saw these signs at Riparo di Za Minica, as well as at six other caves, was how very much they looked like two groups of lines and open angles—also deeply incised—I'd seen the previous year just outside the entrance to Venta de la Perra, in northern Spain. While not an exact match, the amount this site has in common with those in Sicily in terms of theme, technique, and image location is a bit uncanny. Stranger still is the fact that Venta de la Perra is one of only two sites in Western Europe to have this type of engraved grouping at the cave threshold (the other is La Viña, farther west, in the province of Asturias), and both sites date to at least the Gravettian (22,000 to 28,000 years ago) if not earlier. Yet all Sicilian art is thought to be from the end

of the Ice Age. Grotta Romanelli—the mainland site with similar animals to Addaura's—also has a lot in common with many other Sicilian sites. Not only does it date to the same era (around 12,000 years ago), but it has the same type of engraved signs. Several pebbles excavated from the floor layer were incised with stacked and overlapping open angles or ladder-like patterns, and an abstract configuration made up of stacked rows of vertical and angled lines was found on a wall near the entrance.[2] But from there, the trail runs cold until we get to northern Spain.

Is it possible that there's a connection between these two regions, when almost 1,500 miles and at least 10,000 years separate them? It could be that some of the people living in Spain moved southward over time and eventually settled in Sicily and other parts of Italy, taking their signs with them. Alternatively, there may have been a widespread tradition of using abstract configurations as some sort of identity or ownership mark to let others know if a cave was "taken." But with exterior stone and cave entrances being the most likely to degrade over time, further examples located between these two points may have since vanished. Or they might only be related in the sense of having been produced by the same activity; some researchers have suggested these markings may just be the result of people sharpening their stone tools by running them up and down the walls. To my mind, a lot of the abstract groupings look a bit too organized to have just been the end product of people sharpening tools; but without more data, it's hard to make an educated guess. The patterns of other signs in different regions are clearer, and I have at least some insight into what may have been happening there.

Animal and human imagery are both categorized as figurative art—art based on objects or entities found in the real world, where the images are considered to be representational, at least to some degree, of how these things really look. By contrast, the

signs are usually classified as being non-figurative, and have tradi-
tionally been interpreted as abstract markings that do not imme-
diately seem to correspond to anything in the mundane world. As
you'll see, I'm here to disagree about that, at least in part.

The more time I spend working with the signs, the more con-
vinced I become that there are in fact several different types of im-
agery all packed together into this convenient catchall. For the past
century, the geometric sign category has pretty much been the dump-
ing ground for all unidentifiable images and has usually been where
researchers have stuck things that weren't recognizable as either
animal or human. The result has been a massive grouping of differ-
ently shaped images that may or may not have anything in common
other than the fact that they are all thought to be non-figurative.
But there could potentially be several different types of motifs rep-
resented within this grouping. Before I get to my theories, though, I
need to familiarize you with the geometric signs themselves.

First some background. The geometric signs are found at nearly
all Ice Age rock art sites in Europe, and in many cases outnumber
the animal and human representations by a ratio of at least two
to one.[3] Considering that thousands of geometric signs have been
found among all the sites, it's interesting that they have received so
much less attention and study than their figurative counterparts.

For a long time it was thought that the animal representations
were the central element of the art, in part because these ancient
hunter-gatherer groups hunted many of the animals they depicted.
Some early scholars were uncertain as to whether the signs were
even purposeful, let alone meaningful. The early French archae-
ologist Henri Breuil considered many of them to be "parasitic
lines" marring his nice animal images and didn't even bother to
include them in his inventories or in the many sketches he made
of the animal and human figures. Others acknowledged their ex-
istence but saw them as being either decorative embellishments to

complement the figurative images or just absentminded doodling. In the early 1960s, influential researcher André Leroi-Gourhan proposed a grand theory to explain most, if not all, of the art.[4] He divided the imagery, including the signs, into a unified binary system that classified everything at a given site as being either male or female. For Leroi-Gourhan, animal species such as horses represented the masculine, while bison had a feminine aspect; the signs were also divided into male (linear and angled) and female (rounded or curved) categories. This theory was widely accepted, and for the next three decades or so, most studies that included signs tended to approach them with this preconceived notion in mind. In general, though, researchers both past and present have felt that the abstract nature of the geometric signs made it difficult, if not impossible, to study them properly, resulting in a lack of knowledge about this intriguing type of imagery.

Until recently, the computer technology necessary to easily complete large-scale studies did not really exist. As a result, most twentieth-century work tended to focus on a single cave or several in the same area, making it difficult to look for broad patterning across multiple sites. But using current technology in the form of a relational database, geographic information, and a lot of time spent crawling around caves, I have been able to complete the first Europe-wide comparison of the signs. Some very intriguing patterns are starting to emerge.

The heaviest concentrations of Ice Age rock art sites currently known are all located in Western Europe. At present there are 170 sites in France, 133 in Spain, and 18 in Portugal, of which 2 are cave sites and the other 16 are open-air sites. Then there are 38 sites in Italy, with a heavy concentration in Sicily. A handful of sites that are not very well known also exists in Eastern Europe and the Balkans, including in Bosnia-Herzegovina, Romania, and Slovakia, and a new site that is the first to be identified in Serbia.[5]

(There are also rumored to be sites in Hungary and Bulgaria, but I have not yet been able to track down any information on them.) Even farther to the east, there is one site located in Russia's Ural mountain range. So, currently, we are talking about 368 rock art sites dating between 10,000 and 40,800 years ago. New sites are being found all the time, though, so this number will undoubtedly increase.

While there will always be a few outliers—signs that only make a single appearance—the vast majority of the signs fit into the typology (sign classification system) I created for my study (see fig. 12 in insert). Altogether there are thirty-two main sign types, each with its own distinct pattern of use. This is a surprisingly small number considering we are talking about an entire continent and a time span of 30,000 years. Keep in mind that when I first started compiling this typology back in 2007, there was no official list of European signs,[6] and I didn't even have a clear sense of how many there might be, as rock art researchers in different regions often used different names for the same shapes. For example, an aviform sign (the name comes from the Latin word for "bird-shaped") is also sometimes referred to as an accolade sign, named for the type of punctuation bracket it resembles ({), or even as a "Placard-type" sign in some French regions after the site (Placard) where several of these images are found.

Because I just never knew what I was going to find at a given site, I wasn't even able to finalize this typology until I had input the data from the last cave. But when I did, and the implications of this small number of signs really hit me, I got goose bumps on my arms. This much overlap in sign types is not an accident; these images were not random decorations dreamed up by individual artists. For there to be this much conformity and continuity between sites, I realized, our ancient ancestors had to have had a system in place. And the way to comprehend that system was through the patterns.

With such a limited number of geometric signs used across time and space, I didn't need to understand exactly what they meant to know that they were important and meaningful to the people who created them. The choices that Ice Age people made regarding what to portray at each site also points toward intentionality. No sign appears everywhere, not even the simple line sign (which is present at only 75 percent of sites). But the repetition of the same signs for so long suggests that, even as certain groups started to diverge culturally, they maintained many of the same graphic traditions. At different places and times, new signs were invented. Some spread out across the landscape, while others remained confined to a small region. But many of the older signs continued to be used alongside the new ones. At each site, people were obviously making a conscious decision about what they should incorporate into their composition. No sign was an automatic inclusion.

Let's return for a moment to those three research questions I laid out in the introduction:

1. Were the signs invented in Europe or are they the product of an even older tradition?
2. Do we find the same small group of signs appearing at sites throughout Europe, and what does this tell us about the movement of people and ideas during the Ice Age?
3. Were the signs in fact being used as a form of graphic communication, and if so, how can we prove this when we don't know what language (or languages) they spoke?

In a way, I have been formulating an answer to the first question since the second chapter of this book. Research out of Africa in recent decades has forced paleoanthropologists to reevaluate the old assumption that art was invented in Europe after the arrival of the first modern humans. It's pretty clear that modern humans

living in Africa prior to 60,000 years ago were already behaving in very modern ways: burying their dead, sometimes with simple grave goods; using ochre in a way suggestive of color symbolism; wearing pierced marine shells as jewelry; and, maybe most important, at least from my point of view, were making abstract marks on portable items like pieces of ochre and ostrich eggshell.

The results from my European database seem to support this idea of an earlier invention of this type of symbolic behavior. Twenty-one out of the thirty-two geometric sign types (65 percent) were already in use during the Aurignacian period, with many of them appearing at the very oldest sites. Even at this early date, the signs are already distributed across a wide geographic area, which is enlarged even further if we include some of the geometric markings on those ivory figurines and other portable art pieces from Germany. There is also a surprising degree of uniformity of signs at many of the oldest sites. Over and over again we see different combinations of lines, dots, open angles (chevrons), ovals, hands, cruciforms (crosses), quadrangles, triangles, and circles. This does not look like the start-up phase of a brand-new invention, but more like the distribution pattern of an artistic tradition with an older common point of origin—presumably from our ancestors' days on the African savannah. I'm not necessarily saying you can draw a line from Blombos or Diepkloof to the Aurignacian in Europe, as we don't know if there is any direct connection between these people and regions. But a symbolic tradition does appear to have arisen in Africa long before the first groups of migrants left to populate the Old World. This would also go a long way toward explaining the degree of commonality we see in the earliest art in far-flung places such as France, Spain, Indonesia, and Australia.

As time passed, some of the earlier shared signs fell out of use, while new ones were invented. This is the type of pattern you would expect to see if a single culture group, in this case the

first arrivals in Europe, spread out and developed along their own slightly different cultural lines as they adapted to a variety of climates and lifestyles (think: arctic village living in Dolni Vestonice versus the migratory hunter-gatherer lifestyle of the more temperate region of northern Spain). And, of course, without regular, continuous contact to maintain the shared traditions and culture, distinctions are bound to emerge.

Now let's look at some specific examples of the divergence of signs in action. The first sign category I want to discuss is the negative hands. While you could certainly argue that these images are figurative, since they resemble human hands, the way in which they are used suggests to me a more symbolic level of meaning. They may have just been used to signal that a particular person had been at a site ("I was here"), or a hand might have been a symbolic representation of a person or a group of people (using the concept of synecdoche, where the part represents the whole), or they may even have been some sort of early sign language. The early-sign-language theory is tied in to the fact that at some sites, different digits on the hands have been curled under to create various finger and thumb combinations. Many modern hunter-gatherers around the world have a hand sign language that they use to direct and coordinate others in a hunting party when they are too close to their prey to speak out loud. It's possible that some of the hands on the walls may have been examples of this practice: hunters leaving simple messages for each other. All of the above would give negative hands a more abstract function, which is why I include them in the sign category rather than with human representations.

As we saw earlier, negative hands are one of the oldest types of imagery in the world (in Europe and in Indonesia). They were never the most common of signs, appearing at only thirty-one rock art sites in France and Spain combined. What makes them very unusual is that they are most prevalent in the first half of the

Upper Paleolithic—the majority of them appear at Aurignacian and Gravettian sites. There are only eight possible examples of them appearing at more recent sites (i.e., later than 22,000 years ago), but the dating of almost all those sites remains fairly tenuously. By comparison, many of the older sites are quite well dated, with either direct dates from the hands (El Castillo) or other contemporary imagery (Chauvet), or taking into account nearby sites with direct dating that have very similar art. There is a definite trend of the hands being discontinued over time, and they vanished completely in Western Europe at the very latest by 13,000 years ago.

The tectiform is a sign type with a completely different history. The name comes from the Latin word for "roof-shaped," and the defining characteristics of this sign are a downward facing open-angle sign (like a peaked roof), with an interior vertical line that connects the "roof" with a horizontal base line (see fig. 11.2). Some early researchers interpreted it as representing a dwelling or some sort of animal trap, and the name comes from those proposed interpretations.[7] While the meaning is no longer so certain, this remains the widely accepted name.

What makes the tectiform sign so unusual is a combination of its late invention and the small territory in which it is found. Tectiforms occur only during part of the Magdalenian period— between 11,000 and 17,000 years ago—and other than one exception, which I'll discuss momentarily, they appear exclusively in the Dordogne region of France. This sign type is only found at nine sites in total, eight of them in the general vicinity of the modern town of Les Eyzies-de-Tayac. The tight grouping of these sites makes it seem fairly apparent that this was a localized invention, and unlike most signs, which seem to start out in one location and then spread from there, this sign appears to have belonged specifically to the people living in this area. There were sites inhabited by other groups of people in neighboring regions at that time, yet we

11.2. Tectiform, Bernifal, France. Created using rows of dots, this tectiform (Latin for "roof-shaped") is located at one of only nine sites in the whole of Europe to contain this sign. PHOTO BY D. VON PETZINGER.

don't find tectiforms at any of their rock art sites. The restricted use of the tectiform could mean that it was some sort of clan sign or other marker of a specific group's identity, and it may have been that no one else was allowed to use it.

Here's where it gets particularly intriguing. The only other site with a tectiform is across the Pyrenees Mountains at a site called Fuente del Trucho, in the Huesca province of Spain.[8] I haven't personally visited this site, but I've seen photos of some of the tectiforms there and have discussed them with the site's principal archaeologist, Sergio Ripoll. They really do seem like a match, and one of them in particular is not only the same shape but even made in the same style, using rows of small red dots like one of the tectiforms from the French site of Bernifal (see above).

So how does an odd pattern like this occur? The shape of a tectiform is fairly specific, so the chance of unrelated people at an unrelated site independently inventing the same shape around the same time is fairly unlikely. There was likely some sort of direct relationship between the people at Fuente del Trucho and those living in the Dordogne. It's possible that one or more of the people from the Dordogne region moved to that area and took the tectiform with them as part of their sign repertoire, possibly through intermarriage. The Fuente del Trucho tectiforms may actually be older than their French counterparts[9] (though this assessment is not based on any direct dating at this time), so it's also entirely possible that the first tectiform was created at that site in Spain, and that one or more of those people took it with them when they moved north, into the Dordogne. The sign could have been transferred as a result of intermarriage, or it could be that some of the people living in Spain moved up to the temperate Dordogne Valley to escape the Last Glacial Maximum—there was a glacier sitting atop the Pyrenees at that time, and their site may have become uninhabitable as temperatures cooled and the ice sheets expanded. Another possibility is that there were two groups of people, one in Spain and one in France, with knowledge of the tectiform sign having been disseminated along a trade network that passed through both of these regions.

Fuente del Trucho is just over 250 miles away, as the crow flies, from the tectiform sites in the Dordogne. While this was a fairly large distance then, especially with a mountain range in the way, trade networks between France and Spain did exist at this time.[10] People had two main focuses when it came to Ice Age trading. The first was an ongoing need for high-quality stone material. Because people had begun to make microblades and other finely honed tools, the quality of the stone they were using made

a big difference. Since good stone is not evenly distributed, having trading partners who could provide you with good material would have been much more expedient than having to travel long distances to find it for yourself. The second focus of Ice Age trading was in exotic goods. These traveled even farther than the stone: several marine shells found in Germany traveled over six hundred miles, originating in the French Mediterranean. This probably wasn't all done in one leg, and the shells may have passed through several sets of hands. Other regularly traded exotic goods include obsidian, amber, and animal's teeth.

Along with trading physical items, these networks would also have acted as conduits for information, both practical and cultural. Not long after the microblade design showed up for the first time, information about it seems to have traveled with astonishing speed across Europe; soon, almost everyone had added this particular stone implement to their tool kit. The fastest and most efficient way for this to happen would have been through a social network. If these trade partners were already exchanging practical information, they could also have been sharing cultural knowledge and practices. While some of the signs may have just been moving around as their original creators wandered across the landscape, in other instances information may also have been shared along the network. Let's look at the penniform sign now, as it is a good potential example of this process.

The name penniform derives from the Latin term meaning "feather" or "plume-shaped." Like the tectiform, the penniform was a later invention, but its movement follows a more conventional pattern. The oldest known depiction of a penniform is at the site of Grande Grotte d'Arcy-sur-Cure in northern France and most likely dates to the cusp between the Aurignacian and the Gravettian periods—so, probably around 28,000 to 30,000 years ago.

Right around the same time, it also appeared at another northern site called Mayenne-Sciences, located a little farther west.

From there, it begins to spread out, moving south into both eastern and western regions of France, before spreading even farther west into northern Spain. By the time of the Magdalenian period (11,000 to 17,000 years ago), the penniform regularly shows up at sites in France (almost 60 percent of known sites), has a strong presence in Spain (30 percent of sites), and toward the end of the Ice Age even made its way into Portugal. While the initial journey could be the result of its creators moving south as the weather worsened and the ice sheets spread, its broad distribution pattern in later times suggests that the sign moved along the trade networks that connected many of these regions.

Each geometric sign has its own distinct pattern that can be tracked. Following these trails has proven incredibly useful for discerning cultural connections between regions as well as for understanding how people and ideas were moving around the glacial landscape. These patterns may also confirm the presence of a developing graphic tradition, making the signs, as well as Ice Age art in general, a potentially important source of information for understanding the origins of graphic communication. In upcoming chapters, I will look at possible interpretations of the signs, but first we need to address two questions: (1) Are the signs a form of graphic communication? And, (2) What do we mean when we use that term? In some ways these are the most interesting questions of all, especially because they haven't been properly explored before in relation to these ancient images.

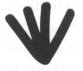

Chicken or Egg: A Brief History of Language, Brains, and Writing

I f you and I were to have a conversation, the words we spoke would vanish from existence as soon as they left our mouths (barring the use of transcription or recording). There is no permanence to spoken language. It is very much anchored in the moment, in the exchange, after which it becomes only a memory, one that we may or may not remember accurately, and even the memory will itself soon fade into oblivion.

For much of the world's history, this is how communication worked.

Whether you and I are discussing the meaning of life as we sit under the stars, or a lemur is warning the rest of its troupe in the jungles of Madagascar about an approaching danger, the ephemeral quality of verbal communication is pretty much the same. The parties involved need to be within hearing range, and once those thoughts have been shared or the warning call issued, the momentary sound of those utterances is gone.

There are substantial differences between human language and that of other living species, but in this one respect, virtually all forms of communication suffer from the same limitation. There

are viable alternatives to speech, such as hand signals, but whether language is being heard or seen, both are fleeting. The honeybee communication system that uses a combination of dance and odor to pass on messages is just as transient as sound. The bees need to be physically present to see the dance and smell the odor, and once the dancing bee has left and the odor has dissipated, the message has also disappeared. All are limited by their immediacy.

The first instance of making an intentional graphic mark was one of the most profoundly important moments in our species' history—right up there with the invention of tools, the control of fire, and the development of spoken language. Whatever this mark may have been, even if it was just a single line, doesn't matter. What matters is that, for the first time, someone purposefully made a mark on a physical surface with the intent to communicate meaning. That message had the power to survive beyond that specific place and moment, and language had officially taken on a life of its own—another life beyond that of its maker. The first mark still had an awfully long way to evolve in order to become the variety of graphic communication systems employed by people around the world today, but once that critical first step had been taken, its spread was inevitable.

Before we start talking about graphic communication in earnest, though, let's delve into spoken language a bit more, since it is, after all, the basis for its written counterpart. In many ways the origins of spoken language remain the murkiest of all the important developments from our distant past. Tools can be examined, hearths containing ancient fires can be excavated, and intact graphical marks that have survived on various surfaces can be identified—all these innovations leave behind some physical evidence for us to study. But the ephemeral nature of speech means that we have nothing physical to excavate or examine, and no way to directly prove its existence. Luckily for us, paleoanthropologists,

cognitive scientists, and evolutionary linguists have come up with several indirect ways to get at the question of its origins.

While speech is generated in the brain, and its end product is a sound with no footprint, there are biological components involved in speech that can be identified. First, we have the hyoid bone. This horseshoe-shaped bone is located in the throat below the chin, near the thyroid gland. It acts as an attachment point for muscles in the lower mouth, tongue, and larynx, as well as several other throat muscles. While most animals have a hyoid bone, only the human version is positioned in such a way that it allows the tongue and larynx to work together to create the complexity of sound that makes up our speech. The larynx is also positioned lower in the human throat than in other living species, which allows us to produce a greater range of sounds.

I say "living species," as there is a strong possibility that the hyoid bone was located in a similar position in Neanderthals. What makes it so tricky to tell for sure is that the small hyoid bone is the only bone in the body that is attached solely to soft tissue, so that as the body decomposes, the hyoid can easily shift positions, or disappear entirely. There are several instances where the hyoid bone has been found in approximately the right place in a Neanderthal burial, leading many paleoanthropologists to suspect that these close cousins of ours were also capable of speech. My personal belief is that they probably did have some form of verbal communication of their own.

Another biological component that we have identified as potentially providing clues to the origins of language is the FOXP2 gene. Many species have this particular gene, which is involved in the maintenance of the neural circuitry in the brain and other major organs. Our human version has two small but crucial differences in the amino acids, which seem specifically to affect speech and language. A damaged version of this gene can cause serious speech

impediments along with word-sequencing problems (called dyspraxia). Members of a British family studied in the late twentieth century who had a slightly mutated version suffered from severe speech disorders,[1] which led scientists to realize that the normal human manifestation of this gene is necessary for the existence of spoken language (though it is by no means the only gene involved).

Our version of the FOXP2 gene has also been identified in the Neanderthal genome. Its presence, along with the likelihood of the hyoid bone being the same shape and similarly positioned in both species, raises some interesting questions about whether these were inherited traits from our common ancestor, *Homo heidelbergensis*. And if they were, does that mean that *Homo heidelbergensis* also had the capacity for language? There have been some tentative identifications of hyoid bones in the right location within the skeletal remains of individuals dating back 300,000 years and possibly even further, which indicates that language was possible. We do not currently have the capability to sequence DNA that old, and so we don't know if the FOXP2 gene was present, but it may well be possible in the foreseeable future.

Scientists have also used endocasts—impressions of the inside of the braincase, usually made to study the structure of the brain in the fossilized skulls of ancestral hominins—to try to identify the presence and development of different regions of the brain that are associated with language. Since we can't see any of the internal structure, and even the external structure's fine details are usually lost, we can only get an overall idea of how much the brain was divided between the right and left hemispheres, and a general sense of how key areas in the frontal and temporal lobes changed over time.

The two main regions associated with language in the brain are Broca's area (in the frontal lobe) and Wernicke's area (in the temporal lobe, on the side, near the ear). The location within the lobe is always the same, but the side it is found on can be affected

Language Centers of the Brain

1. Broca's area
2. Wernicke's area
3. Geschwind's territory

12.1.

by whether the person is right- or left-handed (both areas are generally located in the dominant hemisphere of the brain, hence usually on the left side in right-handed people). Broca's area controls the production of speech as well as writing or manual signs, so you can think of it as the output part of the system. When people suffer damage to Broca's area, they still understand language but are not able to physically produce speech, gestural signs, or written words. Wernicke's area relates more to the input part of the process and seems to be involved in language comprehension, especially in ordering words, vocabulary, and overall linguistic structure.

One other part of the brain that is significantly involved in language is known as Geschwind's territory, located in the parietal lobe, near Wernicke's area but higher up on the side of the brain. This area seems to be responsible for the identification and subsequent sorting of incoming words, whether written or

spoken, into their appropriate categories, so that it appears to also play an important role in language comprehension and in the classification of individual words.

Because the regions associated with language are mainly internal, identifying them on a fossil-skull endocast is difficult. The best indicator is Broca's area in the frontal lobe. In earlier hominin species, the location of Broca's area is constricted, without the telltale bulge we see in modern human brains, suggesting that this region had not yet developed all the functions associated with language. It is larger in *Homo erectus*, and from there continues to gradually expand until it reaches modern human proportions. We don't know what the critical mass was for Broca's area to start generating spoken language, but the endocasts do point to this area already being fairly developed by the time we get to *Homo heidelbergensis*. Being able to track the growth of one of the key areas in the brain necessary for language so far indicates that language could have existed prior to the appearance of the first modern humans in Africa. Some Neanderthal endocasts exhibit a Broca's area similar in size and shape to our own, though it's impossible to say if it had acquired the modern functionality necessary for language production.

The 400,000-year-old burials from Sima de los Huesos in Spain, the color-specific selection of ochre from Twin Rivers in Zambia dating to at least 260,000 years ago, and the 230,000-year-old purposefully engraved markings on the Berekhat Ram figurine all occurred within the time frame of *Homo heidelbergensis*. Their existence suggests the presence of an evolving repertoire of symbolism, something that is a definite prerequisite for language. Yet all of them could have been carried out without language (though less easily), leaving us with no real proof one way or the other. To me, however, the archaeology does suggest that some type of communication system was already in place.

The mystery surrounding the origins of language is not just one of timing, but also a question of what prompted it to evolve in the first place. A number of linguists and paleoanthropologists have come up with different theories to explain this process, including gradual evolution from simpler verbal communication systems,[2] a sudden gene mutation that unlocked the capacity for speech,[3] greater ease in teaching complex processes like toolmaking,[4] gossip evolving as a way to maintain social ties within a group,[5] and even that the first spoken language may have developed between mothers and their infants and then expanded from there.[6] Many other theories have been proposed, and it's possible that the mechanisms behind several of these proposals may each have played a role in the emergence of language.

One of the reasons it's so hard to figure out what influenced the invention of the first language is that, unlike the first tool or the first fire, where a single instance would have been useful on its own and could have led to the creation of more, one word by itself was probably not enough to get things going. You needed at least two people to be involved, or else no communication could even have taken place; and then by some means, without the use of any language, since they hadn't invented it yet, they had to reach a consensus as to what that particular first word sounded like and meant. Conversations from a one-word language would have been awfully brief and repetitive, and assuming that, like other species, they already had a good communication system of danger, food, and social calls (e.g., personal identification, friendliness), it's hard to envision a situation where a single word—or even a few—would have been beneficial enough on its own to encourage people to keep going. I like linguist Derek Bickerton's challenge: he asks us to try to think of a set of ten words or fewer that would have actually been useful on their own. Try doing it and you'll see how hard it is.

But somehow, it happened. And once this new capacity spread, it must have been an extraordinary moment for those ancient ancestors. All the thoughts they'd had locked up in their heads could now be shared with those around them; they could discuss the past and plan for the future, and innovative ideas could be built up collaboratively to create unprecedented new ways of understanding and interacting with the world. The momentum achieved by this development would have been affected, to a degree, by how thoughts were structured inside their minds prior to the first external communication.

This area of research is known as the theory of mind, and it's another puzzle. Much has been written on this subject, but basically it's a chicken-or-egg question: Did the hominin brain first begin using language internally as a way to order and structure thoughts, and did this then set the scene for the later arrival of external communication? Or did the use of language between people drive a restructuring of the brain? Whether you think in words, ideas, or images, all these ways of organizing our thoughts have language at their base, and I have a hard time trying to imagine what it would be like to think without this underlying order. But obviously it is possible, since babies don't have language at first, yet they are able to think, learn, and develop a linguistic structure over time.

As with trying to imagine how earlier species, or even early *Homo sapiens*, may have perceived one another and the world around them, trying to imagine a mind without language is a near-impossible task for us. Given the lack of any direct evidence for either the timing or motivation for the origin of language, this has become one of the most challenging subjects in science today.

In the meantime, I personally lean toward *Homo heidelbergensis* having already developed some type of language—expressed either verbally or with hand signs—and to our own species and the Neanderthals having inherited this capacity from them. And I

feel fairly confident that by the time modern humans arrived on the scene around 200,000 years ago, language was present in some form. By the time we get to the first burials and oldest symbolic artifacts in Africa, around 100,000 to 120,000 years ago, I join my colleagues working in Africa in thinking we are probably dealing with people who had full syntactic language.

"Syntactic language" means that rather than just dealing with individual words or ideas, you have a framework in place that allows words to be strung together into longer sequences (i.e., sentences). For this to work, and for your sentences to convey meaning, you need to be able to combine different classes of words, such as nouns, verbs, adjectives, pronouns, etc. There is no other species alive today that can communicate with that level of linguistic complexity, but I would bet that our distant ancestors from those early African sites had already figured out most—if not all—of this. The reason why syntactic language and the geometric engravings are thought to support the presence of each other is because of the symbolic complexity required in each instance.

Another big difference between human speech and that of other species is that while other species may have developed a restricted vocabulary relating to a specific topic, our system is open. Our speech is not limited to categories like alarm calls or food calls, and one of the things that makes it so unique is its lack of constraints. We can endlessly recombine words to create new sentences, to talk about things that happened in the past or may happen in the future; we can make up stories, or poetry, and we can discuss imaginary worlds and supernatural beings that may not even exist. Basically, if you can think of something, you can probably articulate it, and if new words are needed, these can always be invented too. No other species' communication system even comes close to what sprang from the minds of our ancestors.

At its foundation, human language is symbolic. Other than those funny onomatopoeic words that try to imitate the sounds they represent (e.g., animal noises like "moo" or "quack"), the sounds denoting words in any given language are totally arbitrary. There is nothing inherently wet or fluid about the word *water* in English, or *eau* in French, or *agua* in Spanish, or *maa'* in Arabic—the specific sound is irrelevant; the only thing that matters is that the speakers of any given language agree that a particular group of vocal sounds refers to water. The individual sounds made within a language are basically a collection of symbols that have developed agreed-upon meanings. They exist within a system of communication that has definite rules and organization but which is also flexible and open.

When it comes to the arbitrariness of its characters and the necessity of agreed-upon meanings, graphic communication shares many of the same characteristics with its spoken counterpart. However, thanks to the durability of the markings it manifests, this form of communication has a much greater likelihood of leaving direct evidence in the archaeological record, giving us unusual insight into the development of this practice, and even into its potential origins. Was there writing in Ice Age Europe? Let's find out.

The "La Pasiega inscription" is probably one of the most unusual sequences of signs found anywhere in Paleolithic art. La Pasiega is part of the same mountain complex where we find El Castillo and several other important Ice Age sites, but even in this company, features like its grinding stone and purple bison make it unusual. And these pale in comparison to the strange row of signs situated high on a wall of their own, deep inside the complex, multileveled warren of passageways that make up La Pasiega. With the dark-red paint of the characters still standing out starkly from the pale, sloping wall, these abstract images are over twelve feet above floor level—the artist would have had to scramble up a steep, slippery incline to even create this series of signs.

What first struck me when I saw these images was how organized and purposeful they looked: they seem to be organized into three closely spaced units (see fig. 13 in insert). The most complex is on the left and consists of a pair of horizontal lines with the other markings extending upward vertically from this base. There is symmetry to the arrangement: in the center is a single line, flanked on either side by two stacked circles, with a pair of lines on each end. The center unit consists of two images that have been described as "stylized feet"[7] and are made up of oval shapes each topped with five short lines extending upward (kind of like the toes on a foot). And, finally, on the right is a single sign most easily described as a reversed capital E, but with two lines in the center instead of one. Henri Breuil described these markings as "cabalistic figures" after visiting La Pasiega in 1913, and was one of the first prehistorians to refer to it as an inscription. Whether these signs should be considered part of a writing system is something that continues to generate discussion and is really part of the larger question that I'm about to try to answer for you, namely:

"Is it writing?"

Without a doubt, this is the most frequent question I get asked about the signs. The first writing systems don't appear until long after the end of the Ice Age, and the origins of writing and the emergence of proto-writing systems aren't something a paleoanthropologist normally studies. On the one hand, I knew I wasn't dealing with a writing system like modern English or even ancient Egyptian hieroglyphs, but on the other hand, the patterns I was finding didn't seem accidental, either. I felt like I didn't have the vocabulary or a strong enough grounding in linguistics to really explain what I suspected I was seeing, so I delved into this material to help me better understand the processes involved in the invention and development of writing. After several years of study, while I'm by no means an expert in linguistics, at least

now I have the words to better explain what I think might have been going on with those early Paleolithic signs.

The idea that some of the signs are a form of writing was originally proposed back in the 1860s, when the first portable artifacts were excavated. Many of these items—ivory batons, stone plaques, bone and antler artifacts—had non-figurative markings on them, and early scholars proposed that these engraved motifs might be some form of undeciphered script. As Ice Age rock art was found in the following decades, the presence of geometric signs at many of these sites fueled the speculation, although this theory fell out of favor as linguistics expanded and more clearly defined what did and didn't constitute a writing system. Linguists still mention Paleolithic art on occasion as an example of what is *not* writing, and paleoanthropologists use borrowed linguistic terms to define the art (calling the abstract markings "signs" comes from linguistics[8]), but neither discipline has really explored the question of how we should classify Paleolithic imagery if it was meaningful but wasn't writing. Nor have they addressed the question I find the most interesting of all: Was the invention of later writing systems made possible by the development of symbol use during the Ice Age? Rather than assuming that writing appeared almost out of nowhere 5,000 to 6,000 years ago, can we trace its origins back to those ancient artists working 20,000 or more years earlier? I believe we can.

There are many ways to define writing, but at its most basic level, it's *a system of intercommunication based on the use of conventional visible marks produced on a durable surface.* In large measure this description could apply equally well to Ice Age art, so let's take a quick look at the different parts of the definition.

Much of the art from the Paleolithic was produced on durable surfaces (e.g., cave walls, pieces of bone and ivory), so in this respect, art and writing have a lot in common. Whether we're

talking about long-term durability (e.g., stone, bone, clay) or shorter term (e.g., wood, animal skin), the permanence of writing is one of its essential differences from spoken language. For speech to successfully transmit information, there must be someone present to receive the message. By contrast, writing requires only the writer to be present in the moment; the information being delivered can be accessed at will by one or more readers at a later time. Once it's been inscribed onto a durable surface, writing almost takes on a life of its own and can even end up far outlasting its creator and the original recipient(s) of the message. In the case of artifacts like cuneiform clay tablets—or Ice Age art, for that matter—the readers may end up being completely unintentional recipients, such as the twenty-first-century scholars who study these ancient texts.

Art and writing both also employ visible marks. Since art is a visual medium, not surprisingly all of the Ice Age imagery—both figurative and geometric—would be considered visible marks. The same applies to the characters that make up the different writing systems of the world, which come in three main varieties: alphabetic,[9] syllabic,[10] and logographic. Since all the oldest written languages in the world—Egyptian hieroglyphs,[11] Sumerian cuneiform,[12] the first Chinese script[13]—are based on the logographic model, let's explore this one a little further.

Logographic writing is based on units of meaning[14] rather than units of sound, such as we find in later alphabets. The reason why the characters convey meaning instead of sound is that many of the symbols found in these early systems started out as pictograms, which are basically stylized drawings of concrete objects, entities, concepts, or actions where the meaning of the character is derived from what it depicts. For example, in the original Chinese oracle bone script dating back over 5,000 years, the word *fish* is represented by a stylized pictogram of a fish. Over time, the fish

becomes more and more abstract until it's hardly recognizable as a fish anymore, but this new version of the fish character still retains its original meaning.

This shift from drawing miniature pictures to creating more efficient abstract signs that can be quickly replicated (as opposed to trying to draw a recognizable fish each time) is one of the indicators that we're dealing with an actual writing system. And this is where the conventional part of our writing definition comes into play.

Writing systems that rely heavily on pictograms are usually classified as being proto-writing. These pictographic symbols can be interpreted, but they are not being "read" in the same sense as writing is. In a proto-writing system, the signs are generally iconic (pictographic), restricted to a narrow topic (e.g., economic transactions, family genealogies, calendar/timekeeping) and only appear to have been accessible to a small number of readers (say to a single tribe or local culture, or even just to a few people within that group). Pictograms certainly do express meaning, but this is accomplished without them necessarily being too formalized. In other words, if I draw a fish with three lines down its back and you draw one with only two lines, both would probably be considered the same character in a proto-writing system. This doesn't work once an actual writing system has been created, by which time the number of lines on the fish's back would have become standardized. Often paired with early pictograms, accounting (numerical) marks are another class of sign that have come increasingly to our attention in recent years as a potential precursor to writing. Not surprisingly, this interest in trade and counting food stores seems to have carried over into the first writing systems as well, with each of them having large complements of numerical or notational abstract counting characters right from the beginning.

In many earlier graphic systems, there was a set of signs regularly used to record information about specific topics, but they didn't include all parts of speech and only represented the subject being recorded (e.g. oxen, wheat, numbers, names of months or seasons). This is not the same thing as a writing system, even an early one, which had moved beyond a few pictographs and counting marks to having characters to represent all the words in its language. One way the Sumerians accomplished this with their cuneiform script was by expanding the meaning of a pictographic symbol. For instance, a depiction of a star (represented by three intersecting lines that look a bit like an asterisk) originally just referred to that one type of celestial object, but this character was later expanded to also mean "sky," and later still to represent the word "god"—all concepts relating to the world above.[15]

The majority of scholars who study early writing would agree that it is the systematic representation of spoken language that differentiates actual writing from other types of visual and graphic representation. This requires the presence of not just isolated words but also the means with which to qualify and link them (pronouns, adjectives, adverbs, etc.). In a nutshell, then, having a writing system means that anything you can say verbally can also be represented graphically, and this is the conventionalization referred to in our definition of writing: *a system of intercommunication based on the use of conventional visible marks produced on a durable surface.*

The number of geometric signs that existed during the Ice Age and the way they were being used makes it extremely unlikely that they were meant to represent the full range of words that existed in the spoken language of the artists. So while these early humans had the durable surfaces and the visible marks required by our definition, what they appear to have been lacking is the conventionalization.

The first manifestations of writing usually seem to coincide with times of great societal change, similar to what we see at the end of the Ice Age. Many of the earliest versions of proto-writing, usually with vocabularies relating to trade and record-keeping, start to show up not long after 10,000 years ago. As the lifestyle shifted toward agriculture, certain graphic systems continued to develop—and in a few cases even conventionalize—as populations grew and people settled into a more urbanized way of life. Writing seems to be a useful tool for creating a collective understanding of the cultural, religious, and economic rules within a larger-scale hierarchal society, but this is not the type of society that existed during the Ice Age in Europe. So maybe part of the reason we don't see actual writing that far back isn't because they weren't cognitively capable, but rather because these hunter-gatherer people had no real need for it.

Pictograms, stylized drawings, and early examples of notation (abstract counting) are found on every continent and in very early prehistoric contexts, suggesting that the urge to visually represent and record extends far back beyond the first writing. I would even argue that the first glimmers of this practice may trace all the way back to those 80,000-to-100,000-year-old abstract markings from Africa, because it was there that the major cognitive leap was made. To us, it seems perfectly normal to connect a bunch of two-dimensional lines and squiggles with objects—entities and ideas from the three-dimensional world—but if you really think about it, they don't have much in common other than the fact that we've been taught that one represents the other. Take a fairly straightforward example, like a drawing of a bison. Most of the features that make it a bison—size, movement, smell, associated sounds, the texture of its fur, its rounded, muscular body, its unpleasant temperament—all are lost when it's reduced to a flat drawing. We don't think about

this because we've been taught from an early age how to "read" this type of image, but there is a high degree of symbolic interpretation required, even for figurative art.

Stylized and abstract markings take this even further, since they have little or no resemblance to what they represent. As an example, let's say, for the sake of argument, that those geometric markings from Blombos and Diepkloof in Africa do represent owner's marks. The individuals or families that the marks represent don't look anything like the crosshatchings, crosses, and other abstract engravings that we find; there is no direct link. Instead, the specific patterns have become associated with particular people or groups, and as long as everyone has been made aware of this and agrees with these associations, then anyone will know at a glance what piece of ochre or which ostrich-eggshell water carrier belonged to them. Obviously we don't know for sure why they were making those marks. Perhaps they hadn't quite reached that level of symbolism yet, but I'm convinced that by the time of the Ice Age in Europe, our ancestors were mentally there. Think about the level of cognitive complexity required to make those symbolic, associative leaps between abstract motifs and concrete things in the world around them. I believe this is what laid the foundation for all the different types of graphic communication that were to follow.

So in answer to the question "Is it writing?" I'm afraid the answer is no. However, I do feel confident that Ice Age rock art was meaningful to those who created it and did have communicative properties; it's just that no clear recording of language is evident yet. Does this make the sequence of signs at La Pasiega an accidental occurrence? I certainly don't think so. In fact, I lean in the opposite direction. My guess is that those particular abstract markings represent an early attempt to string multiple signs

together in order to create a more complex message. And while it does show that at least some Paleolithic people already understood the potential of combining signs, when it comes to the "writing question," the problem is that this row of geometric images was a highly unusual occurrence, not part of a flourishing system.

The question now, of course, is: If the signs were meaningful and meant to transmit information, then what exactly were they trying to say?

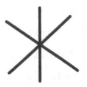

The Lady of St. Germain-la-Rivière and Her Mysterious Necklace

A long time ago a young woman died in a land that is now called France. The world of cold and tundra she lived in was very different from the Europe of today. Glaciers a mile high had crept down into northern France. By the time this woman died, nearly 16,000 years ago, the ice sheets were just starting to release their grip on the continent, but the Ice Age was far from over. From her animal-hide tent, before her death, this woman would have seen an arctic steppe of rolling plains interspersed with small stands of trees. The limestone cliffs of the region—which we know today as the Dordogne—would have stood out in stark relief. No verdant forests grew where they now soften the craggy profiles. But this land was fertile. Vast numbers of bison and mammoths roamed the steppes, herds of wild horses galloped across the plains, and reindeer nibbled at the ground cover. Hunting large game was essential to the people's survival, and the life of the tribe was regulated by the migrations of the herds and the changing of the seasons.

When she died she was only twenty-five years old. She was in good health, and no signs of violence or injury are identifiable on her

skeletal remains; the cause of her death remains a mystery. She was carefully buried in a grave dug near the back of a rock shelter whose entrance faced south on a hillside overlooking the Vézère River, which wound its way through her tribe's lands. She was arranged on her left side, her legs drawn up to her chest, and her right hand covering her head. Her head points east and her feet west. On the wall near her resting place, part of an engraved horse and a human figure are visible, both decorated with lines and angled markings.

The interior of her grave was stained with bright-red ochre pigment—whether from her body having been painted directly or from ochre being sprinkled into the burial—and grave goods were positioned both on and around her upper body. These funerary offerings included finely made stone tool blades, an engraving implement, two daggers made of deer antlers, some seashells, and what may have been food offerings. The stone tools seem to have been placed deliberately on her body, and the seashells may well have been affixed to her clothing, which has long since turned to dust. As a final parting gift, a highly unusual necklace was around her neck, made up of seventy-one deer teeth, all of them highly polished until they gleamed like pearls. Many of them had been inscribed with mysterious geometric signs.

After the tribe had arranged the woman and her grave goods and covered her with earth, they did a very uncommon thing for that time: they built her a tomb. Using four blocks of stone as pillars, they positioned two large slabs of rock over her burial place; they did not want her interment disturbed. Beneath the shadow of the rock shelter, they lit a bonfire atop her tomb. The flickering light from this testament to her passing would have been visible far out across the river and onto the sweeping steppes below. Using ceremonial items such as a bison skull and reindeer antlers, they completed her funerary rite, and sent her on to the afterlife. She

lay quietly in this resting place for many millennia, until French archaeologists found her remains in the 1930s and she became known as La Dame de St. Germain-la-Rivière.

It was her necklace that caught my attention. I got shivers down my spine the first time I read about it, and I knew instantly that I had to see it for myself. While quite a few necklaces and other pieces of jewelry from the European Ice Age have been found, a necklace with a large number of geometric signs as decoration is almost unique. It took me several years to organize the trip, but finally, on a cold January morning sixteen millennia after this young woman's demise, I found myself standing in front of her necklace at the Musée National de Préhistoire in Les Eyzies-de-Tayac.

La Dame and the majority of her grave goods now reside in this museum, which is roughly sixty miles from her original burial site. The village shadows the curve of the Vézère River on the valley floor, nestled into and surrounded by towering limestone cliffs. The rock is a warm yellow color streaked with gray, and is pockmarked with entrances to caves, many of which were inhabited during the Ice Age. Indeed, the surrounding countryside hides one of the greatest known concentrations of decorated caves from the Ice Age. Within these underground grottos, prancing horses, bristling bison, shaggy mammoths, and enigmatic geometric shapes adorn the walls. Here are some of the most famous rock art sites in the world—Lascaux, Font-de-Gaume, Pech-Merle—all centered in this one region.

I arrived in winter, and a light dusting of snow lay on the fields surrounding the village, and a cold wind ruffled the surface of the Vézère River. I got a strong sense of what it might have been like to live here so very long ago. At the height of the last Ice Age, all along the Dordogne and Vézère rivers, in valleys like this one, people took refuge from the frigid arctic winds. Protected by the limestone cliffs, these sheltered basins were a few degrees

warmer than elsewhere, in spite of the advancing ice sheets. While in warmer periods of the Ice Age, people had been scattered across most of the continent, by 20,000 years ago, the habitable areas had retracted to refuges such as this valley, which would have been alive with the sights, sounds, and smells of our ancestors.

The necklace I had traveled five thousand miles from Canada to see is on public display at the museum. With the stringing material having disintegrated long ago, each deer tooth now hangs from a little hook in neat rows in a darkened case, a spotlight bathing them in a gentle golden glow. The museum was closed to the public on the first day I was there, but I had arranged access as a researcher, and so stood alone in the quiet gloom of the empty gallery. Surrounded by the remnants of another time, I felt drawn to the glistening ornaments. Even though they were lit by a circle of light, they still seemed to want to protect their secret. The geometric signs were not visible from the angle at which the teeth were hung. I waited impatiently for the museum staff to open the case so that I could examine them closely.

Before learning of the necklace, I had been focusing on the abstract signs found in caves and rock shelters. But I had hit a blank wall (as it were) when it came to identifying compound signs (two or more signs used in conjunction to create a single, more complex, character). I'd noticed that certain signs often seemed to appear together at rock art sites, and at some sites the signs were found in larger groupings, or in rows. But I couldn't decide how to approach these configurations. Should I treat each line or shape (e.g., cross, triangle) as its own entity, or were there instances where the signs were made up of several separate elements? Was this necklace the missing piece of the puzzle I had been looking for?

To have such a large body of signs from one source provides a unique opportunity to document geometric configurations that were in use. Using the teeth as a guide, I might be able to get inside

the heads of the people making the signs. How were they dividing, structuring, and pairing them up? And, since deer teeth are quite small and not many signs could be engraved on any one tooth, the teeth with multiple markings might well be examples of compound signs. In all likelihood, I could also assume that the signs engraved on any given tooth were related to those engraved on the neighboring teeth. These configurations could then be compared with the signs at rock art sites, and all of this could provide important new insights into the way symbolic fluency was developing during the Upper Paleolithic period.

I'd read that many of the teeth had either a sign or multiple signs engraved on them, and almost none of the configurations of multiple signs repeated.[1] If the majority of the teeth bore signs that were unique, the markings were likely more than just decoration. Few necklaces are known from this time, especially any with such a large number of pieces; but if they were only decorative, you would expect to find matching teeth with the same markings, or repetitions at regular intervals to create a symmetrical pattern. This did not appear to be the case.

I was already sure that the signs were an important part of the graphic tradition of that time. If they were being used to convey information, it would be possible to say they were part of an early form of graphic communication. But where exactly were they on that spectrum between random markings and a full-blown writing system? Where might these non-figurative signs fit in?

The technicians arrived and gently removed each tooth from its hook in the display case and transferred them to a tray, laying them out carefully in rows. Then we took the tray to one of the archaeology labs in the Les Eyzies museum, where I could finally examine each one. Though I have been to many rock art sites and have handled many ancient artifacts, I never lose that sense of wonder at actually touching something that belonged to a fellow

human separated from me by tens of thousands of years. That connection with another individual across time is electrifying, almost mystical. And in this case I felt the added excitement of not knowing what signs I was going to find or whether they would provide the clue I'd been searching for. As I gently lifted up that first tooth in my gloved hand, the red ochre from the grave still clinging to it in places, I took a deep breath and turned it over. As my eyes focused on the clearly engraved signs on its side, I saw a row of three signs: two lines with a cross between them. I had seen this same exact configuration on a cave wall before—the tooth was a perfect match. I couldn't help but smile.

As I examined tooth after tooth, I kept finding matches for signs I had seen at rock art sites. Altogether, forty-eight of the teeth had geometric signs on them, and many were compound characters (see fig. 14 in insert). There was something almost surreal about the ease with which I was now able to identify potential composite signs after struggling with this aspect of my research for the past couple of years. Part of me couldn't quite believe this was happening.

My heart was pounding. Here, in front of me, I had evidence that not only were the necklace's creators *capable* of using more complex signs, but that they had begun using them at least 16,000 years ago. It would still take another 10,000-plus years for the Chinese, Egyptians, and Sumerians to develop actual writing, but this necklace provides yet more solid evidence that we can trace this practice back to its roots in the Ice Age. While La Dame de St. Germain-la-Rivière may have taken the actual meaning of the signs with her to her grave, her necklace can help identify the full range of signs used by her and her contemporaries.

Unfortunately, when the burial was first excavated in 1934, the sequence and placement of the teeth were not recorded, and with the stringing material long disintegrated, it does not appear

possible to reconstruct their original order (wouldn't that have been amazing?).[2] However, a recent physical examination of the teeth[3] has provided a great deal of interesting new data about the teeth themselves. First of all, the majority of the red deer canines come from adult males, and out of this large number of teeth, only five pairs have been identified—all the others are single teeth collected from different individuals. This suggests that their initial collection may have been spread out over the course of a number of hunts. Animal teeth are one of the exotic goods that were traded in the Ice Age, so I'm guessing they weren't cheap. I wonder what seventy-one teeth might actually have been "worth" within that economic system.

Which leads to the next intriguing discovery: the teeth do not appear to have originated in France. This burial took place during the Last Glacial Maximum, and at that time the Dordogne had a much colder climate than at other times during the Ice Age. An analysis of the animal remains found at contemporary sites in the region confirmed that only reindeer were present in the Dordogne during this period.[4] There were no red deer. The closest probable source of red deer teeth would have been northern Spain. Red deer did also live along the Mediterranean coast of France, but because there was a trading relationship between the Dordogne and northern Spain at this time, researchers have concluded that Spain was the more likely source. And this of course raises the question of whether the teeth were engraved before or after transport.

I was on the lookout for indications of the origins of the engravings while working more recently at sites in France and Spain. Guided by my database of Ice Age signs, I visited sites with potential matches in both regions, and I can now say with a fair degree of certainty that the signs were incised onto the teeth *after* they arrived in the Dordogne. In fact, following some of the

more unusual signs on the teeth—and there are some pretty rare ones—I believe I have tracked down the rock art sites that were directly associated with this woman and her people.

Before we get to that, though, let me tell you a little bit more about the signs on the teeth. On the forty-eight teeth with geometric markings, there are forty-five different signs or configurations. Only three groupings are repeated, with each appearing on two separate teeth. One pair of teeth is marked with a single cruciform; another set each has a pair of parallel lines; and the final pair has a row of three lines, spaced in the same manner. The rest of the teeth are distinct from one another, not necessarily based on the specific signs present, but in the spacing and the way the geometric markings have been ordered. So here, finally, eighty-plus years after the original discovery of the necklace, is a complete inventory of all the signs found on the teeth.

Now that this visual documentation exists, it has also been possible to divide the teeth into categories, based on the production of the markings (or lack thereof). This could show us whether more than one person was involved in producing the engravings, as well as whether they were made all at once or if some were made at different times. Of the forty-eight teeth with signs, forty have clear, deliberate markings, examples of which can be seen in fig. 13.1, while the other eight, though also deliberate, were engraved less precisely.

The "clear and deliberate" teeth are very similar to each other in style. Using microscopic analysis,[5] we can see that the incisions were made with a stone tool and that there was no hesitation or retouching of the lines. The person making them knew what he or she was going to engrave before ever putting tool to tooth. The eight teeth that fit into the "deliberate but less precise" category were also made with a stone tool, but in some cases lines were gone over more than once. All of the twenty-three unmarked teeth that were part of this ensemble were also polished and their roots

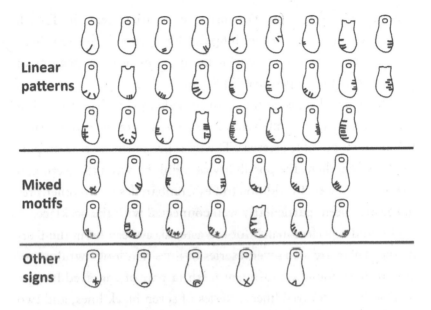

Linear patterns

Mixed motifs

Other signs

13.1. *Range of geometric markings found on the St. Germain-la-Rivière teeth.*
GENEVIEVE VON PETZINGER.

were drilled in a similar manner to the engraved ones. If the actual order of the teeth on the necklace were known, it would have been interesting to see if these unmarked teeth had acted as "breaks" or spacers between the teeth with markings.

So let's start connecting these teeth to the cave walls. Quite a few cave sites in the Dordogne that were being actively used during the Magdalenian period contain one or more of the signs from the teeth. Font-de-Gaume has a row of four lines partway in on the right wall and a series of five lines on the left. Commarque Cave, located under the foundations of an early medieval castle in the same vicinity, has several sets of paired lines and three cruciforms, including one with a line beside it. The main cave at Les Combarelles, Les Combarelles I, has a pair of engraved lines not far from the entrance and a row of four lines near the back of the cave. But rows of lines are by no means

exclusive to this region. For instance, Isturitz, near the French Pyrenees and the border with Spain, has a row of five red lines, and sequences of lines occur at many caves in other regions of France and at multiple caves in Spain.

The unusual signs on the teeth provide us with better proof of a connection. Les Combarelles I also has several engraved cruciforms and a possible asterisk. The presence of the asterisk in particular strengthens the possibility of a link between the teeth and the region's caves. In addition to Les Combarelles I, two other sites in the area seem particularly well connected with the necklace.

I found a perfect match for the asterisk at Bernifal in the Dordogne. There are also several series of lines that look awfully similar to those found on different teeth (a pair of engraved lines, a row of three engraved lines, a series of seven black lines, and two pairs of black lines next to each other). This cave is approximately ninety miles from St. Germain-la-Rivière, near Les Eyzies-de-Tayac, and it has been stylistically dated to the earlier part of the Magdalenian period, making it about the same age as the burial site. The entrance to Bernifal is tucked into the base of a craggy hillside, framed by dark-green moss and overhanging rock.

As with many French caves, Bernifal is privately owned. Having written ahead to request permission to enter the cave and study the art, it was exciting to finally pull into the gravel parking lot at the front of the traditional French farm property where the cave is located. To get to the site, we had to walk down a little path that winds past the landowner's fields and then up through a patch of forest that follows a spine of exposed limestone with cave entrances dotted along its length. Several have Ice Age art in them as well, and we had the chance to work in them too on this trip, though with a handful of crumbling animal engravings and several faded handprints, these sites were definitely not in the same category as Bernifal. It was summertime when we were there,

and the sun was shining through the leaves, dappling the ground with an ever-changing pattern of shadow and light. In the quiet of the forest, with no houses or major roads nearby, I felt as if I had stepped back in time; it was easy to imagine the cave artists making the same trek over 15,000 years earlier.

The entrance to Bernifal sits up near the crest of the ridge, and from there you can see the forest falling away below you, until it reaches a small stream at its base. The mouth of the cave itself looks like a dark-gray funnel descending at an angle deep into the earth. An old metal door, installed right into the rock long ago by the owner and his family, protects the cave from unwelcome visitors, with the result that unlike the slow transition you normally experience at caves as you move from the light into the dark, here, once that door clangs shut behind you, you are instantly plunged into darkness. You have to stoop a little to enter the site, but once through, the roof quickly starts to rise in the entrance passage before leveling out at around fifteen feet overhead in the first chamber. Bernifal is actually a fairly shallow cave, only extending about 250 feet into the hillside, but a rich and varied collection of rock art survives here. There are more than a hundred paintings and engravings at this site—everything from mammoths, bison, and horses to faded black negative handprints, engraved ovals, several tectiforms (including a bright-red one high up a wall farther into the cave), and a sign that looks a bit like the Greek omega character near the very back. Many of the signs, including that rare asterisk I'd come to find, are concentrated in a narrow section of the cave between the first and second chambers. As I stooped down to enter this passageway formed by a series of cascading calcite formations, I couldn't wait to finally see it in person.

The funny thing is that the asterisk was only mentioned vaguely in the site inventory and had simply been lumped in with the other engraved signs found in this constricted part of the cave. As I

crouched in front of a panel etched with an array of lines, ovals, and tectiforms, I had to search a little while before I saw my asterisk. Made up of three fine, intersecting lines, it was carved perfectly by itself into a depression in the wall. Its location made it challenging to photograph properly as it was incredibly difficult to get the light right so that the lines stood out, but thankfully Bernifal's owner was very patient with us, as it ended up taking two visits to finally capture this elusive sign properly on film for the first time.

When I first saw the asterisk, in my mind it felt like a piece of the puzzle had just clicked into place. I knew that Bernifal had to be connected somehow to the necklace and its owner. After all, there are only five sites in the whole of Ice Age Europe that have asterisk signs. Three are in the Dordogne (we'll get to the third in a moment), and the other two are in northern Spain— one engraved, one painted. The Spanish engraving has been dated to about 10,000 years older than the asterisk from the necklace, while the painted one is thought to date to the Neolithic, making it more recent than 10,000 years ago and unlikely to be directly related to La Dame's necklace. To find such a perfect replica in close proximity to the St. Germain-la-Rivière burial, especially when Bernifal is dated to the same period and contains a fair number of rows of lines matching those on the necklace, makes it a pretty good bet the two are connected.

Other than Bernifal, there was one other cave in the region that I'd also read had one asterisk, and I'd planned to go there as well during my time in the Dordogne. This is the cave of Gabillou, which is approximately forty-five miles from St. Germain-la-Rivière, so only half the distance of Bernifal. It has also been stylistically dated to between 13,000 and 17,000 years ago. Not only is this site closer to the burial, but the river L'Isle, near the cave's entrance, runs west through a valley right to the vicinity of the burial, where it joins with the larger Dordogne River. River

valleys often make natural pathways, strengthening the likelihood the two areas were connected at that time.

I'm sorry to say that I can't give you an eyewitness description of the cave itself or its surroundings, as I was unable to get permission to visit it. Many caves in France are still owned by private citizens, and Gabillou happens to be one of those. The owner is a lovely ninety-three-year-old lady, Mme. Gaussen, the widow of the only researcher ever to study this cave in detail. Understandably she is very protective of her late husband's legacy, and when I was in France in 2013, it looked like she was going to let me into the site (though we were still negotiating about photography), but then she fell and injured herself and the visit had to be canceled. It was a major disappointment, but luckily her husband had created detailed drawings of most of the site, so at least we have his sketches to work with. I remain hopeful that at some point I can get permission to document the signs myself.

Gabillou and the tooth necklace have so many signs in common that it really is hard to imagine there not being a link. It's the third site in the Dordogne containing an asterisk sign, along with Bernifal and Les Combarelles I. Its asterisk is also a perfect match for the ones found on the teeth. Its location is even more interesting: it is engraved in the middle of an arch at the entrance to a chamber inside the cave. On top of that, Gabillou has five different occurrences of the cruciform-line combination that appears on one of the teeth. This particular tooth also has a set of three lines, with a small degree of separation between the two groupings, so this could very well be an example of a tooth with two related signs on it. Engraved sets of three parallel lines occur in several locations within this cave as well, as do larger sets of lines, including ones that match the set of four, the set of five, and even the set of six from the St. Germain teeth. But if that seems impressive, I've saved the best for last.

On two of the necklace's teeth is a "pi" sign (see fig. 13.1). It turns out that Gabillou also has a pi sign engraved on one of its walls. You may have noticed that I don't currently have the pi sign in its own category in my typology, and that's because this is the only sign of its type anywhere in Europe (that I've found so far). I don't actually think this sign represents the mathematical concept of pi, but it does look the same and it's an easy way to refer to it. Strangely, this sign was not even listed on the official inventory for Gabillou, so I didn't know it existed until I found a drawing of it while I was at the museum. When I was there to photograph the necklace, I had the opportunity to see an out-of-print book written by Dr. Jean Gaussen in the 1960s about Gabillou.[6] It contained a sketch of a section of the site that includes a line drawing of a pi sign. This was the first time I even knew that this particular sign existed anywhere in a rock art site, even though I had just found pi on two different teeth from the necklace. The young woman from St. Germain-la-Rivière had to have known about Gabillou. Perhaps she was even one of the artists who worked at the site.

While the signs' meanings remain as elusive as ever, I do have some thoughts about what the function of these sign configurations could have been. Based on the type of signs being used, I believe the necklace may have been some sort of system of notation or mnemonic device (memory aid). The reason I say this is because rather than the necklace having a variety of signs such as we see more commonly in cave art, here the teeth are dominated by different numbers of lines in rows, something often seen with tally sticks. In a hunter-gatherer context, these sticks can be used for everything from recording animal kills to tracking seasonal events (say, a fall salmon run) or timing ceremonies. Another potential explanation is that these linear markings were a memory aid for an important narrative or ceremonial recitation, meaning that the

storyteller could use the teeth as a way to ensure that an oral story was recounted correctly, the major story elements being recalled via the markings on the teeth.

Granted, these are only guesses, but many such systems have been identified in the form of knotted cords, variably painted seashells, marked clay pebbles, and items such as tally sticks. While this doesn't directly help us understand the markings on the teeth, it does suggest that the Lady of St. Germain-la-Rivière and her contemporaries may have already begun to store information externally in the form of graphic marks for later retrieval—a highly abstract practice that is often closely related to the development of proto-writing systems.

Through the Eyes of the
Ancestors: A Rock Art Epiphany

Caves are mysterious, somehow separated from the real world. Even after exploring more than seventy different caves, I have never lost that feeling.

Even now, as I write this in my own home, I can see and feel what it's like to be at the entrance to a cave, waiting with anticipation to enter, to see what signs our ancestors left for each other—and possibly for us. I wonder if they thought about us, or about a time so far in the future. Did they imagine other worlds, in which people had powers not yet invented? Even today, we barely make projections past a few generations, and many people trace their own ancestry back only a few hundred years, perhaps twenty generations. It's hard to imagine our relatives six hundred generations ago, or six hundred generations into the future.

I want to take you to another place where very few have trodden since those Ice Age groups departed, leaving their haunting and mysterious imagery behind them.

In a limestone cliff, at a break in its stone face, partially obscured by grasses or bushes or trees that sway gently in the breeze, a dark entrance beckons beyond the sounds and sights of nature

going about its daily business. I step from the light of the world into the shadow of the rock, and I can feel the exhalation of the earth: wisps of cool air encircle me, the smell of damp soil and moss arises, and as I walk into the earth the sounds of the outside world recede. All that is left is the sound of my own breathing and a muted, intermittent dripping. But in the silence I feel a sense of expectancy.

As I wind my way deeper into this secret world, the last of the light of day fading behind me, I feel like I've crossed into a different realm, one governed by stone and silence and an all-pervasive sense of the great age of the earth. Time seems to move differently here, the passage of hours measured only by the occasional drop of water, falling, as it has, over millions of years, before our kind evolved, shaping stalactites and stalagmites that give each cave its unique personality.

The floor is always uneven. The need to watch for treacherous rocks or gaping holes means that I spend much of my journey looking down. The small pool of light from my lamp illuminates the path ahead, only touching the walls for brief moments until, suddenly, I get a glimpse of something, a flash of color or a shadow that is not of the earth's making.

I stop. The light travels back up the wall, revisiting the spot that caught my eye, and there it is: a red deer, or a black bison, or an engraved horse. Or, even more intriguing to me, a sign: an engraved triangle or a cloud of red dots or a black cross, its meaning obscure. Sometimes these images stand alone; sometimes they're part of a panel or section of the cave that has been decorated profusely.

In all cases, I feel a sense of awe. No matter how many caves I visit, that first moment when I stand in front of a wall decorated 10,000 or 20,000, or in some cases 40,000, years ago is always the same. It's the shock of realizing that I am standing inches from an image that was made by someone like me, in both appearance and thought, someone just as human as I am, but separated from

me by such depths of time that it's hard to truly comprehend. And yet this picture connects us. Time seems to contract, and in this dark, hushed underground realm, I feel closer to this ancient artist than I could anywhere else.

Always I'm filled with a burning desire to learn more about this individual: Who was he or she? What was her people's life like? What were her thoughts, her dreams? Standing where she stood, I can almost feel her presence. The feeling resonates deeply within me, a visceral response, as though somehow we are linked across the millennia. She lived in a time and place that is forever beyond my reach, but her images have given her a kind of immortality, offering a tantalizing glimpse into the minds that made this art. Even so, a definitive answer to the mystery of why these people journeyed deep into the earth remains outside our grasp.

While some cave art sites do seem to have been frequented fairly regularly, there is still a sense of separateness, of removal from the daily reality of life. Whether Ice Age people felt this, too, or if it's just our modern reaction to entering these dark, silent spaces, the location of these images has certainly affected how some scholars in the field have interpreted what the rock art could mean. Many of the earliest theories proposed that the animal images had a magical element to them, and this interpretation is still being pursued today. Whether the images were intended as sympathetic magic (e.g., the idea that the ritual depiction of the killing of an animal would increase the success of the hunt), rites of passage, the depiction of mythological creatures, or the representation of spirit animals seen in trance visions, most scholars see them as being more than just reproductions of actual animals the artists had observed.[1]

The same applies to the geometric signs. Even more than their animal counterparts, these non-figurative markings are abstract and enigmatic (see fig. 15 in insert). One common explanation is that they are the result of shamanic visions and were drawn in the caves

as part of the ritual process. Another interpretation with many sup-
porters is André Leroi-Gourhan's proposal that the signs represent
masculine and feminine aspects of the world (rounded signs = female;
angular signs = male) and that they were used in the caves to create
sanctuaries that reflected a balance between these two forces. This
theory has even been extended to include the animals, which are also
then thought to possess characteristics of one of the two sexes.

For over a century, any images that weren't easy to identify
as objects from the mundane world were identified as geometric
signs. This resulted in all sorts of interesting shapes and images
being classified into this category. But, really, how do we know
if signs like, say, dots, circles, rectangles, or zigzags do have any-
thing in common with each other? Even before I had embarked
on my current research I was already starting to feel that the geo-
metric sign category had become no more than a depot for un-
identified imagery. The signs didn't all seem to me to be intended
for the same purpose—they didn't necessarily share a theme. I
thought there might be several different possibilities, including:
stylized representations of real-world objects found in nature and
everyday life (e.g., plants, landscape features, tools); geometric
shapes that may in fact depict the manifestations of transcendent,
shamanistic-like experiences; and abstract non-figurative repre-
sentations that could carry a more symbolic meaning.

Context is important. Concealed in darkened chambers, far from
the light of day and from any possible inspirations for their forms,
the signs feel disconnected from the world and the mundane lives
of those who created them. But I wonder how much the location of
the art is affecting our understanding of why it was made. Caves are
not places we normally visit. For us they are dark and slightly dan-
gerous, set apart from our regular lives. But we don't know how our
distant ancestors felt about them. Were the caves just as mysterious
to them as they are to us, or did they see them in a totally different

way? While people during the Ice Age didn't normally live inside caves, they often lived in or near their entrances; the caves were, in a sense, their backyards. Could this familiarity have meant the caves were just part of the landscape for these people, or did they also feel that they were entrances to an underworld that was separate from the rest of their domain?

This question has huge implications for us when we try to put ourselves in their proverbial shoes and understand their motivation (or motivations) for creating the art. During the Ice Age, people were decorating other areas besides caves. We have evidence that rock shelters were decorated and a few very unusual examples of open-air rock art have survived to the present day. Could the caves be noteworthy simply for their state of preservation rather than for being special locations for art and other images?

This question led me on an interesting trip to the Côa Valley region of northeastern Portugal during my first field season to visit a series of open-air sites. All the photos I had seen of engravings there seemed to be of animals,[2] so I had e-mailed the head archaeologist and asked if there were any geometric signs as well. He confirmed that there were, so I knew I had to see them for myself. I had no idea how important this decision would turn out to be for me. This side trip, taken almost on a whim, ended up completely altering my perception of the art.

I was in the front passenger seat of a four-by-four as we wound down a narrow dirt track from the high plateau toward the Côa River far below. Its sparkling blue waters meandered through steep valleys as the late-spring sun shone down from a cloudless sky. Fields of yellow grass and low green brush covered the hillsides and swayed gently in a hot, dry breeze. Here and there the silver-gray leaves of a gnarled olive tree stood out from the sea of grass and bushes. Taller trees and clusters of wildflowers in red, white, and bright yellow grew along the edges of the Côa and its

tributaries, a vibrant contrast to the landscape's otherwise sub-
dued palette of colors. In the distance I can see the telltale signs
of modern human activity in terraced vineyards that zigzag down
the precipitous slopes.

The air has a Mediterranean clarity. With virtually no atmo-
spheric moisture to cloud the view, I can see all the way to the
Serra da Coroa Mountains, which separate Portugal and Spain.
My Portuguese colleagues point out the routes that were traveled
by our distant ancestors in and around this region.

I try to imagine this landscape without any human modifica-
tion: the same sort of dry climate, albeit a few degrees cooler; the
same vista of high rocky hilltops split by a series of winding rivers;
and an ecosystem with similar types of trees and ground cover. This
is the world early humans would have seen as they went about their
daily lives. Unlike most places in Europe, where the environment
has changed quite dramatically since the Ice Age, in this northeast-
ern corner of Portugal it is as though time has stood still.

Our four-by-four comes to a halt on a ridge overlooking the
valley floor. As the dust settles, we get out and start organizing our
gear for the hike ahead. A bubbling stream, a tributary of the Côa,
cuts through the valley below us, bordered by trees and lush water
plants. A chorus of cicadas serenades us with their rhythmic song.
Overhead a bird of prey rides a thermal, looking for movement in the
field of wildflowers we pass through as we approach the rock art.[3]

The circumstances that have led to the survival here—without
shelter—of rock art from the Ice Age are very unusual. There are
two main factors: the dry climate, virtually unchanged for mil-
lennia, which has protected the art from being scoured by wind
and rain, and the type of rock into which these ancient markings
were pecked and engraved. Early rock art in Europe is almost
always found on limestone surfaces, but there is no limestone in
this region, so the people used what they had at their disposal—a

much more durable type of metamorphic schist that has not crumbled or flaked the way limestone is prone to do.

As we work our way down to the banks of the brook in the warm sun, it feels almost surreal to think that at the end of this journey is art that has survived in the open for perhaps 25,000 years. Prior to this, all the sites I had visited had been caves where I was worried about being cold and wet. Even more, I was worried about getting our camera equipment wet. But now I'm wearing sunglasses, worrying about not having applied sunblock and wondering if I've brought enough water.

All these thoughts are forgotten as we follow the curve of the brook around a corner and step into an open grassy area at the base of a steep hillside. Standing with my back to the water, I see slabs of iron-brown stone jutting out from the slope. Ranging up the hill, they stand out like exclamation marks from the yellow and green foliage. The smooth faces of these rocks are etched with familiar imagery: on one panel is a bellowing deer, on another two aurochs face off, and yet another displays the fine details of a horse's head.

These are astoundingly similar in theme and technique to the images in what are often thought of as sacred places inside caves. Yet these are located in what is essentially the home base of the artists: remnants of a site where they lived were only a few hundred feet away. No doubt, this art was public and visible to all who lived in or visited this valley. When newly made, these images would have been even more eye-catching as the freshly carved markings would have stood out as starkly white against the dark rock before the passage of time concealed them behind a weathered patina.

My head is spinning with questions. Was this decoration of the natural landscape the Ice Age norm? Did other Paleolithic groups decorate their settlements, too? Was rock art an integral part of daily life, available to all, rather than an exceptional practice limited to a small group of special individuals? Could

both types of art have existed simultaneously, and were there differences between the public and the private?

As the noon sun blazes down, I follow my Portuguese colleagues up the side of the hill toward the first outcropping. We climb all the way to the top of the ridge, admiring the engraved animal imagery that has garnered most of the attention since the discovery of the Côa art in the 1990s and documenting geometric markings on the blocks of schist as we go. Then we work our way back down toward the river, photographing the last of the non-figurative images before we break for lunch. Each time we stop to study the signs I pause to glance around, trying to envision what these ancient artists would have seen as they looked out across this sweeping landscape. Art in the open air, art embedded in the natural world, feels very different from art shut off in the dark, quiet spaces of a cave. I am starting to wonder if all the signs are quite as abstract as we had supposed . . .

When we are nearly back down to level ground, we stop at a dark-brown slab of stone that reportedly has a single "meander" on it—a sign made up of a sinuous line or lines that curve across the stone without any clear intent or discernible shape. These markings have occasionally been identified at cave art sites in France and Spain, but lacking a clearly defined shape, they have generally been treated as decorative or unimportant.

I carefully pick my way across a mat of flattened dry grass that is as slick as ice; several times today, I've come close to losing my balance and sliding to the valley floor far below as we climbed up and down the near-vertical hillside. With my eyes down to find safe footing, I can't look up to view this meander until I am in position in front of the rock face for the first time. It is indeed a meander, but an unusual one. There are two quite distinct pairs of double lines that run one above the other horizontally across the face of the rock before converging into a single pair of parallel lines (see fig. 14.1).

Something about their contour seems familiar. I do a quick sketch of it as Dillon sets up the equipment to capture it on camera, and then, as I have done so many times that day, I turn to look out over the landscape, seeing what the artists would have seen.

From this height I can just see over the next hill to where the little brook below us converges with the larger Côa River beyond. I turn to Thierry Aubry, the head researcher for this archaeological park, and ask:

"Thierry, has anyone ever noticed that this meander looks like two rivers converging?"

To which he replies, "Actually yes, we wondered about that ourselves when we first found it."

"Has anyone followed up on this?"

"No, not yet. There's just so much work to be done that no one's had the time to pursue it further."

At the end of the day I could not wait to get home and look up the aerial maps of the terrain where we'd been. Based on the angle at which the sets of lines met, I found two definite candidates for them to represent converging rivers: the joining of the stream at the base of the meander's hill with the Côa River, and the nearby location where the Côa joins the larger Douro River. Both would make perfect sense to depict if the goal was to replicate an important geographic marker in the surrounding environment.

As I looked at the similarity of the rivers to the meander, I realized: this is what an epiphany feels like.

This meander may be only one of many geometric signs that turn out to be figurative after all. While it might seem self-evident that some of the markings labeled as non-figurative could actually represent everyday things, this is something no one has been able to prove. One of the biggest things we have been missing is context. Rock art researcher Paolo Graziosi summed up the sign conundrum very nicely in 1960 when he observed that the signs

14.1. *Abstract meander, or possible depiction of two converging rivers? Ribeira de Piscos, Portugal. This engraving from the Côa Valley is found on an open-air stone block on a hillside overlooking the Piscos River near its point of confluence with the Côa River.* CONVERTED PHOTO BY D. VON PETZINGER.

in the caves seem to "float in an atmosphere of pure symbolism or abstraction"[4]—thus obscuring their significance. As long as we only had caves to work with, most paleoanthropologists have been understandably hesitant to suggest a connection with the concrete, everyday world of sun and grass and trees.

But seeing the art in such a different setting changed everything for me; suddenly the abstract art didn't seem so disconnected. With the tentative identification of the meander sign as the convergence of two rivers, a whole new world of possibilities has opened up, and it all comes back to context. In Portugal, I stood in the same spot as the artists and looked out on the same vista that they would have seen and inhabited while creating these images. I really was able to perceive the world through the eyes of the ancestors.

A few different literal interpretations have been proposed over the years, but the geometric signs have continued to languish in their catchall abstract category, mostly because the data just did not exist to examine figurative possibilities. But I now have the data. With the insight gained from my Portuguese side trip, I have been able to revisit many of the geometric signs in the caves from a new perspective: Are some of them real-world objects represented in a stylized form? The meander in Portugal is a good place to start, but now it's time to examine a wider range of signs and different possibilities of meaning in this ongoing quest to make the abstract more concrete.

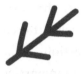

Feather or Weapon: The Real-World Meanings of Cave Signs

Many of today's researchers have come full circle in their ideas about Paleolithic art. Researchers from the late nineteenth and early twentieth centuries were actually quite willing to entertain the idea that some geometric signs represented objects from the mundane world, but later generations of researchers became more cautious about making direct interpretations. Earlier enthusiasm for identifying and deciphering the art was replaced with a more studied approach that focused on questions like how the art was made (e.g., what tools were used, how paint formulas were made, the order in which the art was created) or how it was spatially laid out within a cave (e.g., which parts of the caves were decorated, studies about the co-occurrence of certain animal species). These are all important issues, to be sure, but quite different in nature from what came before. The social sciences were going through a period of philosophical angst (asking, How can we know anything about anything?) and grand, abstract theories took hold from the 1960s onward.

For instance, French anthropologists André Leroi-Gourhan and Annette Laming-Emperaire came up with a broad theory to

explain the art: the imagery in cave sites was part of an Ice Age system based on a binary view of the world—opposites like light or dark, open or closed, male or female. They believed that the distribution of the art inside the caves followed a certain organizational structure in which different species of animals were likely to occur in specific sections of caves and often in relation to certain signs. Leroi-Gourhan in particular saw the caves as reflections of the larger landscape, which could be divided up spatially, with species like bison and horses that lived on the open plains being found in large chambers that mimicked this openness, while felines, bears, and other creatures that lived in closed spaces, or lairs, would be located in small antechambers or recesses.

On top of the spatial organization, this famous French researcher came to believe that there was also a sexual division to the imagery, with some animals or signs representing the masculine aspect, while others represented the feminine. As I mentioned earlier, he interpreted bison as being female and horses as being male, and when they appeared together, which happened quite often, he saw this as the two aspects achieving equilibrium. All the images were divided up this way, but the category where it probably had the most impact was in the geometric signs. Overnight they went from having a broad range of interpretations to all being considered either male or female signs, with many of them having a sexual interpretation.[1] Linear and barbed signs were classified as male, owing to their supposed phallic resemblance, and all the rounded and triangular signs were identified as being female and collectively came to be known as "vulvas."

The identification of certain individual signs as vulvas, or, more discreetly, as "female fertility symbols," has an even longer history. Early rock art researcher Henri Breuil first started identifying some of the circular or triangular imagery as such, but it was Leroi-Gourhan's sweeping classification system that really

15.1. A vulva? Commarque, France. This engraved open-angle sign above a cruci-
form has been identified by some researchers as an example of a vulva, but whether
the depiction of female genitalia is as widespread as some assume (or whether this
interpretation is the result of our own cultural biases) remains an open question.
PHOTO BY D. VON PETZINGER.

took off (these were the days of the Sexual Revolution, after all).
Many other researchers from that time also adopted this descrip-
tion, and before you knew it, circles, half circles, ovals, open-angle
signs, and triangles were all being lumped into this category.

This made my life pretty challenging when I first started
building profiles for each of the rock art sites in my database, be-
cause I would regularly run into site descriptions which listed off
image inventories somewhat like this: three bison, one possible
horse, two red deer, and six vulvas. A lot of the time that would
be it. There'd be no further description in the text of the shape of
these supposed vulvas, and since drawings and photos of signs, if
they even existed, usually weren't included in articles or reports

(the animal images generally got top billing), I would often have absolutely nothing else to go on other than this vague and, in my opinion, overly interpretive description. I selected some of the rock art sites I worked at specifically to find out what these alleged vulvas actually looked like so I could classify them by form rather than presumed meaning.

Now, I'm not saying that there are no vulvas represented in Ice Age art, as nude females in figurine and rock art form do sometimes have their genitalia represented in detail, and there may even be some cases where oval or triangle signs are meant to be depictions of female genitalia. But I also don't think that they were plastered all over the cave walls. And even more than that, a lot of the supposed vulvas don't look very vulva-like. And, really, sometimes a cigar is just a cigar. The first time Dillon and I were in Les Combarelles Cave, in the Dordogne, I pointed out an engraved oval sign to him with a bisecting line that extended beyond one side of it. Without explaining why, I asked him what he thought it looked like. After staring at it for a few moments, he hazarded a guess of it being either a leaf or a paddle. When I told him it was *supposed* to be a vulva, he got a very perplexed look on his face as he stood there, tilting his head in different directions, trying to see it. No matter how hard he stared, he never managed to see it that way and maintains to this day that his proposed interpretations are much more plausible.

Over time, the dominance of Leroi-Gourhan's theory began to wane. I'm afraid he never did manage to find a cave with images organized in a way that quite matched his ideal structure, but what he did do, and for this I am forever grateful, is document the art at more sites than almost any other researcher out there. Thanks to the signs being an integral part of his system, they got a lot more attention than they had prior to his work. I often used his inventories as a starting point for my database, and found

them generally quite detailed and useful—other than the vulva blind spot. In 1986, Paul Bahn proposed what I happen to think is rather a good alternative interpretation to there being multitudes of Ice Age vulvas everywhere. He pointed out that many of these supposed representations of female genitalia could in fact be "animal footprints across various kinds of ground surface."[2] British archaeologist Steven Mithen has since expanded on this theory, going so far as obtaining the impressions of various game animals' hooves on different types of ground (wet grass, snow, mud, etc.), then matching those with signs that had been classed as vulvas from a number of sites.[3] Some of the matches are pretty convincing, and I think these two researchers may well be on to something. In a society that relies heavily on hunting for survival, tracking game animals is a key skill, and Dr. Mithen has even proposed that their depiction in the caves may have been some sort of teaching tool for younger members of the tribe.

Vulvas or hoofprints, leaves or paddles, or something else entirely—whatever the sign type, the question is always one of interpretation. As you know, I lean toward at least some of the abstract signs actually being figurative. And if they are an early form of graphic communication, then it could well be that the majority are either iconic or notational. We'll talk about the possibility of early notation later, but for now I want to focus on some of the potential pictographic interpretations of the signs.

If some of the triangles, circles, open angles, and ovals really are meant to depict vulvas, then this would technically make those signs figurative, and you could even call them iconic representations. If these signs, or some of the other similarly shaped ones, are meant to represent animal tracks, then this would make them a different type of sign known as an indexical—a sign that points toward its meaning indirectly. In other words, the tracks are not a direct representation of the animal but instead rely on an abstract

understanding of the indirect connection between the animal and the tracks it left behind. And either an iconic or indexical interpretation would place these signs squarely in the category of graphic communication.

I'm not the only scholar in recent years to revisit the ideas of the earliest researchers. In fact, after a long period of relative silence about meaning, many of the early theories now seem to be making a bit of a comeback, albeit with a good deal more caution than we see with the enthusiastic interpretations of nineteenth-century scholars. The art emerged from modern human minds, and more recent examples from cultures producing rock art give us a broad sense of the types of things people are likely to depict. I'm not talking about universal meaning here so much as general themes and topics that may have been of interest to Ice Age people. The danger of trying to assign universal meanings to the signs is that signs can look the same while having radically different meanings. Let me give you an example.

The San people of South Africa have a long tradition of creating rock art, and they still actively do so. They attribute much of the art's meaning to their shamanistic practices, and one sign in particular that they associate with the spiritual world is the half circle. In their culture, half circles represent the unseen worlds above and below our own, and the orientation of the half circle (curving upward or curving downward) tells us which world they are referring to. Now let's travel halfway around the world to the outback of Australia, where tribal groups of Aborigines also have a long history of making rock art and continue to do so. The same half circle motif is found at many rock art sites—both modern and prehistoric—across the continent, but here the meaning has much greater variability. For instance, according to the Warlpiri people of central Australia, a half circle in any orientation often means "human" generally, but can also refer more specifically to a

person who's either sitting (because of the impression left behind in the sand where someone sat) or standing, and there are even a few cases where it's used to represent an ancestral kangaroo deity—in this case, insider knowledge and contextual interpretation are necessary to identify which meaning is being referenced.[4] So here we have the same shape in South Africa and Australia, but with completely different meanings. And not just between continents either: even within that single cultural group in Australia the meaning changes while the motif stays the same—a perfect example of why I'm so cautious about assigning meanings to any of the signs. In a more restricted setting, where there are provable relationships between the groups involved, it is possible that certain signs could share the same type of meaning. Or, as we shall see when I discuss shamanism, if there is some sort of physiological basis for the argument, this could improve the chances of a connection. However, even in these cases, the argument for the signs having the exact same meaning based on some sort of universal human model would be pretty tenuous.

And so, with all these caveats about interpretation out of the way, let's talk about possible meanings for the geometric signs. You may have noticed a rather large omission in the figurative categories to which Ice Age imagery is assigned. We have animals and people, but what about images of daily life? Many rock art traditions around the world include imagery associated with everyday objects and activities, but for some reason these seem to be completely missing from the Paleolithic art in Europe. Or are they?

Considering the large number of game animals depicted, a hunting theme would seem to be a reasonable explanation for at least some of the art, but where, then, are the implements involved in this activity? Like me, Spanish rock art researcher Manuel Gonzalez Morales has raised this question, and he believes our focus on the abstract nature of the signs may be obscuring our ability to see

some of them for what they really are. As we discussed in chapter 11, the category name "penniform" comes from the Latin word meaning "feather-" or "plume-shaped," but this designation is just a comment on their general form and does not necessarily denote meaning. So what about cases where we find penniforms sticking out of the sides of game animals? Frankly they look an awful lot like spears or arrows, especially as some of these penniforms have fewer "plumes" than others, such that what we are left with is a single back-facing open angle on the end of a line (◀——) or a line that has a series of open angles near its far end and looks suspiciously like an arrow shaft with fletching.

Early researchers such as Henri Breuil identified the penniforms as being weaponry in this context. He assumed that it was either a depiction of a hunting scene or an attempt to guarantee success in the hunt by ritually killing a representation of the animal ahead of time.[5] Equally, mid-twentieth-century Italian archaeologist Paolo Graziosi identified some of the penniforms as being "feathered missiles or darts," and suggested that different sign types could be representations of other hunting gear or tools. Additionally, Breuil labeled red dots, radiating lines, and open angles found on the sides of some animals as "wounds" or spear holes. Some of these red images show up in conjunction with the penniforms, or are found on animals that were either engraved or created using black paint, suggesting that making the signs red was a specific choice. So at least in this narrow context, I would say there is some merit to the idea that red dots, lines, or open angles could be interpreted as injuries inflicted by hunters (see fig. 16 in insert). If so, this would be another instance where the signs are actually figurative rather than abstract symbols. Later on, however, these interpretations got put on the back burner, in part due to Leroi-Gourhan's theory that penniforms were male signs and dots female; also, in part, due to researchers' new, cautious attitudes.

In more recent times, Gonzalez Morales has also argued that penniforms on game animals probably indicate weapons.[6] We know from archaeology that Ice Age people did hunt these animals. Stone blades were made to be hafted onto some sort of spear shaft, and small stone blades appear to be arrowheads. Multiple examples of more recent rock art traditions depict animal hunts. With all this evidence, it seems pretty reasonable to assume that penniforms in this setting could be weaponry, and that related red signs like dots, lines, and open angles could be hunting-related wounds. It's important to keep in mind, though, that the frequency with which penniforms and this class of red signs appear on the sides of animals is very low, and only about 3 to 4 percent of all animal depictions have these markings on their sides.[7] It is more commonly seen with certain species, like bison (maybe 15 percent) and at specific sites, like Niaux, in France, where nearly a quarter of the animals have penniforms or other types of "missiles" associated with them, but overall the phenomenon is uncommon. I don't think this necessarily negates the interpretation, but it does reinforce the fact that it's unlikely the signs have the same meaning across all sites and time periods.

Dots are a perfect example of a sign that probably had several different meanings, depending on location and time period. On the side of an animal, especially when there are missiles present, it may make sense to interpret red dots as wounds, but dots appear in a lot of other places as well. In a number of caves, dots are found alone in passageways, or near intersections where cave corridors branch in more than one direction. Seeing these as I traversed sites made me wonder if these dots were intended as path markers to guide these early explorers. I've also seen isolated lines and paint splatters at intersections. Many of the caves the artists entered and decorated were dangerous and difficult to navigate, and leaving signs to mark their path would have been a logical way to prevent

them and those who may have followed from getting lost (see fig. 17 in insert). I'm not the only one to notice this, either. Over the years, several French and Spanish researchers have raised this possibility at sites like Lascaux, Niaux, and Altxerri[8]—but no one has actually done a large-scale study to see if this is a regular occurrence. (Another thing to add to the to-do list!)

The tectiform—the sign that has a rooflike peak with a vertical line connecting the open angle up top with a horizontal line that runs the length of its base—is another sign that has been noted as possibly having a real-world meaning. Some early scholars proposed that it could be a representation of the type of dwelling the artists lived in. Some tectiforms are very stylized and don't obviously resemble a Paleolithic shelter, but those from Font-de-Gaume, in the Dordogne, have a lot more detail to them. Paolo Graziosi noted the potentially pictographic quality of one of the tectiforms at Font-de-Gaume in particular and described it as follows: "There is a sign painted . . . that in a simplified manner really does appear to represent a hut, with a roof, a supporting ridge-pole and two semi-circular openings."[9]

A lot of rock art cultures do include images of their homes and villages, so this is by no means a far-fetched notion. I am not certain myself, because we don't have any hard evidence one way or the other. In any case, it would be hard to prove this for sure since we don't have any amazing sites in Western Europe like Dolni Vestonice, where the nonperishable building materials (the mammoth bones and large stones that were the basis of their structures) collapsed in place, giving us a good sense of what the dwellings looked like. We do, however, have evidence at several sites in the Dordogne of the postholes for what may have been animal-hide tents. If—and this is a very big if—the configuration of the holes is fairly well preserved, then it might be possible to at least get an idea of the size and general shape of the dwellings used in Western

Europe during this time, and to see whether these correspond at all with the tectiforms at Font-de-Gaume and elsewhere.

Another possible interpretation of the tectiforms is that they represent some sort of animal trap. At certain sites, like Rouffignac, they appear around or even on top of some of the animal images. With their boxlike shape and angled top, they have been tentatively identified by some researchers[10] as resembling a trap used by more recent indigenous groups. As with the question of weapon imagery, the trap could be either a depiction of an actual hunt or a teaching diagram demonstrating how to build it, or even an attempt at sympathetic magic whereby the artists are hoping that ritually trapping its image in the cave will improve the likelihood of an actual animal getting stuck in a trap. Unlike with the penniform interpretations above, we have no archaeological evidence to explore this claim one way or the other; even if these people were using traps, chances are they used perishable materials like wood, in which case we would never find them (unless one got tossed in a bog—we can only hope).

Now to address the other big question marks in the Ice Age art categories: the sky and the landscape. First, let's turn our gaze skyward, to the sun, the moon, the planets, and the stars (and the occasional comet). These celestial bodies dominate our sky, and in the days before light pollution, the objects in the night sky were much brighter and more detailed than what we city dwellers can see today. People living during the Ice Age were not only aware of the sky, but also probably actively observing it. And yet, surprisingly, there aren't any clear examples of either the sun or the moon in the art. Drawing the sun with radiating lines is more of a convention than a necessity, but we don't even find any circles positioned in a way that could suggest they're meant to represent the sun beaming down on a land-based scene below. Same with the moon—since its shape changes throughout the lunar cycle,

we might expect to find one or more of its aspects in the form of circles or half circles, but here again, we just don't have any good examples of signs of this sort. Does this mean that they really weren't being represented on the cave walls? Perhaps. But it's just as likely that they are there but aren't being represented in a way we can easily recognize.

The depiction of star constellations, on the other hand, has been proposed for several rock art sites that have groupings of dots. As with so many of the theories about meaning, this one dates back to the early days of the discipline, and has recently been revisited.[11] Our human brains love to find patterns in things, and the way the stars are arranged in the sky seems to naturally encourage us to start connecting the dots (pardon the pun), so this is a reasonable proposal. Over the years, several different groups of dots at Lascaux have been potentially identified as star constellations including a group of seven dots thought to be the Pleiades, or Seven Sisters, plus another row of three dots that has been interpreted as Orion's Belt. The problem, as always, is how do we prove this one way or the other? Knowing that not all cultures divide the stars up the same way, we have to be really careful not to place too much emphasis on the present-day star clusters that we recognize here in the West.

To try to determine if stars are being represented in the art, researchers examined the frequency with which more recent hunter-gatherer groups record celestial information.[12] They found that tracking the sun, moon, and stars is widespread among people with similar lifestyles to those living during the Ice Age and concluded that it would be reasonable to assume that complex hunter-gatherers like our Paleolithic ancestors not only took an active interest in the skies overhead, but would have also benefited from the knowledge gained by this study (e.g., knowing the timing of herd migrations based on the appearance and relation of certain seasonal stars). A major stumbling block with trying to prove this

one way or the other is that even if some of the groups of dots do represent constellations, there are at least as many that seem not to—so how do you determine if a row of three dots is Orion's Belt or a notation, or an abstract pattern viewed in a trance state? The likelihood of multiple meanings certainly complicates the issue, doesn't it? Now, though, let's bring this discussion back down to earth and focus on some instances where there seems to be a better chance of understanding what the signs represent.

The animals from cave art sites in Europe often seem to float across the walls or ceilings without any appearance of orientation or connection to the real world. The artists didn't draw horizontal lines to represent the land, and there are no scenes from this era with clear representations of the animals in their natural environment. At some sites, it may be that preexisting structures in the rock wall were used to represent ground features, but this is not something that has been well documented. There are currently no official site inventories that include plants, trees, rivers, mountains, etc. This doesn't mean that there aren't a few such possibilities, though. Let's see what we can find.

At a handful of sites, images have been tentatively and informally identified as plants and trees, but the images are officially listed as penniforms in the inventories. Funny how this category keeps popping up, isn't it? You can see why I have some misgivings as to whether all the penniforms—along with many of the other signs, for that matter—should really be categorized together in these broad geometric sign categories. In this case we are talking about the more typically shaped penniform, with pairs of branching lines extending out from the center for most, if not all, of its length.

A penniform located above one of the "Chinese horses" in Lascaux has been interpreted by certain researchers as either a branch or a piece of summer grass—or a missile in midair, depending on who you talk to. Another example is the red penniforms from

Marsoulas Cave in France. Altogether there are ten of them. Many are oriented horizontally, and some are a yard or more in length. One that doesn't have regular branch lines extending from its center line (they're more spread out and sporadic) almost looks like it's meant to represent the ground with a bison walking over it, but this is only a tentative thought at best.

In a neighboring region is the cave of Le Tuc d'Audoubert. One penniform here looks a little different from many of the others. It's made up of a center line with rows of little half circles extending up both sides—rock art researcher Alexander Marshack identified this one as potentially a plant and thought that the half circles might represent leaves or side branches.[13]

Some early researchers did propose that this type of penniform could represent a plant, a blade of grass, or the bough of a tree; but the fact that most of the penniforms are drawn horizontally doesn't match the way that plants and grasses generally grow. As well, if some of the penniforms are supposed to be tree branches, where's the rest of the tree? That they appear in isolation rather than grouped together into a bush or treelike depiction is also somewhat perplexing.

One exception to this is a black penniform at El Castillo Cave (see fig. 18 in insert). This image is oriented vertically. A single line makes up most of its length, with only a few paired, extending lines near the top. If anything, it almost looks a bit like a palm tree, which is highly unlikely considering we're talking about an Ice Age here. The only other imagery on this panel is a series of five red campaniforms (bell-shaped signs), which don't provide any useful context, so it's really hard to say. It could just as easily be a depiction of an arrow stuck into the ground, or something else entirely. In this case I think I'd probably just stick to calling it a penniform!

Since we put so much emphasis on the Ice Age hunting lifestyle, it's easy to forget that these people were in fact hunter-*gatherers*, and that their health and survival would have depended just as much on

the plants, berries, nuts, tubers, etc., that they collected for consumption as it would on the meat. Even if rare examples—Lascaux, Marsoulas, Le Tuc d'Audoubert, and El Castillo—actually do contain plant imagery, they're still an incredibly rare occurrence. (And in case you were wondering, no examples of flowers have ever been identified, even tentatively, in the art, either.) Why weren't they depicting this type of material more often? I would certainly expect to find some representation of flora along with the fauna, but then, I don't know what the motivation or motivations were for the art. In modern art, we regularly see depictions of natural scenes—called landscape art—so it could just be that we are programmed by the art of our own period to believe this is normal. Other art traditions don't put nearly as much emphasis on realism as our own, or the detailed reproduction of the natural world, so depending on why these early humans were making the art, it just may not have been important to them to include plants or trees.

Moving on to nonliving objects from the natural world, the identification of any possible rivers, lakes, or mountains is even less frequent; in fact, it's pretty much unheard of. There is really only one acknowledged potential instance of water appearing at a rock art site, and even in this case, it's only an indirect reference. I'm referring here to the panel of "swimming deer" at Lascaux. Only the antlers, heads, and necks of the five deer are depicted in this frieze (though they may be reindeer, depending on the interpretation). All are facing left, and it is thought that this is a portrayal of a herd swimming across a river—something that does happen fairly regularly in real life. No lines or other markings have been used to represent the water, so it's more of an inferred interpretation based on how much of the animals is generally visible in this situation above an imagined waterline. On this part of the wall, though, right below the line of deer heads, and on the same angle as the row of images, the rock curves out slightly, creating a minor prominence.

It's certainly possible that this location was chosen specifically so the artist could incorporate this natural feature into his or her painting to suggest the surface of a body of water.

Other than my personal hunch that the converging "meanders" at the Côa Valley site could be a depiction of the nearby stream joining the adjacent Côa River, there is only one other site where this kind of suggestion has been made about any of the imagery. It was suggested that some of the finger flutings found on the ceiling of Gargas Cave in France[14] could represent either trails or waterways, though no one has tried to link them with anything specific. More recently, a Spanish paleoanthropologist has compared the meanders with aerial data of the region around Gargas and raised the possibility that these flutings could represent the convergence of two rivers near the site.[15]

The percentage of Paleolithic sites where triangles and open-angle signs are present is approximately 25 percent and 40 percent, respectively; and while many of them have the correct orientation, with the peak pointing upward, no one to date has even raised the possibility that these could be representations of mountains. A 2016 study has proposed the depiction of a volcanic eruption at the French site of Chauvet[16] (there's a triangle etched on a cave wall with lines emerging from the top), but this is the only one of its kind. Considering the number of sites situated within or near mountain ranges, and with them being such obvious landmarks, their apparent absence at rock art sites does seem a bit odd. But again, as with the lack of floral depictions, a lot depends on the purpose of the art for its creators. There are also some differences in subject matter between the rock art and the images found on portable art pieces,[17] and the portable art pieces often seem connected to daily life. There is more correlation between the animal species depicted and those being eaten (i.e., fewer horse and bison, more red deer and ibex), but it's possible that this observation has

a wider application as well. Several portable art pieces have been tentatively identified as maps, and these do seem to include some of those missing natural features we've been talking about.

The Abauntz Cave in northeastern Spain, dating to around 13,500 years ago, has yielded just such an object. A group of researchers led by Pilar Utrilla Miranda from the University of Zaragoza has studied two pieces of portable art found on brown stone blocks in the archaeological layers there. Each of the stones weighs between two and three pounds, and one of them appears to have doubled as an oil lamp (a depression in the middle was probably filled with animal fat). They believe that the markings engraved on these blocks may be maps or sketches of the landscape surrounding the cave. This team has distinguished mountains, ponds, and rivers on these stones, all of the images fairly stylized, but which they believe correspond to specific landscape features in the area. In particular, they think that one section of the non-lamp stone shows a river being joined by two smaller ones near two mountains, and they have noted that one of the two peaks is very similar in appearance to a mountain visible from the cave entrance where it was found. Another section of that stone block displays bundles of lines in configurations that match the flooding patterns seen in a nearby flat meadow when the spring flood flows through it.

If their reading of these engravings is correct, this would be the first confirmed artistic representation of mountains during the Ice Age in Europe. It would also be one of the first certain examples of the depiction of waterways. All these purported landscape elements are being portrayed using what would normally be categorized as non-figurative signs, which returns us again to the question of how many of the geometric signs are truly abstract markings. Is there more representational art here than we realize?

Utrilla Miranda and her colleagues have made a fairly persuasive argument that the stone pieces from Abauntz are some

sort of diagram or map of the surrounding landscape. The types of markings they identified as representing rivers also happen to resemble the meander engraving I saw in the Côa Valley. Other portable art pieces have been tentatively identified as maps as well, especially some from Eastern Europe in the vicinity of the Dolni Vestonice and Pavlov sites, so it's even possible that creating two-dimensional representations of features of the landscape was already a fairly widespread practice. If so, it makes me wonder if other portable objects—or for that matter, panels of non-figurative rock art—should be revisited from this perspective. As with any type of theory, though, the problem with going looking for something specific is that sometimes you start seeing what you want to see. Still, if approached carefully, using aerial data and other archaeological and environmental information, it's possible that more examples of these early attempts at mapping are waiting to be discovered among the geometric signs.

Seeing meanders and other non-figurative markings as depictions of the landscape is pretty exciting. But there are larger implications as well. More than just a portrayal of natural features, the proposed map from Abauntz could be a way to better understand the "early modern human capacities of spatial awareness, planning, and organized hunting."[18] If maps, even simple ones, were really being made this long ago, then that would push back the origins of mapmaking by several millennia, as well as serving as an excellent indicator of the development of artificial memory systems.

Francesco d'Errico has studied this process in early modern humans, and defines an artificial memory system (AMS) as a "means of recording, storing, transmitting and handling information outside of the actual body."[19] A computer is a type of AMS, as is writing. Basically, any system that allows the external coding and storage of information that can be retrieved and used at will falls within this category. This kind of abstraction involves higher

cognitive functions, and modern humans are the only species we know capable of creating and using this kind of system. A map would also be considered an AMS, and if these ancient people were mapping their world, then it lends credence to the idea that they may have been using other early types of artificial memory systems as well. I want to close this chapter by talking about two in particular: mnemonic devices and notation.

A mnemonic device is, in a general sense, any type of memory aid that assists someone in recalling information. These devices can be verbal cues (think "*i* before *e* except after *c*"), but what we are interested in here are physical mnemonic devices, such as recitation aids (e.g., prayer beads) or accounting aids (e.g., tally sticks). A recitation aid may be used in a culture without a formal writing system, where the accuracy of recounting origin stories and tribal histories is vital for the successful transmission of this information between people and generations. In more recent cultures, mnemonic devices are often some type of portable artifact with markings that provide visual or tactile reminders during the recitation. These cues signal important elements in the recounting and help ensure that the story is relayed in the correct order and that nothing is left out. The marks can be either pictographic representations of main characters and landscape features, or more abstracted memory cues in the form of a series of lines or other non-figurative motifs that follow the progression of the story.

The first archaeological mention of mnemonic devices goes back to the late 1800s. Almost as soon as they began to excavate Ice Age sites, early archaeologists started to find stone, bone, and antler artifacts, often marked with notches, lines, crosses, and other geometric shapes arranged in linear configurations. The suggestion that these were either recitation aids or tally sticks, particularly the latter, garnered a lot of attention. The French called these *marques de chasse* and thought they might have been made

by hunters to record the number of their kills. As the name implies, tallying is a type of notation where things are added up and tracked using the stick as an external memory aid. While this was seen as the most likely explanation, based on the prevalence of this type of counting system among more recent hunter-gatherer groups, other tallying theories were also proposed, including storage of astronomical data, proto-mathematical systems, and an early method for tracking days, seasons, or years.

The big problem with all these theories was the difficulty of proving them. Even if the early people of Ice Age Europe did have a counting system—which is likely—we have no idea what they may have been counting, or even what type of numeral system they were using. In the twenty-first century, most countries use a system based on the number ten, but the ancient Sumerian system was based on sets of sixty, with subunits of ten (both our sixty-minute hour and 360-degree angle measurements are thought to derive from this practice), and the traditional counting systems of several indigenous North American groups were based on the number eight (they counted the spaces between the fingers rather than the fingers themselves). With no way of knowing how to "read" the rows of lines on the artifacts, many researchers gave up on this line of inquiry entirely.

And then along came Alexander Marshack, an American science writer, who stumbled across these ancient notched and marked artifacts as he was working on a book about the history of the Space Age in the late 1950s. For the book's introduction, he'd decided to provide some information on the origins of mathematics—a trail he followed all the way back to the Ice Age. Even after he finished his book, Marshack remained intrigued by what he thought might be tally marks (rows and groupings of lines and dots) on some of the portable Paleolithic pieces. He wasn't quite sure how to study this when it wasn't even known if counting systems existed at that time,

but then it came to him: there was a type of number that could be tested—the lunar calendar. Whereas other groupings of numbers are pretty much impossible to distinguish, since we have no reference for what they may have been counting or the system they were using, the lunar cycle is a constant, and he set out to search for this on portable artifacts.[20] Marshack found what he thought might be groups of twenty-eight or twenty-nine lines on multiple pieces across Europe, sometimes with three or four sets in a row. Believing these could represent the seasons, and bucking the trend of the late 1960s and early '70s, he identified some of the animals, fish, and non-figurative markings accompanying these lines and notches as being seasonally relevant information. For instance, a carved salmon on one artifact was depicted with a hooked lower jaw, something seen only during the spawning season. He took a similar approach with some of the deer representations (engravings showing antlers on species that shed them at the end of rutting season), and even suggested that some of the penniforms and other geometric markings could be seasonally available plants.

Marshack's theories went completely against the mainstream views on Ice Age art at this time, which were still in the grip of a binary universe with a heavy dose of sexual symbolism. And here was this fellow coming in from the outside and proposing that rows of engraved lines were in fact early methods of timekeeping, and that some of the geometric signs were really stylized representations of real-world items. Yet Marshack's theories received serious attention from a number of researchers.

Marshack was also one of the first people to start systematically using a microscope to examine the artifacts, looking for evidence of different tools having been used and for changes in marking style (harder, shallower, different angling, etc.) in order to determine whether all the marks had been made at once or if there were separate engravings over an extended period of time.

You would expect the engravings to be more spread out if the artifact was for keeping track of days, lunar cycles, seasons, or other important temporal information (say, the timing of a ceremony).

The results of Marshack's studies were somewhat mixed, as there was not always a very clear division in the right spot for the markings to be a lunar cycle. However, it certainly does seem to work on some of the artifacts, and perhaps more important, his studies got people thinking about the possibilities of notation and timekeeping for the first time. Most scholars would agree that counting fingers on the hand (or hands) was probably the starting point of this incredible cognitive leap. However, as with so many things to do with prehistory, notation and counting were thought to have developed with the more recent rise of agriculture, when people began tracking inventories and trades. As paleoanthropologist Sally McBrearty explains it, "The earliest Homo sapiens probably had the cognitive capability to invent Sputnik. But they didn't yet have the history of invention or a need for those things."[21] But maybe they *did* already have the need to count and record things in the world around them. Being able to track time could have had many benefits for people living in such an unforgiving environment, and a growing spatial awareness may have improved their ability to organize hunts and exploit the resources in their surroundings.

The geometric imagery associated with many of the artifacts interpreted as tally sticks offers us a completely different type of insight into possible functions for the signs. If lines and other non-figurative markings were being used for timekeeping or other forms of counting, then this really is a more abstract use of some of the signs. Returning for a moment to the signs found on the St. Germain-la-Rivière burial necklace, the types of markings on these teeth (rows of different numbers of lines, lines mixed with cruciforms, asterisk signs, and the elusive pi sign) have a lot of the characteristics we would expect to see if they were some sort of

mnemonic device. The rows of lines could be counts of a specific item, or have been designed to track specific time periods. It's also possible that the teeth acted as some sort of recitation aid or an external storage system for important tribal information. While this explanation might make it seem less likely that her tribe would have been willing to lose this knowledge by burying it along with the woman, keep in mind that there may have been multiple artifacts that recorded this information, and that including valuable and powerful personal items as grave goods has a long tradition. This would still make the signs on the teeth meaningful and a useful guide for better understanding their rock art counterparts, but in a different sort of way than if they were actually representing words or ideas directly.

Many linguists believe that mnemonic devices such as recitation aids and tally sticks are the type of graphic communication closest to proto-writing.[22] This is because the signs no longer necessarily represent an object or thing directly, but are instead designed to help the "reader" remember an event, keep track of a period of time, or record numbers of things, all of which require a higher degree of symbolic construction. This more abstract relationship starts to build an indirect correspondence between the object and its sign, which is an important cognitive step toward the creation of a writing system.

So many possibilities, and so little certainty. Having carefully constructed my sign typology chart, my new goal is to start figuring out how to break it back apart to better represent the different types of imagery that may be included within the category of geometric signs. I do believe there are some representations of real-world objects buried in there, especially as regards weaponry, plants, trees, waterways, and stars. The penniform sign in particular is a prime candidate, and I plan to start reassessing whether some of the penniforms can be interpreted as concrete objects. In

other cases where it's not as certain, I may have to content myself
for the moment with leaving them as non-figurative. Indeed, some
of them could well be abstract. But once you start bringing lin-
guistic research into the equation and understanding how symbols
are formed, it seems likely to me that the vast majority of signs
started life as a pictographic representation of something tangible,
even if we can no longer tell what it is.

We researchers tend to split portable art off from rock art, but
the reality is that they are all part of the same artistic tradition, and
there's no reason why what we learn from one can't be applied to
the other. The Abauntz map from Spain is a good example of how
these two types of art could potentially overlap: if landscape fea-
tures are being depicted in that context, then the same themes may
be present in the rock art as well—more things to follow up on!

Next we will take a look into the supernatural world of the Ice
Age as we explore the possibility that some of the geometric signs
may be the product of shamanistic trance visions.

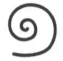

Seeing the Unseen World: Visions, Shamans, and the Seven Signs

I t's dark, the kind of dark where you can't tell if your eyes are open or closed. Even on a moonless night with heavy clouds obscuring the sky and stars overhead, you don't get this kind of darkness.

It's quiet—so quiet that after a while the absence of sound starts to become a sound itself. But you're not alone. Now and then you hear a whisper of clothing as someone shifts their position, a stifled cough, the scrape of a foot against the dirt floor, the faint sound of suppressed breathing.

You've been in the dark and the quiet for what feels like hours, part of a chosen few holding vigil for the good of your tribe. Lulled by the lack of sensation, you feel yourself slipping into a different state of mind. Your eyes begin to create their own images. Dots flash at the edge of your vision, rows of lines dance across your field of view, joined by zigzags, grids, branching lines, curving lines. Your mind's eye is a riot of movement and shape. You feel yourself slipping deeper into the trance.

A drum starts. At first it's just a single repeated beat, a low reverberating sound that echoes off the walls before it fades

away. You can feel it in your body. Slowly, the pace begins to quicken; the drumbeat becomes regular, pulsing. The high trill of a bone flute starts, it merges with the drumbeat momentarily, only to break away in a scale of rising notes, and a wordless chant is added to the growing swell. You join in.

Outside the chamber a torch is lit, and the sudden flare of light is enough to make you wince as your eyes are assaulted by the brilliance. A figure wearing the skin of a bison enters the chamber. She carries the torch high as she shuffles forward in a rhythmic dance, threading her way through the seated people to the far wall of the chamber.

The torch flares, light and shadow dance across the rocky walls, revealing the vibrant paintings that encircle the chamber. Herds of bison and horse are set in motion, moving in the flickering light. The cave is alive.

The drum cadence changes, the flute falls silent, the chant drops to a low hum.

The bison-woman passes off her torch and crouches down in front of the wall. She dips her hand into a preparation of ochre pigment. The barrier between the seen and unseen worlds is thin here. She presses her hand flat against the stone surface, the membrane that separates the mundane from the supernatural. She pulls her hand away, leaving a bright-red imprint behind, then collapses to the floor as she begins her journey into the underworld, searching for the herds of animals that are late this year. The tribe needs her to succeed or else they will suffer a long hungry winter.

The torch is extinguished. The chamber, deep beneath the earth's surface, is plunged back into darkness as you await her return. The drum continues its steady beat to help her find her way home. All else is silent.

I have no idea if this is what happened in the caves of Ice Age Europe, or even if these ancient people practiced some form of shamanism. This scene was based on ceremonies and descriptions of shamanistic practices I have seen and read about from different parts of the world. But when you spend a lot of time in caves like I do, especially ones filled with ancient rock art, it's hard not to let your imagination run wild on occasion (apparently it's not just me either—other researchers have confided in me that they do the same thing).

There's just something about caves that feels otherworldly. In many cultures, past and present, caves play an important role in spiritual practices, so it's really not surprising that shamanism was one of the earliest theories proposed to explain Ice Age art. Unlike many other initial interpretations that have long since been discarded, this one was revived in the late 1980s, drawing on new data from neuropsychology. Revival of this theory was in large part due to a new understanding of the human eye and nervous system, and the way in which they function in altered states of consciousness.

What had been confirmed was that all modern humans have the exact same eye function and nervous system, regardless of where or when they lived—meaning that physiological responses to altered states of consciousness were also universal. Rock art researcher David Lewis-Williams and neuroscientist Thomas Dowson were the first scholars to apply this neuropsychological model to the study of rock art.[1] They focused on entoptics—a series of geometric shapes generated from within the eye itself (the word *entoptic* comes from the Greek words *ento* and *optic* and means "from within the eye"). The human nervous system produces abstract entoptic visions while in altered states of consciousness, and Lewis-Williams and Dowson contend that the geometric signs from the European Paleolithic may in fact be the product of these trance states.

16.1. *Possible shamanic figure, Ojo Guareña, Spain. Some researchers have suggested this humanlike figure with outstretched arms could be a shaman.*
PHOTO BY D. VON PETZINGER.

Contemporary neuropsychological studies on the abstract shapes seen during altered states of consciousness, including those experienced during shamanistic trances, show that human eyes see only a certain number of forms. These universally recognized entoptic images—sometimes called "phosphenes"—appear in an altered state without the aid of outside illumination. As the researchers describe it, "these visual phenomena, although complex and diverse, take geometric forms such as grids, zigzags, dots, spirals, and catenary curves," and are perceived as "incandescent, shimmering, moving, rotating, and sometimes enlarging patterns." Basically what's happening is that when a person goes into a trance, the pressure in the eyes rises, causing the cells in the retina to fire and produce abstract images. (These entoptics can also be produced by pressing on your eyes when they're closed.) No matter what the cultural background, the human nervous system always responds the same way. Since many of these abstract shapes appear on the

walls of caves in Ice Age Europe, Lewis-Williams and Dowson, along with a few other researchers—such as French rock art expert Jean Clottes—who've explored this in the years since, believe this confirms that ancient people were entering altered states of consciousness and then reproducing these entoptic visions in their art.

In my shamanistic example above, I purposefully didn't have you taking any sort of hallucinogen. In my opinion, too much emphasis has been given to this particular method of entering a trance state. Altered states of consciousness can also be reached through meditation, sensory deprivation, drumming, dancing to exhaustion, repetitive chanting, excessive heat and sweating (as in sweat lodges), intense pain, and other practices. There are hallucinogenic plants in Europe that Ice Age people could have been using—e.g., *Amanita muscaria* (fly agaric mushrooms), *Hyoscyamus niger* (henbane), *Atropa belladonna* (deadly nightshade), etc.—but we have no direct evidence they were doing so. We've never found any pollen at archaeological sites that would identify the presence of these particular plants (though mushroom spores—likely from edible bolete mushrooms—were recently found embedded in tooth plaque from a female skull at the cave site of El Mirón, Spain[2]). This doesn't mean they weren't there, since perishable materials like plants do not survive well in the archaeological record. But a dark cave is basically one big sensory-deprivation chamber, and we do have evidence that flutes were taken into these spaces (and presumably played there), and that percussive sounds were made (from marks found on certain rock formations). So you could make a pretty strong argument for something other than hallucinogens having been the stimulus.

Using the universality of the entoptic visions as his starting point, Lewis-Williams has since attempted to connect the meaning of the art directly with possible spiritual practices of these early humans. To do this, he turned to modern examples of hunter-gatherer people who still create rock art, and who do so

for shamanistic reasons—in particular, the San people in South Africa. Archaeological and genetic data show that the ancestors of these people have lived there since the Paleolithic, and there is a long history of rock art in the area. To date, the only Stone Age art found in the region is a series of 25,000-to-27,000-year-old black animals drawn on stone slabs from the site of Apollo 11 to the north, in Namibia. (This site is named after the first successful lunar landing, as it was being excavated at the same time that this spaceflight took place.)

The San people live in the Kalahari Desert and practice, at least in part, a hunter-gatherer lifestyle. They follow a shamanistic tradition in which up to 40 percent of the individuals in a given group—both male and female—are practicing shamans who help their tribe by interacting with supernatural entities to try to influence the outcome of events. They generally reach a trance state through singing and dancing to the point of exhaustion. Different shamans have different specialties, such as bringing the rains, finding game animals, and healing the sick. They also regularly create rock art. Based on their firsthand accounts, the rock art they produce is inspired by the visions they see when they journey into the unseen worlds above and below our own. The San perceive these images to be "storehouses of supernatural potency" for shamans to tap when they cross over into these dangerous realms. They believe that the physical rock surface on which they paint and engrave their art is a veil, or membrane, that separates the real world from the spiritual. The negative and positive hands they create on the rock are a way of directly connecting with that membrane.

Since the geometric content of visions is a universal occurrence and is restricted to the shapes our eyes can produce,[3] identifying these particular motifs in the rock art could mean that some of the signs had a spiritual meaning. Some of the figurative imagery could also stem from shamanism, especially the animal-human

hybrids. Perhaps they represent shamans dressed in ceremonial regalia, or spiritual entities and guides the shamans encountered during their otherworldly travels; or perhaps they represent the shamans themselves during their time in the spirit world. Let's go through these possibilities individually, as each of them can be found in recent rock art examples from around the world.

First, in some cultures, shaman wear the skin of an animal, often with the head intact, while in others they wear a mask to represent the animal they are mimicking. Recent examples of rock art from the nineteenth and twentieth centuries are known to depict shamans in this type of costuming. Second, spirit guides are a common occurrence in many shamanistic traditions and can be either fully animal or a hybrid animal-human, depending on the culture. These are often personal guides with whom the shaman has cultivated a relationship over time, and who can help the shaman when he or she crosses over into the unseen world. Finally, the San in particular believe that they take on some animal characteristics once they've entered the spirit realm, and many of the animal-human hybrids they paint and engrave are actually portrayals of themselves in this other place. All three explanations have potential merit, and indeed we may be seeing more than one of them depicted on the cave walls—though it also remains possible that some or all of these figures represent something entirely different, such as characters from origin stories and mythologies, or even something we haven't considered yet.

David Lewis-Williams and Jean Clottes have proposed that some of the more unusual animal depictions from Ice Age Europe could potentially be spirit animals rather than poorly rendered representations of real-world wildlife.[4] The San people depict both natural-looking and stylized animal imagery in their art, and in many cases these animals are meant to be spirits, not actual animals. Certain species are even associated with

16.2. *Entoptic signs? These are the seven abstract shapes identified by David Lewis-Williams and his colleagues as potentially being evidence of shamanistic visions in Ice Age art.* GENEVIEVE VON PETZINGER.

specific gods, and representations of these creatures are thought to be powerful symbols of the traits of that deity, or even of the gods themselves. Knowing that people often see distorted animal images along with entoptics while in the advanced stages of hallucination, Lewis-Williams has suggested that some of the potential spirit-animals are distorted because of the artist's neuropsychological reaction to the depth of the trance state.[5] Here again it is possible that Ice Age people were thinking along similar lines. Unfortunately, with all these proposed interpretations of animal and human figures, it's difficult to decide one way or another without access to something external and more universal, like the entoptic shapes. This is why the geometric signs are an important part of this theory.

Using the neuropsychological data and the information from the San as a guide, Lewis-Williams has identified several specific geometric signs from the Ice Age that he believes to be the product of shamanistic trance experiences.[6] These non-figurative markings include crosshatches (grids), sets of parallel lines, dots, half circles, finger flutings, zigzags, and spirals (see above). While Lewis-Williams does provide a few examples of caves in Europe that contain some of these

signs, he has offered this more as a general suggestion, while not specifically measuring the frequency with which these signs appear. Thanks to my database, I happen to have all this information from across Europe at my fingertips, so I thought it would be an interesting exercise to see if this theory actually worked in practice.

To prove that the geometric imagery from the Ice Age was inspired by shamanistic entoptic visions, the first thing we need to do is lay out some criteria based on what Lewis-Williams has proposed.

1. Since the human eye is wired to produce only certain signs, and in other instances of shamanistic art we see all these images appearing fairly regularly, do we see the same sort of distribution in Ice Age rock art?
2. If an individual was creating a depiction of his or her shamanistic experiences, you would expect to find all the related imagery in fairly close proximity, at least in the same site, if not in the same section of the site. Are there examples of sites that include all the entoptic signs, and are they located near each other?
3. Negative and positive hands seem to play an important role in many cultures that create shamanism-inspired rock art; are there any Ice Age sites where we can specifically link the entoptic signs with the hands?
4. Having identified many of the animal-human hybrids in Ice Age art as potentially being related to shamanistic practices, are any of the entoptic signs found in the same sites where these hybrid figures are located?

With these questions to guide us, let's see what we can find. First, I'm going to go through each of the seven sign types separately: crosshatches, sets of parallel lines, dots, half circles, finger flutings, zigzags, and spirals. Then we'll reexamine them as a group and assess the likelihood of them being the result of entoptic visions.

Crosshatches: Also sometimes referred to as grids or grills, this sign in its basic form looks a lot like a tic-tac-toe grid. Crosshatches are present at approximately 20 percent of Ice Age sites and are fairly well distributed across France and Spain, but largely absent in Italy or farther into Eastern Europe. Crosshatches often appear at the same sites as other proposed shamanistic signs, making them good candidates for having an entoptic origin. On the other hand, crosshatches have also been interpreted as being traps or other mundane objects.

Sets of Parallel Lines: Lines are present at 75 percent of Ice Age sites in Europe and occur across all time periods. Since we're interested specifically in sets of parallel lines here, if we remove all the occurrences of single lines or lines oriented in other ways, then we are left with just under 60 percent of sites having the right kind of line configurations. Parallel lines often appear with other sign types and on the sides of animals. They are one of the better contenders for being an entoptic, at least in particular locations. But, as we saw, some sets of parallel lines could also be a form of counting or tally system.

Dots: I have included both painted dots and cupules in this category, since the latter are in many ways a type of engraved dot. Dots are present at just over 40 percent of Ice Age sites and occur in all time periods. Spain in particular has a large number of sites with painted dots, including instances where they occur in various formations (e.g., rows, clouds, quadrangles, and circular shapes). Dots often appear with other sign types, including hands and lines, which does make them a good candidate for being an entoptic in certain contexts. Other potential theories of meaning for dots include wounds on animals, mnemonic devices (such as counting or timekeeping), and even the possibility that some groups of dots could represent specific stellar constellations.

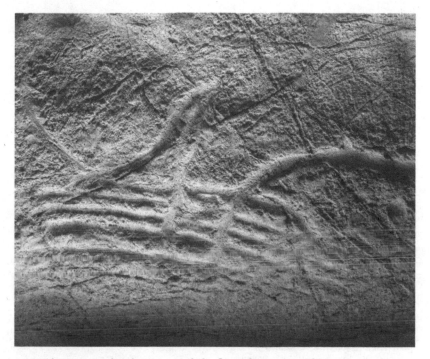

16.3. Abstract crosshatch image made by finger fluting, Las Chimeneas, Spain. Many abstract shapes such as this one, made by dragging a finger across a soft clay surface within a cave, can be found in caves across Europe. Some researchers think these shapes were inspired by images seen while the artist was in a shamanistic trance. Photo by D. von Petzinger.

Half circles: Half circles are present at approximately 20 percent of sites but rarely appear in the stacked configuration identified by Lewis-Williams and Dowson in their list of entoptic shapes seen while in altered states of consciousness. There are two concentric half circles at the site of Cougnac, in France, but these have also been interpreted as the horns of an ibex; and there are at least two examples at Lascaux, but these look more like penniforms with curving branches than they do stand-alone half circles. This sign type often appears near other non-figurative markings linked to shamanistic imagery, such as lines, dots,

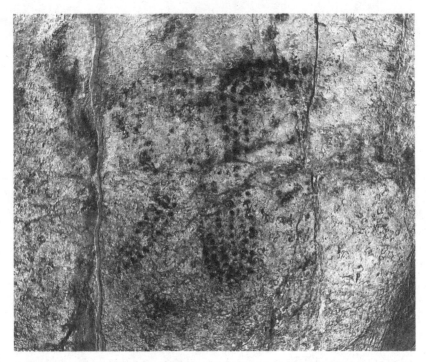

16.4. Serpentiform created using rows of dots, La Meaza, Spain. This sinuous style of sign is also sometimes associated with imagery seen during altered states of consciousness. Photo by D. von Petzinger.

and hands, so half circles should certainly be considered potential entoptic candidates.

Finger flutings: These can result in figurative as well as nonfigurative imagery, but the type Lewis-Williams and his colleagues are referring to are the abstract motifs. Finger flutings occur at approximately 20 percent of Ice Age sites, and while they are found in all time periods, they are most common in the early part of the Ice Age. Finger flutings are quite regularly identified at sites that also include hand paintings and dots, making them another possible candidate for being an entoptic.

Zigzags: Sometimes also identified as "rows of open angles" or "chevrons," these markings occur at less than 10 percent of rock

art sites from this era. Only seven sites in France, ten in Spain, two in Portugal and three in Italy include zigzags. This sign type is one of the rarest non-figurative markings from the Ice Age, making it a poor candidate for being a common inclusion in representations of shamanistic visions. Zigzags also rarely cross over with other signs on the potential entoptics list. Other possible interpretations for them include depictions of natural phenomena, such as lightning or mountain ranges.

Spirals: This is the rarest sign type from the Ice Age and only appears at three rock art sites in Europe. All three are in France and they are spread out across the country, making it difficult to identify a clear link between them. Interestingly, all of them date to the Gravettian period, and it may be that spirals were used only by this one culture group in Western Europe. Farther east, a few more examples of spirals occur on portable objects, including an ivory plaque from Mal'ta, in Siberia. This portable piece has several hundred pits incised into its surface to form seven spirals. While it has been interpreted by some scholars as a calendar, others think there may be a connection to shamanism.[7] This is based on the presence of other portable objects, female and bird figurines, and the style of burials in this region (very similar to the village sites of Dolni Vestonice and Pavlov). After being virtually absent from the Ice Age, spirals become much more common in European prehistoric art after 10,000 years ago, appearing in all sorts of contexts, from Scandinavian rock art to the megalithic gravestones of later cultures. There is not enough data about this unusual sign from the Ice Age to really assess whether it could be an entoptic or not.

Now that we've reviewed the potential entoptics, we can return to the questions. First, are all the entoptic signs even found in Ice Age art, and if so, do we have a fairly even distribution of these images? The answer to the first part is yes. All the non-figurative signs that Lewis-Williams has identified as being entoptics do

appear at rock art sites in Ice Age Europe. But the answer to the second part of the question is more negative, since there is quite a bit of variation between the frequencies with which different signs appear.

Lines and dots are the most common types of geometric sign overall, so it's not surprising that they appear at a large number of sites. I still think that they may have had different meanings in different places. Looking specifically for sets of parallel lines narrows the playing field a little, but even in this configuration they could be related to one of the other theories we've discussed, such as timekeeping or accounting. Then we have several different entoptic candidates that appear at roughly 20 percent of sites, which does look hopeful, except that they don't always appear at the same 20 percent of Ice Age sites. Frankly, the crossover between sites does not look promising, as at most of them only two or three of the entoptic contenders appear simultaneously, and these aren't always the same ones. Finally, we have the extremely rare signs like zigzags and spirals, which play such a central role in the art of many shamanistic cultures. Normally you would expect to see a fairly even distribution of the different entoptic shapes, such as we find in other cultural settings; and so for important categories like zigzags and spirals to be virtually absent does not bode well for the shamanism theory.

The second question was about the relationship between the different entoptic signs themselves, since we would expect to see all or most of them appearing together at specific sites if shamans were indeed depicting their trance experiences. Are there any sites where all the entoptic candidates appear together? The answer is a definite no. The closest we get is five out of seven signs, and this only happens at a handful of sites (we'll discuss some of them in more detail below). The majority of sites that have some of the potential entoptics only contain two or three of the signs, and often

these include either parallel lines or dots, so this doesn't help us narrow it down. In addition, the signs themselves are often spread out in different sections of rock art sites rather than being grouped together, which doesn't suggest a close association between these particular markings.

This leads to the third question: Do we find these seven signs at the same sites where we find positive or negative hands? As we know, the San believe that the rock surfaces in shelters and caves are the veil, or membrane, between the real world and the supernatural. Since they make hand paintings as a way to create a bridge between worlds, and since these images are linked with the entoptics and other shamanistic imagery in their art, perhaps the hands at sites in Europe could have had a similar function. Altogether, almost forty sites have at least one hand—positive or negative—along with one of the seven sign types we're looking for. If we raise the bar to two signs plus a hand, that number drops to seventeen sites across the whole of Europe, and if we go even further and look at sites with a minimum of three signs plus a hand image, that number is down to twelve. That's not such a big difference between two and three signs, but what we are left with in either case is a very small data set to work with, especially given that there are more than 350 Ice Age rock art sites currently known across Europe.

It's important to keep in mind, though, that there are very few sites with hands in Europe at all, so a lack of overlapping sites could have more to do with this factor than anything else. As we've seen, the hands are also at their most common during the earlier part of the Upper Paleolithic, so any later sites that potentially contain shamanistic imagery are unlikely to include hands. This could either mean that the early people of Europe were not really involved in this type of spiritual practice (as evidenced by the lack of hands) or that they did not interpret the cave walls and hand paintings in the

same way as the San. To complicate matters even further, at several of the sites I included (e.g., El Castillo), the images were made over a long period, and it may even be that the hands and other signs were made at different times. Rather than helping, I'm afraid that adding the hand paintings to the equation has only made things murkier. But let's try adding in one final criterion.

The last question was whether we find the entoptic signs co-occurring with animal-human hybrid figures. Well, in this case, there is actually a surprising degree of overlap. Not so much in pure numbers, but in the fact that many of the sites with animal-human images also have a larger variety of possible entoptics. Let's look at a few specific examples. The first is the famous Chauvet Cave in south-eastern France, which, you may recall, has a depiction of a figure with the head of a bison and the body of a woman. Chauvet also has five of the seven sign types we've been looking for—crosshatches, half circles, dots, parallel lines, and finger flutings—along with both positive and negative hands. Chauvet is probably one of the best matches for the shamanic theory anywhere in Ice Age Europe.

Another French site that seems an equally good match is Pech-Merle in the south-central region. We discussed the series of bison-women found there, and Pech-Merle also contains the same five potential entoptic sign types as Chauvet, along with both positive and negative hands. Further, I mentioned the bison-man from the cave of Les Trois-Frères in the South of France, in the foothills of the Pyrenees. This site is unusual in that it has two different animal-human hybrids—the bison-man and "Le Sorcier," a stag head on a human body. Here again we find the same five signs as at Chauvet and Pech-Merle, and while positive hands are absent, there are several negative hands.

Strangely, these three sites are almost identical with regard to these images. There are substantial differences elsewhere in these

sites, but in this one respect there's a great deal of similarity. What makes this even odder is that this pattern doesn't seem to repeat with quite the same degree of overlap at any other sites. Gargas, also in the Pyrenees region of France, does have five of the seven potential entoptics, but with zigzags instead of crosshatches. It contains more than 250 negative hands, but no positive ones, and there are no hybrid figures, making it only a partial match for our criteria, though still a promising match overall. And then there's the site of Gabillou, which, as we know, has many of the same signs and groupings we find on the St. Germain teeth. Gabillou also happens to have two animal-human hybrids with bison heads and human bodies, but it doesn't have any hand paintings or a large number of signs that could potentially be entoptics. The only ones present at Gabillou are crosshatches, dots, and sets of parallel lines. However, with dots and lines being so widespread and multiple ways to interpret them, overall this site doesn't seem like a good match for the shamanic entoptic theory.

None of the Spanish sites corresponds really well, either—none has more than three of the entoptic signs—nor do any other rock art sites in Europe have this kind of pattern, leaving us with three sites in France that are good partial matches. And this is before we even get to the issue of time.

Chauvet dates to roughly between 35,000 and 37,000 years ago, whereas Pech-Merle is more in the 28,000 to 30,000 range, and Les Trois-Frères is currently stylistically dated to the second half of the Upper Paleolithic, or around 18,000 to 22,000 years ago. With Les Trois-Frères, I think there is a chance that some of the imagery, including the negative hands, finger flutings, and some of the dots, could date to the Gravettian, which would make it closer in age to Pech-Merle, but in any case, this is a very small set of sites to work with.

With only three good potential sites, all separated by time and distance, and another nine that have only three to four matching signs and the occasional hand, it doesn't seem like we've found a lot of evidence to support the existence of shamanistic practices during the Ice Age in Europe. Add to this the lack of zigzags and spirals, and we end up with rather mixed results. If these particular geometric signs are the end product of imagery seen during an altered state of consciousness, then you'd expect to see most, if not all, of them together at rock art sites, especially in concentrated areas within those sites. We don't find that. Indeed, no single site has all these signs. While the range of entoptic shapes produced by the human eye is a universal trait governed by the eye's physiology, it could be that early shamans were depicting only some of what they saw. This is always a possibility, but it doesn't really fit the pattern that we find in more recent examples of shamanism-inspired rock art, in which the artists generally draw everything fairly equally, rather than purposefully omitting some entoptics while including others. The reality, though, is that without having any actual firsthand knowledge, it really is difficult to prove or disprove a link with shamanism.

This doesn't mean that I don't think early humans in Europe had some form of spiritual belief. In fact, based on the range of symbolic artifacts we find in the places they lived, as well as some of the rock art imagery, I feel pretty certain they did, and I think that most scholars would agree with me. What we don't know is when this way of understanding the world emerged, or what form(s) it may have initially taken. Shamanism is one possibility, but these people could just as easily have been practicing some form of animism (where animals, plants, and inanimate objects are also thought to have spirits) or ancestor worship, or a combination of these things. The approach taken by Lewis-Williams and his colleagues, with their focus on the biological aspects of altered

states of consciousness, is a clever way to circumvent how little we really know about Ice Age cultures. And it may very well be that these ancestors of ours did sometimes enter a trance state; maybe it just wasn't important to them to depict what they saw in their visions in the form of art, or maybe they were recording it, but on perishable materials rather than cave walls.

According to linguists, the term *shaman* originated at least two thousand years ago in the icy tundra of Siberia, and only started to be applied to similar spiritual practices in other parts of the world in the recent past. Paleolithic archaeologists working in Siberia and Eastern Europe have wondered whether the earliest version of this tradition may in fact trace back to those ancient Gravettian villages that span geographically from the Czech Republic eastward across Russia.[8] Part of the problem with trying to apply this model to Western Europe during the Ice Age could be that this particular set of spiritual beliefs hadn't moved farther west. Even at this early date, we are beginning to see cultural differences emerge across the various regions of Eurasia. And while many of these groups maintained contact through trade and social networks, this doesn't mean that we're dealing with a monolithic culture that blanketed the whole continent. As with hunting techniques (e.g., deer and sheep in mountainous regions versus mammoth on the open steppes) and lifestyle (skin tents and cave entrances versus bone villages), it may well be that people in different parts of Europe had already begun shaping their spiritual practices to match their localized needs and their own emerging understanding of the world around them.

Conclusion

○

was eight months pregnant when I got the letter from the John Templeton Foundation confirming that they had approved my grant application and were going to pay for my fieldwork for the next two years. I was, of course, extremely excited that the Templeton Foundation saw the value of my project and was willing to fund me, but it was also kind of scary. Here I was, a PhD student, about to have my first baby, and I was about to embark on one of the more ambitious projects ever undertaken in my field. It took six months of fieldwork over two years across seven different regions in four countries to document fifty-two rock art sites—and it was totally worth it. I'm not going to lie; there were moments when I seriously doubted if I was going to be able to pull it off, but somehow it all worked out and the results have far exceeded my expectations.

I focused on Ice Age art in Europe partly because this region accounts for a large percentage of known rock art sites that are over 10,000 years old, and partly because there was already a strong research base here that I could draw on to supplement the fieldwork I proposed to complete in person. Using the data I collected at each of those fifty-two sites, combined with all the archaeological reports, articles, and books created by the many

excellent scholars past and present in my field, I now have the world's largest database of geometric signs. And it's only going to get bigger. I want to add to the database the signs found on portable artifacts. As we saw with the St. Germain-la-Rivière necklace, studying signs found on small portable items like teeth can provide a much better sense of how the signs may have been grouped or organized than a large panel of them on an expansive rocky surface. And then there are all the blank spots on the map that I would love to fill in. I'm sure there are more sites in Central and Eastern Europe waiting to be discovered, and the search is now on for Ice Age rock art sites in Africa, Asia, Australasia, and the Near East. With all the new research methods and dating technology now at our disposal, exciting discoveries like the early dating of those rock art sites in Sulawesi are already emerging. I have a feeling that the coming years are going to be particularly exciting ones for my field. Prepare to be amazed and astonished!

In other regions, like Australia, there is already large-scale documentation of early rock art sites that I would like to compare with the European data, as I suspect that many of the oldest signs in Europe will also be found there. While not everyone in my field agrees with me, I believe that the first meaningful graphic marks were made in Africa long before the first modern humans set foot anywhere else in the Old World. I think they took this new ability to understand and manipulate symbols with them as they spread out across the globe, and that this new way of thinking helped them adapt and shape the world around them wherever they went. I also think that they kept the first signs they made—at least for some millennia—and that this is why we find so many of the same signs at the earliest sites in Europe. While certain groups may have remained in contact, others became increasingly separated by time and space, and cultures began to grow in different directions. We can see this story playing out when we look at the patterns of the

signs: continuity and divergence, discontinuation and new invention. I think this will prove true for signs found on continents other than Europe as well.

This is why I see the geometric signs as such a powerful study tool for this ancient chapter of our history. These abstract shapes are not bound to the physical world around them in the same way the figurative art is. You won't find kangaroo images in Europe or elephant images in Australia or bison images in Africa. The figurative art always reflects the animals from the landscape where the artists lived. And there is a good possibility that some of the images currently categorized as signs are actually figurative depictions in disguise. Plants, landscape features, representations of celestial bodies, tools, or other items of everyday life—some of these may very well be hiding in the non-figurative category due to their stylized portrayal. For these as well, I would expect to see a correlation between the real world around them and what was being depicted (i.e., no Australian boomerang weapons in Europe).

And then there are the signs that really do seem to be non-figurative, where the link between the sign and its meaning would have needed to be taught rather than it being self-evident. We're not necessarily talking yet about full-fledged symbols such as we see in later writing systems, but something more on the order of habitual symbols, where the meaning is known only within a restricted setting. The ability to conceive of arbitrary relationships between symbols and meaning, as well as the likely use of pictographic signs, are both foundational concepts for the creation of writing. To my mind, it is during the Ice Age that we see these processes starting to develop, opening the door for the later invention of complex graphic systems.

Meaning—this is probably the most difficult conundrum of all when it comes to dealing with the signs. As we saw with the differing meanings of half circles between the San in Africa and

the Aborigines in Australia, the physical form of a sign might be the same, but it may well signify something different. This is why I don't think the signs are likely to carry a universal meaning. In Europe, we are dealing with a 30,000-year time period and a massive geographic region, and it may very well be that the same sign acquired differing meanings in different times and places.

Right now I would have to say that the likelihood of us ever knowing for sure what any of the Ice Age signs meant is extremely unlikely. However, many questions that were considered impossible to address ten or twenty years ago have now been answered, so I would be delighted to be proved wrong. In recent years, an archaeological excavation at the site of Jiahu, in Henan Province, has turned up 8,000-to-9,000-year-old turtle shells with signs engraved on them. While the signs are far removed in time and culture from the appearance of writing during the Shang dynasty some 5,000 years later, researcher Li Xueqin and his team have cautiously proposed that these early markings may be a step in that direction. They also point out that at this time in China, societies were already moving toward sedentary living in urban settings, the most common conditions for writing to arise. Dr. Li and his colleagues have very tentatively interpreted what some of these signs may have meant by comparing them with similarly shaped characters from the script that emerged in this region over the following millennia (e.g., an eye, several different numbers, a reference to a window, etc.); however, many scholars who work on the origins of Chinese script believe the distance is just too great between the Jiahu signs and the later emergence of writing for any real comparisons to be made.

There also happens to be rock art in China, and while not much is known about it outside of the country, this is starting to change.[1] If there happened to be any rock art sites that dated to near the end of

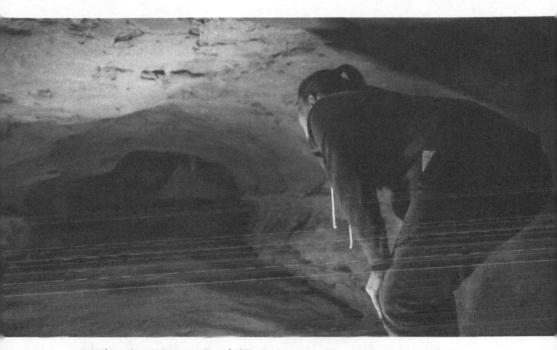

Searching for ancient art, Roc de Vézac, France. PHOTO BY D. VON PETZINGER.

the Ice Age, and if these just happened to have some of the same signs as the Jiahu tortoise shells, then, based on their geographic and temporal proximity, this could be a very interesting example of Paleolithic signs remaining in use even after the end of the Ice Age and the lifestyle transition from hunter-gatherer to sedentary farmer.

Closer to home, in the region of the Danube River, there is the 8,000-year-old Vinča proto-writing system. Artifacts incised with both pictographic and non-figurative markings have been excavated from the burial sites of this culture. Some of the same sign shapes found in Ice Age rock art also appear in samples of their script, alongside a whole series of new ones. Unfortunately, at this time only the short burial inscriptions are known, and the Vinča script remains undeciphered.

I would love to know why our distant ancestors created a series of signs to communicate. And I will keep crawling through caves and assembling data to try to answer that question. We can learn a lot about these signs' creators by studying the patterns of how they were used and the way they developed over time. I can tell you with absolute certainty that they are the product of a fully modern mind, one capable of great abstraction and symbolic thought. I personally believe that without those first tentative steps they took into the world of graphic communication, the cognitive building blocks would not have been there for their descendants to create the writing systems we take for granted today. So many of our greatest achievements would not have been possible if it weren't for those distant ancestors in Africa, Europe, and beyond, who came up with this new and innovative way to connect with fellow humans both near and far. And to put this all in perspective, if it weren't for their first signs, I wouldn't have been able to write this book about them to share with you.

Acknowledgments

First and foremost, I want to thank my family for all their support, both at home and in the field. This includes not only my incredible husband and project photographer, Dillon von Petzinger, but also my parents, Alison and Peter Gardner, and my mother-in-law, Darlene von Petzinger, for spending months overseas watching their darling grandson while his crazy parents crawled around caves (and for watching him at home as well while I worked on this book).

Thanks also to my tireless literary agent, John Pearce, for his endless dedication to this book; and to my wonderful editor at Atria Books, Leslie Meredith—thank you both for your patience and for giving me a nudge when I needed it.

And to my PhD supervisor, April Nowell, for all her encouragement over the years—thank you for believing in me and supporting me throughout my graduate journey.

Special thanks also goes out to all the wonderful archaeologists, government representatives, and private cave owners who made this work possible by giving me their time and opening their rock art sites to me: Jean-Christophe Portais, Dany Barraud, and Nathalie Fourment with the Ministry of Culture and

Communication in Aquitaine, France; Gilbert Pémendrant at Bernifal Cave, France; Jean-Max Touron at the Sorcerer's Cave (Saint-Cirq), France; Mme. Moulinié at Bara-Bahau Cave, France; Hubert de Commarque at Commarque Cave, France; Catherine Birckel-Versaveaud at Villars Cave, France; Joëlle Darricau, Aude Labarge, and Diego Garate Maidagan at Isturitz-Oxocelhaya, France (and thanks also, Diego, for the cave tours in Spain); Roberto Ontañón Peredo, Raul Gutierrez Rodriguez, and Gustavo Sanz Palomera from the archaeology branch of the Ministry of Education, Culture, and Sports in Cantabria, Spain; Ana Isabel Ortega and Miguel Martin Merino, as well as Cristina Etxeberria Zarranz, with the Territorial Service of Culture in Burgos, Spain; Fernando Real, Thierry Aubry, Luís Luís, and André Santos from the Fundação Côa Parque in Côa Valley, Portugal; and Stefano Vassallo and Giuseppina Battaglia from the Department of Cultural Heritage in Palermo, Sicily, Italy. Special thanks also to Jean-Jacques Cleyet-Merle and Peggy Jacquement for facilitating my study of the St. Germain-la-Rivière teeth at the National Museum of Prehistory in Les Eyzies-de-Tayac, France.

Much appreciation as well to Francesco d'Errico and April Nowell for the use of their photos of the Berekhat Ram figurine; Allison Tripp for the use of her figurine photos from Mal'ta and Kostenki; Kirstin Foreland for her fabulous illustration skills; and Sergio Ripoll for kindly sharing information and photos with me from his work at La Fuente del Trucho, Spain.

And finally, a heartfelt thank-you to Jean and Ray Auel, the John Templeton Foundation, and the Social Sciences Research Council of Canada for their generous support of my project.

Notes

CHAPTER 1: TWO RED DOTS

1. At El Portillo, as with many of the caves I've visited, no archaeological excavations have been undertaken, meaning that if sediment has been building up over the millennia, there could be more art hiding below the current floor level. However, the height of the dots suggests that the floor wasn't too different from what we see today. As well, if water has flowed down the walls over the years, it is certainly possible that there were originally more painted images that have since been washed away.

CHAPTER 2: ONCE UPON A TIME IN AFRICA . . .

1. Due to physical variations between different pockets of population, the branch of the *Homo erectus* species that stayed in Africa is often referred to by scholars as *Homo ergaster* instead. For the sake of simplicity, and since I will be using examples from different regions, in this context I am going to use the blanket term *Homo erectus* to refer to all these closely related extinct relatives.
2. Ian Tattersall, *Masters of the Planet: The Search for Our Human Origins* (New York: Palgrave Macmillan, 2012), 126.
3. For anyone interested in exploring human evolution in greater detail, two excellent general-interest books are Ian Tattersall's *Masters of the Planet* and Chris Stringer's *Lone Survivors: How We Came to Be the Only Humans on Earth* (New York: Henry Holt, 2012).
4. S. Harmand et al., "3.3-million-year-old stone tools from Lomekwi 3, West Turkana, Kenya," *Nature* 521 (2015): 310–15.

5. E. Hovers and D. R. Braun (eds.), *Interdisciplinary Approaches to the Oldowan* (Dordrecht: Springer, 2009). Using refitting techniques to track the movement of particular pieces of stone, paleoanthropologists have found evidence of the transportation of stone tool materials even at very early sites like Gona, Ethiopia (2.6 million years ago) and Loka-lalei, Kenya (2.34 million years ago).

6. The term *hominin* refers to us, *Homo sapiens*, plus all of our extinct relatives (*Homo erectus*, Neanderthals, Australopithecines like Lucy, etc.), back to the point when we split from the chimpanzees. The term *hominid*, which is also used quite often, is a bit broader and includes all the great apes living today, as well as their ancestral species. Since we're talking here only about humans and their direct lineage, I'm using the term that refers specifically to this group.

7. For anyone interested in learning more, the team studying Sima de los Huesos and other early sites in the vicinity have created an excellent website about these discoveries: http://www.atapuerca.tv/atapuerca/yacimiento_huesos.php?idioma=EN.

8. In Europe and Africa, *Homo heidelbergensis* starts to replace *Homo erectus* between 600,000 and 800,000 years ago, but in certain regions of Asia, the *Homo erectus* species survived until as recently as 250,000 years ago.

9. J. C. A. Joordens et al., "Homo erectus at Trinil on Java used shells for tool production and engraving," *Nature* 518 (2015): 228–31.

10. L. S. Barham, "Systematic pigment use in the Middle Pleistocene of south-central Africa," *Current Anthropology* 43, no. 1 (2002): 181–90.

11. F. d'Errico and A. Nowell, "A New Look at the Berekhat Ram Figurine: Implications for the Origins of Symbolism," *Cambridge Archaeological Journal* 10 (2000): 123–67.

12. There is one other possible example of a 300,000-plus-year-old artifact from Morocco known as the Tan-Tan figurine, but there is more debate surrounding this find.

CHAPTER 3: GLIMMERS OF A MODERN MIND

1. The two local archaeologists were Jonathan Kaplan (director of the Agency for Cultural Resource Management), and then doctoral student Peter Nilssen, who now works as a researcher along with Curtis Marean at the Pinnacle Point sites.

2. C. W. Marean, "Pinnacle Point Cave 13B (Western Cape Province, South Africa) in context: The Cape Floral kingdom, shellfish, and modern human origins," *Journal of Human Evolution* 59 (2010): 425–43.

3. One of the nearby sites contains a 120,000-year-old burial of a Neanderthal woman, raising all sorts of interesting questions about the possibility of early interactions between modern humans and Neanderthals.

4. For anyone interested in learning more about Paleolithic burials, Paul Pettitt's recent book, *The Palaeolithic Origins of Human Burial* (Oxford: Routledge, 2011), provides a comprehensive look at this topic.

5. While this archaeological layer has a pretty broad time span, scholars who have studied Paleolithic burial practices (such as Paul Pettitt) believe that they occurred within a fairly short window of time and were probably the work of one culture group.

6. F. d'Errico et al., "Pigments from Middle Paleolithic levels of es-Skhūl (Mount Carmel, Israel)," *Journal of Archaeological Science* 37, no. 12 (2010): 3099–110.

7. E. Hovers et al., "An early case of color symbolism: ochre use by modern humans in Qafzeh Cave," *Current Anthropology* 44 (2003): 491–522.

8. D. E. Bar-Yosef-Mayer, B. Vandermeersch, and O. Bar-Yosef, "Shells and ochre in Middle Paleolithic Qafzeh Cave, Israel: indications for modern behavior," *Journal of Human Evolution* 56 (2009): 307–14.

9. P. Van Peer et al., "The Early to Middle Stone Age Transition and the Emergence of Modern Human Behaviour at site 8-B-11, Sai Island, Sudan," *Journal of Human Evolution* 45 (2003): 187–93.

10. F. d'Errico et al., "Additional evidence on the use of personal ornaments in the Middle Paleolithic of North Africa," *Proceedings of the National Academy of Sciences of the United States of America* 106, no. 38 (2009): 16051–56.

11. A. Bouzouggar et al., "82,000-Year-Old Shell Beads from North Africa and Implications for the Origins of Modern Human Behavior," *Proceedings of the National Academy of Sciences of the United States of America* 104, no. 24 (2007): 9964–69.

CHAPTER 4: INTERMITTENT SIGNALS

1. Quoted in Jeff Tollefson, "Human Evolution: Cultural Roots," *Nature*, February 15, 2012; http://www.nature.com/news/human-evolution-cultural-roots-1.10025.

2. Quoted in Kate Wong, "The Morning of the Modern Mind," *Scientific American* (June 2005): 93.

3. C. S. Henshilwood et al., "A 100,000-year-old ochre-processing workshop at Blombos Cave, South Africa," *Science* 334 (2011): 219–22.

4. C. Henshilwood, F. d'Errico, and I. Watts, "Engraved Ochres from the Middle Stone Age Levels at Blombos Cave, South Africa," *Journal of Human Evolution* 57 (2009): 27–47.

5. F. d'Errico et al., "*Nassarius kraussianus* shell beads from Blombos Cave: evidence for symbolic behaviour in the Middle Stone Age," *Journal of Human Evolution* 48 (2005): 3–24.

6. P. J. Texier et al., "The context, form and significance of the MSA engraved ostrich eggshell collection from Diepkloof Rock Shelter, Western Cape, South Africa," *Journal of Archaeological Science* 40 (2013): 3412–31.

7. Chris Henshilwood, Francesco d'Errico, and the team at Blombos, along with Pierre-Jean Texier and his colleagues at Diepkloof, have all proposed the existence of full syntactic language by this time.

CHAPTER 5: WELCOME TO THE ICE AGE

1. Both Ian Tattersall's *Masters of the Planet* and Chris Stringer's *Lone Survivors* contain good overviews of this journey.

2. A. Thorne et al., "Australia's oldest human remains: age of the Lake Mungo 3 skeleton," *Journal of Human Evolution* 36, no. 3 (1999): 591–612.

3. M. Aubert et al., "Pleistocene cave art from Sulawesi, Indonesia," *Nature* 514 (2014): 223–27.

4. J.-J. Hublin, "The modern human colonization of western Eurasia: when and where?" *Quaternary Science Reviews* 118 (2015): 194–210.

5. Randall White, *Dark Caves, Bright Visions: Life in Ice Age Europe* (New York: American Museum of Natural History in association with W. W. Norton, 1986).

6. Both Randall White's book *Dark Caves, Bright Visions* and Paul Bahn and Jean Vertut's book *Journey Through the Ice Age* (Berkeley: University of California Press, 1997) provide excellent overviews of what life was like in Ice Age Europe.

7. J. Rodríguez-Vidal et al., "A Rock Engraving Made by Neanderthals in Gibraltar," *Proceedings of the National Academy of Sciences of the United States of America* 111, no. 37 (2014): 13301–6.

CHAPTER 6: VENUSES, LION-MEN, AND SIGNS BEYOND THE MUNDANE WORLD

1. Jean Clottes, "Les Mythes," in M. Otte (ed.), *Les Aurignaciens* (Paris: Éditions Errance, 2010).

2. There has been some debate as to whether the body is that of a man or a woman, but as of November 2013, when newly found pieces of

the figurine were added to the reconstruction, additions to the genital region allowed researchers to confirm the statuette is male.

3. For anyone wanting to see photos and learn more about many of the German figurines I've been describing, the government of Ulm (the region where the finds were made) has created an excellent website about these artifacts: http://www.ice-age-art.de/.

4. A couple of recent articles that address these misperceptions are A. J. Tripp and N. E. Schmidt, "Analyzing Fertility and Attraction in the Paleolithic: The Venus Figurines," *Archaeology, Ethnology and Anthropology of Eurasia* 41, no. 2 (2013): 54–60; and A. Nowell and M. L. Chang, "Science, the Media, and Interpretations of Upper Paleolithic Figurines," *American Anthropologist* 116, no. 3 (2014): 562–77.

5. There is a good selection of the Vogelherd figurines, including some with geometric markings, featured on the Ulm government website I recommended above: http://www.ice-age-art.de/.

6. T. Higham et al., "Testing models for the beginnings of the Aurignacian and the advent of figurative art and music: The radiocarbon chronology of Geißenklösterle," *Journal of Human Evolution* 62, no. 6 (2012): 664–76.

CHAPTER 7: LIFE AND DEATH IN THE FIRST VILLAGES

1. E. Trinkaus and H. Shang, "Anatomical evidence for the antiquity of human footwear: Tianyuan and Sunghir," *Journal of Archaeological Science* 35, no. 7 (2008): 1928–33.

2. E. Kvavadze et al., "30,000-Year-Old Wild Flax Fibers," *Science* 325 (2009): 1359.

3. The main site of Dolni Vestonice was only accessible for a few years in the middle of the twentieth century (it is currently buried under a private vineyard), so much of our knowledge about this early village and its mammoth bone houses comes from a series of excavations by Bohuslav Klima, director of the excavations at both Dolni Vestonice and Pavlov for many years, B. Klima, *Lower Věstonice: Camp of mammoth hunters*, 1947–1952 (Prague: Czechoslovak Academy of Sciences, 1963). More recent excavations in the area (at Pavlov and other nearby sites) have been conducted by Jiří Svoboda and his international team. An overview of some of their discoveries can be found in J. Svoboda, "The Gravettian on the Middle Danube," *Paleo* 19 (2007): 203–20.

4. I. Morley, *The Prehistory of Music: The Evolutionary Origins and Archaeology of Human Musical Behaviours* (Oxford: Oxford University Press, 2013).

5. P. B. Vandiver et al., "The Origins of Ceramic Technology at Dolni Vestonice, Czechoslovakia," *Science* 246 (1989): 1002–8.

6. R. Farbstein et al., "First Epigravettian Ceramic Figurines from Europe (Vela Spila, Croatia)," *PLoS ONE* 7 (2012).

7. To see photos and learn more about a variety of the figurines at Dolni Vestonice and Pavlov, as well as at many other sites across Europe (including some fairly unknown ones), I would recommend Jill Cook's book, *Ice Age Art: Arrival of the Modern Mind* (London: British Museum Press, 2013).

8. O. Soffer, J. M. Adovasio, and D. C. Hyland, "Perishable Technologies and Invisible People: Nets, Baskets, and 'Venus' Wear ca. 26,000 BP," in B. A. Purdy (ed.), *Enduring Records: The Environmental and Cultural Heritage of Wetlands* (Oxford: Oxbow Books, 2001).

9. P. Pettitt, *The Palaeolithic Origins of Human Burial* (Oxford: Routledge, 2011), 142.

10. One scholar in particular who has studied the trade networks of Ice Age Europe is Clive Gamble, *The Palaeolithic Societies of Europe* (Cambridge: Cambridge University Press, 1999).

11. For anyone interested in learning more about the burials at Dolni Vestonice and Pavlov, these are covered in Paul Pettitt's book, *The Palaeolithic Origins of Human Burial*, as well as in a book specifically about these sites: E. Trinkaus and J. Svoboda (eds.), *Early Modern Human Evolution in Central Europe: The People of Dolni Vestonice and Pavlov* (Oxford: Oxford University Press, 2006).

12. K. Alt et al., "Twenty-Five Thousand-Year-Old Triple Burial from Dolni Vestonice: An Ice-Age Family?" *American Journal of Physical Anthropology* 102: 123–31.

CHAPTER 8: HOW TO MAKE CAVE ART

1. E. Chalmin, M. Menu, and C. Vignaud, "Analysis of rock art painting and technology of Palaeolithic painters," *Measurement, Science and Technology* 14 (2003): 1590–97.

2. A good source for detailed information about paint mixtures and different methods of making art is P. Bahn and J. Vertut, *Journey Through the Ice Age* (Berkeley: University of California Press, 1997).

3. K. Sharpe and L. Van Gelder, "Evidence for Cave Marking by Palaeolithic Children," *Antiquity* 80 (2006): 937–47.

4. D. Snow, "Sexual Dimorphism in European Upper Paleolithic Cave Art," *American Antiquity* 78, no. 4 (2013): 746–61.

CHAPTER 9: SIGNS ACROSS THE AGES: THE MANY STYLES OF THE OLDEST ART

1. A. Pike et al., "U-series Dating of Paleolithic Art in 11 Caves in Spain," *Science* 336 (2012): 1409–13.

2. For those interested in learning more about the history of dating rock art and the various methods developed for accomplishing this, Paul Bahn and Jean Vertut's book *Journey Through the Ice Age* (Berkeley: University of California Press, 1997) as well as David S. Whitley's *Introduction to Rock Art Research* (Walnut Creek: Left Coast Press, 2005) provide detailed information about this topic.

3. Some scholars who've looked at the potential impact of refuge areas on the development of Ice Age culture and art include Lawrence G. Straus, "Southwestern Europe at the Last Glacial Maximum," *Current Anthropology* 32, no. 2 (1991): 189–99; Margaret W. Conkey, "The identification of prehistoric hunter-gatherer aggregation sites: The case of Altamira," *Current Anthropology* 21 (1980): 609–30; and Steven Mithen in his book *After the Ice: A Global Human History, 20,000 to 5,000* (Cambridge: Harvard University Press, 2003).

4. While the dates I have provided for the Solutrean and the Magdalenian are sequential, there are many scholars who have different time lines for this transition, resulting in an overlap between these two phases of up to 1,500 years. Some see the Magdalenian first appearing around 18,000 years ago, while others believe that the Solutrean continues until 16,500 years ago. This is the result of there being some crossover in tool types between these two cultures, as well as the fact that the Magdalenian didn't appear at exactly the same time in all regions.

5. For those interested in learning more about dating methods in general, British geologist Chris Turney (one of the researchers who did the radiocarbon dating on the "Hobbit" fossils from Flores Island in Indonesia) has written an accessible book that covers a number of different dating techniques: *Bones, Rocks and Stars: The Science of When Things Happened* (London: MacMillan, 2006).

6. The Chauvet dates are often cited as being between 30,000 and 32,000 years old, but this is carbon years, not calendar years. The amount of carbon in any given year can vary a little bit because of changes in Earth's magnetic field, the sun's electromagnetic field, or because of the amount of CO_2 being sequestered in the world's oceans. Dating specialists have devised ways to correct this variance by comparing carbon 14 results to other materials where they can obtain an age independently (tree rings, coral reefs, lake sediment, etc.). They then

calibrate the carbon dates and convert them to calendar years, which is why the Chauvet dates become about 5,000 years older once they've been corrected.

7. M. Aubert et al., "Pleistocene cave art from Sulawesi, Indonesia," *Nature* 514 (2014): 223–27.

8. Quoted in Pallab Ghosh, "Cave paintings change ideas about the origin of art," BBC News, October 8, 2014; http://www.bbc.com/news/science-environment-29415716.

CHAPTER 10: OF ANIMALS AND HUMANS AND STRANGE TABLEAUX

1. J. Clottes, "Thematic Changes in Upper Paleolithic Art: A View from the Grotte Chauvet," *Antiquity* 70 (1996): 276–88.

2. Since the main focus of this book is, after all, the geometric signs, I've only covered the animal images—and the human depictions that follow in this chapter—briefly. For those interested in learning more about Ice Age figurative art, further information about animal and human imagery can be found in a number of books, including Jean Clottes, *Cave Art* (New York: Phaidon, 2008), and Paul Bahn and Jean Vertut, *Journey Through the Ice Age* (Berkeley: University of California Press, 1997).

3. P. Bahn and J. Vertut, *Journey Through the Ice Age*, 163.

4. P. Graziosi, *Palaeolithic Art* (New York: McGraw-Hill, 1960), 200–201.

5. Ibid., 204–5; and B. J. Marconi, "Incisioni rupestri dell'Addaura (Palermo)," *Bulletin di Paletnologia Italiana* (1952–53): 5–22.

CHAPTER 11: PATTERNS: TRADING SIGNS AND SHARING SYMBOLS

1. Many of these publications also happen to be in Italian, which has probably further restricted the number of people who've been able to read about these discoveries.

2. Paolo Graziosi, *Palaeolithic Art* (New York: McGraw-Hill, 1960), 196.

3. P. Bahn and J. Vertut, *Journey Through the Ice Age* (Berkeley: University of California Press, 1997), 166.

4. A. Leroi-Gourhan, *The Art of Prehistoric Man in Western Europe* (London and New York: Thames and Hudson, 1968).

5. A. Ruiz-Redondo, "Seeking for the origins of Paleolithic graphic activity: Archaeological Rock Art survey in Serbia," in *Palaeolithic and Mesolithic Research in the Central Balkans*, D. Mihailović (ed.) (Belgrade: Serbian Archaeological Society, 2014), 131–38.

6. This isn't to suggest that no one had ever tried to classify the signs before, but these attempts were generally more restricted in geographic scope (one region or several adjoining ones only), and the signs were often divided up into more loosely organized categories, such as rounded and angular—M. R. Casado Lopez, *Los signos en el arte Paleolítico de la Península Ibérica* (Zaragoza: Departamento de Prehistoria y Arqueologia de la Facultad de Filosofia y Letras, 1977)—or simple and complex—D. Vialou, "L'art des grottes en Ariège magdalénienne," *XXVI supplémentaire à Gallia-Préhistoire* (Paris: CNRS, 1986)—or even into interpretive categories such as masculine and feminine— A. Leroi-Gourhan, *L'art pariétal. Langage de la préhistoire* (Paris: Jérôme Millon, 1992). There was one French team in the 1970s that did begin the process of creating a more specific, shape-based typology for parts of France and Spain (G. Sauvet, S. Sauvet, A. Wlodarczyk, "Essai de sémiologie préhistorique," *Bulletin de la Société Préhistorique de France* 74: 545–58), but they then moved in other research directions and did not pursue it further.

7. L. Capitan, H. Breuil, and D. Peyrony, *La Caverne de Font-de-Gaume aux Eyzies (Dordogne)* (Monaco: Impr. vve A. Chêne, 1910), and P. Graziosi, *Palaeolithic Art*, 185–86.

8. S. Ripoll et al., "La Fuente del Trucho," *Bolskan* 18 (2001): 211–24.

9. Personal conversation with Dr. Ripoll about the possible age of the Fuente del Trucho tectiforms.

10. C. Gamble, *The Palaeolithic Societies of Europe* (Cambridge: Cambridge University Press, 1999).

CHAPTER 12: CHICKEN OR EGG: A BRIEF HISTORY OF LANGUAGE, BRAINS, AND WRITING

1. J. A. Hurst et al., "An extended family with a dominantly inherited speech disorder," *Developmental Medicine & Child Neurology* 32, no. 4 (1990): 352–55.

2. S. Pinker, *The Language Instinct: How the Mind Creates Language* (New York: William Morrow and Co., 1994).

3. M. D. Hauser, N. Chomsky, and W. T. Fitch, "The Faculty of Language: What Is It, Who Has It, and How Did It Evolve?" *Science* 298 (2002): 1569–79; and R. G. Klein, *The Dawn of Human Culture* (Hoboken: Wiley, 2002).

4. K. R. Gibson and T. Ingold (eds.), *Tools, Language and Cognition in Human Evolution* (Cambridge: Cambridge University Press, 1993).

This book is an excellent resource with contributions from a range of specialists in a number of related fields (everything from primatology to experimental psychology).

5. R. Dunbar, *Grooming, Gossip, and the Evolution of Language* (Cambridge: Harvard University Press, 1998).

6. D. Falk, *Finding Our Tongues: Mothers, Infants, and the Origins of Language* (New York: Basic Books, 2009).

7. M. R. Casado Lopez, *Los signos en el arte Paleolítico de la Península Ibérica* (Zaragoza: Departamento de Prehistoria y Arqueologia de la Facultad de Filosofia y Letras, 1977), 86.

8. Paleoanthropologists use the term *sign* in a general sense when referring to abstract images like the geometric signs from Ice Age rock art sites. Linguists, on the other hand, uses the term *sign* in a much more specific way and even divide the signs into three subcategories: icon, index, and symbol. An icon is a sign that bears a physical resemblance to the object it represents. In other words, a picture of a sheep really represents a sheep (note: icons and pictograms are the same sort of sign). By contrast, an index sign refers to its subject indirectly. For example, a sign depicting animal tracks does not represent the word for animal tracks, but instead indirectly represents the animal itself. A symbol, meanwhile, is an arbitrary sign that has no direct relationship with the object it represents—this is the type of sign you find in fully developed writing systems.

In proto-cuneiform the sign representing an ox still looks like an ox's head, making it an iconic sign, but by the time cuneiform became an actual writing system, that ox's head had been stylized to the point of no longer being recognizable: rotated 90 degrees and reduced to a few strokes of the stylus, it had become a symbol. At this point, the association between the symbol and its subject is established through a habitual connection or existing cultural convention between the name and the object (i.e., someone has to teach you what it means), not by any visual cues.

9. Alphabetic systems are the most recent invention and rely entirely on combining different units of sound (called phonemes) to form recognizable words. These units can either be individual letters or combinations of letters, like "th" or "st." Altogether there are somewhere between forty and forty-five separate phonemes, or sounds, in the English language, depending on which version of it you speak.

10. Syllabic writing, as you might guess, is made up of characters that represent syllables as opposed to single sounds; words are created by combining the different syllable characters in the language. Not many writing systems are purely syllabic though it appears that the dead language of Linear B, from Mycenaean Greece, actually was. A variation on this type of system is the abjad—Arabic is written this way—in which the characters represent only the consonant sounds of syllables. Many of the oldest writing systems were partially syllabic as well as being logographic.

11. Unlike the other early scripts, which relied more heavily on pictograms in their earliest incarnations, Egyptian hieroglyphs—created around 5,000 years ago—were a mixed system of both logograms and phonetic (sound) elements right from the beginning. Another peculiarity of hieroglyphs is that the direction in which they can be read is flexible and is signaled by the way in which the glyphs themselves are oriented; this allowed the characters to be integrated into other graphic images, such as we find on temple walls. While there has been considerable debate about whether the Egyptians were influenced by their neighbors the Sumerians, the two writing systems are quite different in form and structure and we have no clear evidence of the Egyptian script having been derived from cuneiform. However, if you compare the Egyptian economic transaction records, which date back to before the formation of hieroglyphs, with the clay tokens from prewriting Mesopotamia, there are a great many similarities.

12. Created in Mesopotamia by the Sumerians, the earliest incarnation of this script is generally dated to about 5,200 years ago. It's often identified as the oldest writing system in the world. All of the oldest signs in this script are representations of natural objects (pictograms) or numbers. Only later were abstract and symbolic meanings added, using the rebus principle and metonymy. Stylization set in early in the cuneiform system, leading to a complete loss of the pictorial appearance of the signs as they took on the sticklike appearance for which the script is named.

 While there still remains some debate about what prompted the Sumerians to develop a fully formed writing system, one particularly interesting proposal comes from archaeologist Denise Schmandt-Besserat, *How Writing Came About* (Austin: University of Texas Press, 1996), who believes that one of the precursors to this script was a

system of accounting. This is due to the discovery of a long history of clay token usage to record economic transactions in the region. These tokens, the earliest of which date to between 8,000 and 10,000 years ago, display pictures of the items being traded or for which a debt had been incurred (e.g., sheep, wheat) and were marked with lines or dots to represent the quantities of each item involved in the transaction. And it's interesting to note that this process seems to have started not long after the end of the Ice Age.

13. Developed in the Shang dynasty in the Yellow River Valley region of what is now modern-day China, this particular script is generally recognized as having become a writing system by about 3,200 years ago. As with the other earliest scripts, it was principally formed using logograms, but while cuneiform and hieroglyphs have both long vanished, a refined version of the Chinese logographic script remains in regular use today. The majority of the earliest Chinese texts are divinations (i.e., asking the deities questions through a diviner) from the Shang period, written on oracle bones (e.g., ox scapula) and turtle shells. A smaller collection of inscriptions predominantly made up of clan names has also been found cast onto bronze vessels. The divinations cover a wide range of topics (e.g., health, family matters, weather, military actions), and Princeton archaeologist Robert Bagley has proposed an earlier, though as yet unknown, time of origin for the Chinese script based on the fact that there were already several thousand characters in use by 3,200 years ago (R. Bagley, "Anyang writing and the origin of the Chinese writing system," in *The First Writing: Script Invention as History in Process*, S. Houston (ed.) (Cambridge: Cambridge University Press, 2004)). No specific precursor to the Chinese script has yet been identified, but it is entirely possible that the lack of earlier material could be a problem of preservation (e.g., the script being written on perishable materials such as bamboo) rather than a lack of existence.

14. Units of meaning are called morphemes and can either be a word or a word modifier, as when we add an "s" in English to pluralize a word, or make it negative by adding "un" in front.

15. Another important linguistic device used by the creators of the first writing systems is the rebus principle. This is when a character that has been used to represent meaning starts to also be used for its sound. In the case of a homonym, then the entire word can be used. A good example of this is the Sumerian word *sar*. It means "plant," and the character representing it resembled a plant. But it just so happens that

the verb "to write" in Sumerian is also pronounced *sar*. It didn't take long for early scribes to start using this character to represent both words (and both ideas). Early Chinese and Sumerian each contain a lot of homonyms, which made it possible for both writing systems to take advantage of the rebus principle.

CHAPTER 13: THE LADY OF ST. GERMAIN-LA-RIVIÈRE AND HER MYSTERIOUS NECKLACE

1. Y. Taborin, *Langage Sans Parole: La Parure aux Temps Préhistoires* (Paris: La maison des roches éditeur, 2004).
2. R. Blanchard, "Découverte d'un squelette humain à Saint-Germain-la-Rivière (Bordeaux)," *Revue Historique et Archeologique du Libournais* 9 (1935): 109.
3. M. Vanhaeren and F. d'Errico, "Grave Goods from the Saint-Germain-la-Rivière Burial: Evidence for Social Inequality in the Upper Palaeolithic," *Journal of Anthropological Archaeology* 24, no. 2 (2005): 117–34.
4. Ibid.
5. Ibid.
6. J. Gaussen, *La grotte ornée de Gabillou près de Mussidan* (Bordeaux: Delmas, 1965).

CHAPTER 14: THROUGH THE EYES OF THE ANCESTORS: A ROCK ART EPIPHANY

1. For those interested in further exploring the different theories of meaning for both figurative and non-figurative art, some good sources include: D. S. Whitley, *Introduction to Rock Art Research* (Walnut Creek: Left Coast Press, 2005); M. W. Conkey, "New Approaches in the Search for Meaning? A Review of Research in Paleolithic Art," *Journal of Field Archaeology* 14, no. 4 (1987): 413–30; and P. Bahn and J. Vertut, *Journey Through the Ice Age* (Berkeley: University of California Press, 1997).
2. There were a few mentions of signs in some of the overview articles, but since they're not common, they weren't what was being pictured or described in detail in the articles. As Portuguese researcher António Marthinho Baptista described the Côa rock art, "The motifs are mostly zoomorphic, with scarce signs and rare human representations." A. Martinho Baptista, "The Quaternary Rock Art of the Côa Valley (Portugal), les premiers hommes modernes de la Péninsule Ibérique," *Trabalhos de Arquelogia* 17 (2001): 239. This sort of statement is what

prompted me to e-mail Dr. Thierry Aubry at the Côa Valley museum to confirm that there really were signs, and then prompted me to go document the abstract art for myself.

3. For those interested in seeing photos and learning more about the rock art found throughout the Côa Valley in Portugal, the Côa Park Foundation has created an excellent website with photos of the art and the surrounding landscape, as well as detailed descriptions about many of the sites in the area: http://www.arte-coa.pt/index.php?Language=en.

4. P. Graziosi, *Palaeolithic Art* (New York: McGraw-Hill, 1960), 185.

CHAPTER 15: FEATHER OR WEAPON: THE REAL-WORLD MEANINGS OF CAVE SIGNS

1. A. Leroi-Gourhan, *L'art pariétal. Langage de la préhistoire* (Paris: Jérôme Millon, 1992).

2. P. Bahn, "No sex please, we're Aurignacian," *Rock Art Research* 3 (1986): 99–105.

3. S. J. Mithen, "Looking and Learning: Upper Paleolithic Art and Information Gathering," *World Archaeology* 19, no. 3: 297–327.

4. N. R. Franklin, "Discontinuous Dreaming Networks: Analyses of Variability in Australian Pre-Historic Petroglyphs, *Rock Art Research* 24, no. 1 (2007): 97, citing signs with multiple meanings as collected by N. D. Munn, "Visual Categories: an approach to the study of representational systems," *American Anthropologist* 68 (1966): 936–50.

5. H. Breuil, *Four Hundred Centuries of Cave Art* (Montignac: Centre d'Etudes et de Documentation Prehistoriques, 1952).

6. M. Gonzalez Morales, "When the Beasts Go Marching Out! The End of Pleistocene Art in Cantabrian Spain," in M. W. Conkey et al. (eds.), *Beyond Art: Pleistocene Image and Symbol* (Berkeley: University of California Press, 1997).

7. P. Bahn and J. Vertut, *Journey Through the Ice Age* (Berkeley: University of California Press, 1997).

8. H. Breuil, *Four Hundred Centuries of Cave Art*, has proposed the possible presence of "topographic markers" in the form of red dots and other isolated marks at some cave art sites, as have fellow rock art researchers Peter Ucko and Andrée Rosenfeld in their book *Paleolithic Cave Art* (New York: World University Library, 1967).

9. P. Graziosi, *Palaeolithic Art* (New York: McGraw-Hill, 1960).

10. Ibid.

11. E. Pásztor and A. Priskin, "Celestial symbols revisited. Palaeolithic sky lore: fiction or fact?" *IFRAO Congress*, September 2010, Symposium: Signs, Symbols, Myth, Ideology.

12. B. Hayden and S. Villeneuve, "Astronomy in the Upper Paleolithic?" *Cambridge Archaeological Journal* 21 (2010): 331–55.

13. A. Marshack, *The Roots of Civilization: The Cognitive Beginnings of Man's First Art, Symbol and Notation* (New York: Moyer Bell Ltd., 1972).

14. A. Marshack, "The meander as a system. The analysis and recognition of iconographic units in upper palaeolithic compositions," in P. J. Ucko (ed.), *Form in Indigenous Art, Schematisation in the Art of Aboriginal Australia and Prehistoric Europe* (New Jersey: Humanities Press Inc., 1977), 286–317.

15. P. Utrilla Miranda et al., "A palaeolithic map from 13,660 cal BP: Engraved stone blocks from the Late Magdalenian in Abauntz Cave (Navarra, Spain)," *Journal of Human Evolution* 57 (2009): 99–111.

16. S. Nomade et al., "A 36,000-Year-Old Volcanic Eruption Depicted in the Chauvet-Pont d'Arc Cave (Ardèche, France)?" *PLOS ONE* 11 (2016).

17. P. Bahn and J. Vertut, *Journey Through the Ice Age*.

18. P. Utrilla Miranda et al., "A palaeolithic map from 13,660 cal BP": 99.

19. F. d'Errico, "A New Model and its Implications for the Origin of Writing: The La Marche Antler Revisited," *Cambridge Archaeological Journal* 5, no. 2 (1995): 163–206.

20. A. Marshack, *The Roots of Civilization*.

21. Quoted in John Noble Wilford, "When Humans Became Human," *New York Times*, February 26, 2002; http://www.nytimes.com/2002/02/26/science/when-humans-became-human.html?pagewanted=all.

22. I. J. Gelb, *A Study of Writing* (Chicago: The University of Chicago Press, 1952).

CHAPTER 16: SEEING THE UNSEEN WORLD: VISIONS, SHAMANS, AND THE SEVEN SIGNS

1. J. D. Lewis-Williams and T. A. Dowson, "The Signs of All Times: Entoptic Phenomena in Upper Paleolithic Art," *Current Anthropology* 29, no. 2 (1988).

2. R. C. Power et al., "Microremains from El Míron Cave human dental calculus suggest a mixed plant-animal subsistence economy during the Magdalenian in Northern Iberia," *Journal of Archaeological Science* 60 (2015): 39–46.

3. D. Lewis-Williams, *The Mind in the Cave: Consciousness and the Origins of Art* (London: Thames and Hudson, 2002).

4. J. Clottes and D. Lewis-Williams, *The Shamans of Prehistory: Trance and Magic in the Painted Caves* (New York: Harry Abrams, 1998).

5. D. Lewis-Williams, *The Mind in the Cave.*

6. Ibid.

7. A. Marshack, *The Roots of Civilization: The Cognitive Beginnings of Man's First Art, Symbol and Notation* (New York: Moyer Bell Ltd., 1972), 336–37.

8. For example, Russian anthropologist Mikhail Gerasimov, who worked at Mal'ta, as well as Czech scholar Bohuslav Klima, who worked at Dolni Vestonice and Pavlov, have both proposed that these eastern Eurasian sites may well be the birthplace of the shamanistic tradition.

CONCLUSION

1. Paul Tacon et al., "Naturalism, Nature and Questions of Style in Jinsha River Rock Art, Northwest Yunnan, China," *Cambridge Archaeological Journal* 20, no. 1 (2010): 67–86.

Index

Page numbers of illustrations appear in italics.

About the Author

Genevieve von Petzinger is a rising star in the study of rock art from the Ice Age in Europe—the only researcher in the world focusing specifically on large-scale connections between the geometric signs from this ancient time period. The unique database she built holds more than five thousand signs from almost four hundred sites across Europe. Her work has been featured in popular science magazines such as *New Scientist* and the European edition of *Science Illustrated*. She was selected as a TED Global Fellow in 2011 and as a 2013–2015 TED Senior Fellow, and in 2015, Genevieve gave a TED talk that has since garnered over 1.5 million views.